FACING FASCISM

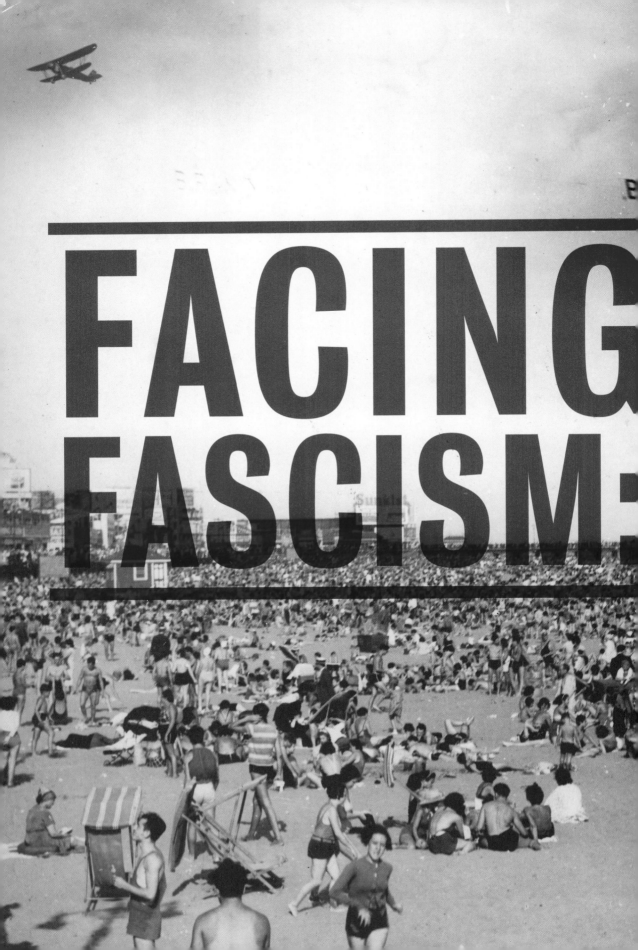

G HOME WOUNDED AMERICANS FROM SPAIN

NEW YORK AND THE SPANISH CIVIL WAR

PETER N. CARROLL & JAMES D. FERNANDEZ, EDITORS

MUSEUM OF THE CITY OF NEW YORK + NYU PRESS

Facing Fascism: New York and the Spanish Civil War is a collaborative project of the Museum of the City of New York, the Abraham Lincoln Brigade Archives, and Instituto Cervantes New York. Lead funding comes from the Puffin Foundation, Ltd., with additional generous support from the Sociedad Estatal de Conmemoraciones Culturales of Spain. The cooperation of the Tamiment Library, New York University, is also gratefully acknowledged.

Advisory Committee: *Lluis Agustí, Ronald Bayor, Joshua Brown, Thomas Bender, Peter Carroll, James Fernandez, Joshua Freeman, Helen Langa, Deborah Dash Moore, Mark Naison, Julia Newman, Fraser Ottanelli, Robert Snyder*

MUSEUM OF THE CITY OF NEW YORK

The Museum of the City of New York embraces the past, present, and future of New York City and celebrates the city's cultural diversity. It does so through its rich collections, a lively schedule of exhibitions, and an array of programs for adults and children. The Museum is dedicated to fostering an understanding of New York's evolution from its origins as a settlement of a few hundred Europeans, Africans, and Native Americans to its present status of one of the world's largest and most important cities.

ABRAHAM LINCOLN BRIGADE ARCHIVES

The Abraham Lincoln Brigade Archives (ALBA) is an educational organization dedicated to preserving the progressive heritage of the United States. Inspired by the ideals, experiences, and legacy of the men and women who volunteered to participate in the Spanish Civil War (1936-39), ALBA creates wide-ranging cultural programs, museum exhibitions, and teaching resources to explain why activist dissent is fundamental to a healthy democracy.

INSTITUTO CERVANTES

Instituto Cervantes is a worldwide non-profit organization created by the Spanish government in 1991. Its mission is to promote the study of Spanish and to contribute to the advancement of the Spanish and Hispanic American cultures throughout non-Spanish speaking countries.

THE PUFFIN FOUNDATION

In 1937, in the throes of the Great Depression, some 3,000 young men and women—close to half of whom were from the New York area—departed from Manhattan's harbor on the Hudson River to fight for the Republic of Spain. They were volunteers seeking to stop an attempt by fascists, supported by Hitler and Mussolini, to overthrow the democratically elected Spanish government. They were joined by thousands of other volunteers from countries as distant as Argentina and China. The war in which they fought, the Spanish Civil War, was to be the prologue to World War II, which ravaged Europe and its population and gave rise to a new chapter in the history of evil—the fascist plan to exterminate all Jews in Europe.

We at The Puffin Foundation are honored to have the privilege of seeing the history of the Spanish Civil War and the city's role in it brought to the light of day in the form of this book and an exhibition at the Museum of the City of New York.

Facing Fascism: New York and the Spanish Civil War tells a long-buried chapter of history—the story of the Americans who volunteered to fight in Spain. It will now be remembered as an inspiration to all. They represented the best of our country and the best of our conscience. This exhibition is a tribute to their courage and sacrifice. —Perry Rosenstein, *President*

CONTENTS

PREFACE

BY SUSAN HENSHAW JONES

PRESIDENT & DIRECTOR OF THE MUSEUM OF THE CITY OF NEW YORK

Seventy years after members of the International Brigades, including nearly 3,000 Americans, first arrived in Spain to defend the democratically elected government of the Spanish Republic against a rebellion led by General Francisco Franco and militarily backed by Hitler and Mussolini, questions continue to haunt us. Why did ordinary New Yorkers—college students, dock workers, doctors and nurses—leave their friends and family, break United States law, and secretly ship off to serve as part of the international forces on the frontlines of a civil war being waged on the other side of the Atlantic Ocean? How do we understand these New Yorkers' level of commitment, idealism, and sacrifice? What explains ordinary people doing extraordinary things?

The Spanish Civil War, considered by many historians to be a prelude to World War II, helped to shape the world for decades to come and forever changed the lives of the many New Yorkers—across a broad social, cultural, and political spectrum—who were passionately engaged in it. New York in the 1930s was a place defined by both desperation and hope. It was a city in ferment. Devastated by the Depression, many despaired that prosperity would never return; radical politics flourished, as did activism of many sorts. Perhaps half of the Americans who fought in Spain came from the New York metropolitan area. Thousands of other New Yorkers supported the Spanish Republic by raising money, sending humanitarian aid, helping refugees, and calling for the United States government to lift its embargo on sending arms to the Republican forces. This book, and the exhibition that accompanies it, tell these New Yorkers' stories.

The full history of New Yorkers and the Spanish Civil War is, however, more complex. The war brought to the surface the intricate patchwork of ideological and ethnic identities so often present in New York politics. In opposition to those New Yorkers who backed the Republic were those who followed the Catholic Church's support of the rebellion. Their story is told here, too. Indeed, the many conflicts, contradictions, and ambiguities that define this chapter in history are in part why we continue to examine it so carefully; this book and exhibition try to help make sense of both global main currents and deeply personal, individual decisions.

It is my pleasure to acknowledge, on behalf of the Museum of the City of New York, the work and dedication of the many people who made this book and exhibition possible. Without the generous support of Perry Rosenstein and the Puffin Foundation, Ltd., the Instituto Cervantes, and the Sociedad Estatal de Conmemoraciones Culturales, none of this would have come to fruition. I am also grateful to Sarah Henry and Thomas Mellins who organized the exhibition with invaluable help from Elizabeth Compa, Autumn Nyiri, and the members of the exhibition's Advisory Committee, and to Peter N. Carroll and James Fernandez who conceived this book and shaped the contributions of the stellar cast of essayists.

FOREWORD

BY E.L. DOCTOROW

It was in the 1930s that Americans in great numbers lost their trust in the economic system that had brought on the Great Depression. A desperate longing for the ideal community produced constituencies for everything from anarchism, and all the varieties of socialism and communism on the left, to conservative agrarianism, and clerical or secular fascism on the right. The passions turned systemic with the Spanish Civil War of 1936–39. That war, in which the leftist Spanish Republic was assailed by an insurgent coalition of army officers, Catholic clergy, and royalists under the leadership of General Francisco Franco, created a simulacrum of itself in the United States, particularly in New York, where a "Popular Front" formed up that was roughly equivalent to the wartime left alliance in Spain, and where right-wing priests broadcast virulent sermons for Franco and brown-shirted Bundists held rallies in which they Heiled Hitler.

That the war was pervasive in the city's consciousness I know, because as a five year old, I had more than once answered the doorbell to find someone collecting money for "Spanish War Relief." Such terms as "Loyalist" and "Falangist" were not at all strange to my ears. Was I aware of the several hundred American communists who sailed off to Spain to fight for the Republic, and did I know of the fascist rallies in Madison Square Garden? Probably not. More likely, as I played on the living room floor in front of the family's console radio, I heard only a generalized voice of adult concern, and tried to understand why, as everyone seemed to believe, this war was preamble to a world war, a planetary battle between freedom and tyranny, which I thoughtfully staged there on the living room rug with my toy soldiers and little metal tanks and trucks.

The present exhibition recalls for our contemplation the moral ambiguities residing in what was essentially a clear contest between an elected government trying to extricate its people from a feudal social system, and a privileged class intent on preserving it. As such attending writers as Ernest Hemingway and George Orwell were quick to perceive, the Soviet communist participation in the Republican effort was perfidious. And whereas the Falangist insurgents were endowed with the modern arms and munitions of Hitler and Mussolini, the Republic did battle with only the musketry left to it after the refusal by the United States and the other western democracies to match such materiel.

When, with the defeat of the Republic, the war in Spain was over, the dynamic political contentions that it had aroused in America went on, to the national detriment, well into the 1950s. In our own time we see the Spanish Civil War template of dogmatic religion in collusion with political extremism both domestically and abroad. Just as in Spain in the '30s, when the church threw its spiritual weight behind the insurgents, so today are Muslim terrorists endowed by the most reactionary clerical interpreters of the Koran.

And at this moment in time, with the world seeming destined to be tormented always by war, to be forever in continuous catastrophic turmoil, if you allow that humanity is a species, then all our wars, like that of Spain in the 1930s, are civil wars.

FOREWORD

CLOSING THE WOUND

BY EDUARDO LAGO

TRANSLATION BY JAMES D. FERNANDEZ

The essays in this volume offer a broad and profound vision of a painful experience that still weighs heavily upon the collective memory of Spain and the United States: the traces of the Spanish Civil War, which was fought between 1936 and 1939. A group of New Yorkers played an important role in that confrontation. When I interviewed E. L. Doctorow for the Spanish newspaper *El País*, right after the appearance of the Spanish translation of his novel *The March*, he remarked to me that civil wars open wounds that take a long time to heal (if indeed, they ever do really heal). Doctorow was thinking about the setting of his novel, the American Civil War, a fratricidal confrontation that took place in a past much more distant than that of the Spanish tragedy.

In 2006, we Spaniards commemorated the 70th anniversary of the outbreak of our war. This is an odd anniversary to commemorate: 100, 50, 75 or 25 years are much more common milestones. Why 70? What is the urgency? Why is there such haste to revisit and analyze the roots of this conflict that had such profound international repercussions and such deep historical consequences? I think the explanation is, as Doctorow suggested, that although we have not fully realized it, the Spanish Civil War is still an open wound.

I speak from my own experience. As a novelist I was surprised when the theme of the civil war insinuated itself into my novel and became one of the main threads of *Call Me Brooklyn*. I simply was not prepared for this. I had been convinced, since my adolescent years, that, artistically speaking, the Spanish Civil War was an exhausted, worn-out topic. Obviously, I was mistaken. As a Spanish writer living in New York, when I looked for a connection between the two countries of my heart—Spain and the United States—I found that link (again, without really trying) in the volunteers of the Abraham Lincoln Brigade. Without really consulting with the author, several brigadistas from Brooklyn simply decided to crash my novel.

In 2006, the Spanish government proposed a Law of Historical Memory. The still-open wounds were urgently demanding the collective attention of the nation. We did not want to wait; we could not wait; but why? The answer to this question is related to a miracle that took place in our recent history. In 1975, despite all the careful plans made by the Dictator to ensure the continuity of his regime after his death, Spain undertook a peaceful and festive transition to democracy. For several years, the country was a big fiesta. After four decades of stifling backwardness, Spain enjoyed a new beginning: an open, bustling, luminous period, character-

ized by major social and economic gains. And among those gains, the most important were social harmony, tolerance, and freedom.

Now that enough time has passed to demonstrate the irreversible consolidation of Spain's democracy, the pluralist country that we are must unbury the keys to a past that is still unresolved, a past that still haunts us. Now that we have reached maturity we are obliged to confront, in all of its dimensions, the trauma unleashed by that terrible war. To recover historical memory means to begin to close that wound (yes, perhaps it is possible). To analyze the past, to cast light on those unspeakably painful moments is, in the end, a task of reconciliation; it means putting behind us the image of the "two Spains" invoked by Antonio Machado. No longer does one half of Spain have to live in fear of the other half; let us hope that a divided Spain is truly a thing of the past.

The current exhibition illustrates one of the many dimensions of the Spanish Civil War: the involvement of Americans, or more precisely, New Yorkers, in the war. Exhibitions like this one invite today's Spaniards and Americans to revisit a moment of great relevance from our shared past, a moment that, despite all the pain, also contains a great deal of beauty. This exhibition tells a story of friendship and solidarity among young men and women from Spain and the United States, and it admirably illustrates an enterprise undertaken in pursuit of the most beautiful of all ideals: liberty.

INTRODUCTION

BY PETER N. CARROLL

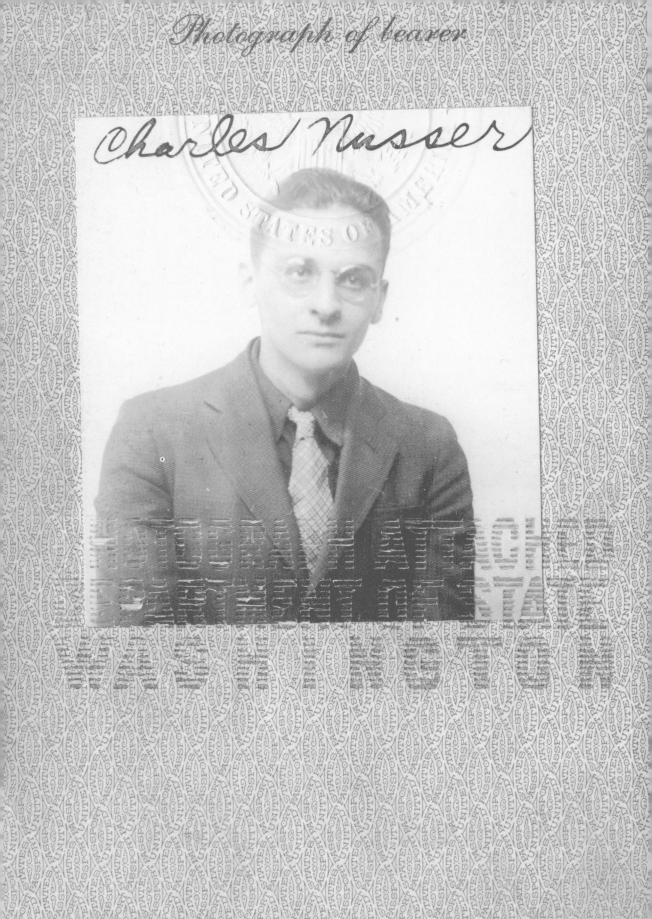

This passport, properly visaed, is valid for travel in all countries unless otherwise specified.

This passport, unless limited to a shorter period, is valid for two years from its date of issue and may be renewed for an additional period of two years.

Limitations

This passport is not valid for travel to

Spain

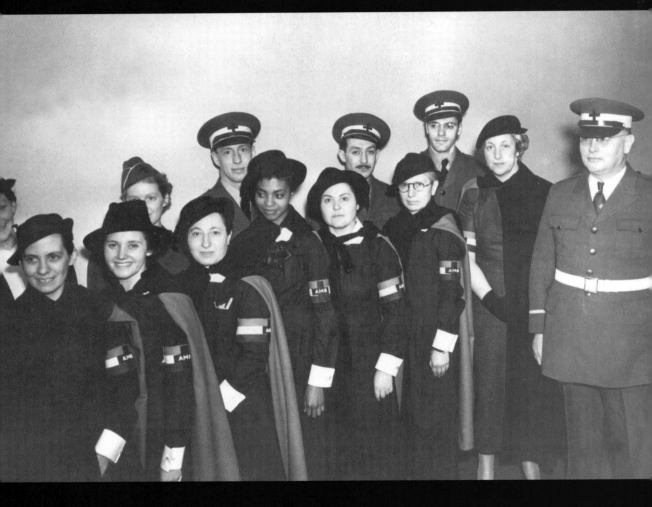

PREVIOUS SPREAD
Passport of American volunteer Charles Nusser with stamp barring travel to Spain (detail).

ABOVE
Group of American Medical Bureau staff shortly before its departure for Spain, 1937.

THE OPENING OF THE Empire State Building, then the world's tallest structure, on May 1, 1931, embodied New York City's self-image as an international metropolis. Since earning huge profits during the Great War, Wall Street could justly claim to dominate global capitalism. Nevertheless, the crash that toppled the stock market in 1929 and the ensuing economic stagnation meant that the giant tower on 34th Street and Fifth Avenue would remain half occupied for years. Hollywood's 1933 thriller *King Kong* opened with scenes of frightened people waiting on a New York City breadline for a meal and ended by showing imperial pretension falling apart as the exotic gorilla smashed the upper floors of the metropolis' crown jewel.

At street level, unemployment reached 25 percent, and thousands pounded the pavement looking for work or charitable assistance or scraps to eat. In 1932, weekly family relief allowances in New York City fell to $2.39, but that measly sum reached only half the eligible households. Without money for rent, evicted families could be seen standing on sidewalks surrounded by all their worldly goods. White-collar businessmen sold apples on street corners for a nickel apiece. Such scenes—and worse scenes—appeared throughout the cities of the nation and around the world. Amidst raging poverty, most New Yorkers could not afford a global view of their afflictions.

International politics were less easily ignored. The same Depression that brought the election of New York Governor Franklin D. Roosevelt to the presidency in 1933 also pushed the Nazi Adolf Hitler into power in Germany. Both promised economic recovery: Roosevelt spoke of a "New Deal" to save capitalism and make jobs; Hitler talked about military rearmament and international expansion. Meanwhile, in Asia, Japan sought economic stability through an East Asia Co-Prosperity Sphere that began with the invasion of China's Manchurian peninsula in 1931 and, six years later, the mainland. In Italy, Benito Mussolini, "Il Duce," pounded his chest like Kong and summoned the restoration of the Roman Empire by attacking Abyssinia and Ethiopia in 1935.

Other imperial nations of Europe—the so-called Allies of the Great War—held similar claims. Great Britain's empire stretched from Singapore and Hong Kong to India, South Africa, and Jamaica in the West Indies; France continued to rule in North Africa (Algeria, Morocco, Tunisia), Indochina (Laos, Cambodia, Vietnam), and the Caribbean sugar islands of St. Pierre and Martinique. Neither power, bled white by the world war, wanted to provoke another conflict. Instead, they adopted policies of appeasement toward the aggressive fascist leaders, Mussolini and Hitler.

By contrast, Roosevelt's America played second fiddle. Having rescued the Allies during the world war, the public recoiled from foreign politics, rejected participation in the League of Nations and the World Court, and adopted "neutrality" laws to prevent even inadvertent involvement with Europe's struggles. Instead, Washington attempted to alleviate Depression conditions by arranging trade agreements with other countries and extended diplomatic recognition to another second-class power, the Soviet Union, led by the Communist dictator Josef Stalin. Both governments hoped that better relations would encourage business and improve their domestic economies.

The outbreak of the Spanish Civil War brought into sharp relief these global configurations. Spain's Republican government had endured explosive political competition since its creation in 1931. On one side, conservatives protected the power of the Roman Catholic Church, the army, the aristocracy, and the great landowners, while Republicans joined socialists in seeking reforms, such as ending the church's control of education, allowing voting rights for women and civil marriages, and more radical demands such as distributing land to the peasants. In February 1936, a coalition of left-liberal groups, the Popular Front, including the small Communist Party, won a bitterly fought election. Immediately, a cadre of army officers led by General Francisco Franco and backed by church leaders and wealthy landowners began to plot a military rebellion. All hell broke loose in Spain on July 18, 1936.

In the first days of fighting, the rebels met stiff resistance in Spain's major cities from loyal members of the army and militia groups formed by labor unions and political parties. Elected officials believed the uprising would soon collapse. But Franco's pleas for assistance reached friendly ears in Berlin and Rome. Within a week, Germany and Italy sent military aid, particularly aircraft to ferry Franco's African troops (including Muslim mercenaries) to southern Spain. As the rebels marched toward Madrid, leaving a trail of destruction and death, the legal government pleaded with other nations for assistance.

Britain and France answered with a policy of non-intervention, demanding that other countries stay out of the conflict. Germany and Italy agreed to these proposals, and even participated in a Non-Intervention Committee, though both countries openly violated the agreements. Other nations understood this deception and made no changes of policy. The horrific bombing of the Basque town of Guernica by German aircraft—immortalized in Pablo Picasso's famous painting that hung for decades in New York's Museum of Modern Art—brought no retaliation.

Despite intense diplomatic jockeying about the Spanish Civil War, the United States and the Soviet Union played minor roles on the international stage. Although many scholars writing after World War II and the Cold War have emphasized the conflict between democratic and communist ideology, it is important to remember that, before 1945, both Roosevelt and Stalin saw their primary enemy

as fascist expansion and both directed their policies to best protect their national interests. Both leaders wished they could influence the outcome of the Spanish conflict, but neither government had sufficient resources to contribute definitively and, in the end, neither perceived a major national interest in the result.

Aware of German and Italian support for the Franco rebellion, Stalin understood the importance of preserving Spain as an antifascist nation and began to sell military supplies to the Republic in September 1936. But the Communist leader also understood that Great Britain viewed such transactions as a threat to European stability and considered Soviet aid a justification for maintaining the non-intervention policy, to the detriment of the Republic. In any case, the Soviet Union, geographically distant and rebuilding its own armies, offered limited assistance. That Stalin did any business with the Spanish Republic nevertheless had vast symbolic power. The presence of Soviet military advisors and Soviet-built equipment increased the prestige and power of the Spanish Communist Party, enabling Stalinist agents to crush rival anarchist and social revolutionary parties. Outside Spain, Soviet involvement reinforced conservative fears and justified anti-Republican policies.[1]

Hatred of the Spanish Republic permeated U.S. politics and crystallized debate in big cities like New York. Roosevelt had built his New Deal coalition on the votes of northern urbanites with roots in the white ethnic working class. Facing reelection in November 1936, ten weeks after the civil war began, Roosevelt's Democratic majority strongly opposed support for the left-leaning Spanish Republic. New York's Catholics remained sympathetic to Franco and hostile to socialists and communists. Indeed, as soon as the civil war began, the Catholic leadership opened an editorial barrage against the Republic's "villainous anti-Catholic government."[2] Roosevelt lacked the political strength within his own party to challenge what he called "isolationist" sentiment.

Passport of American volunteer Charles Nusser with stamp barring travel to Spain.

"It's a terrible thing to look over your shoulder when you are trying to lead," he observed in 1937, "—and to find no one there."[3] That summer, two American writers, Ernest Hemingway and Martha Gellhorn, returned from Spain for a private exhibition at the White House of a pro-Republican documentary film, *The Spanish Earth*. During the screening, the President sighed, commenting "Spain is the vicarious sacrifice for all of us."[4] Roosevelt's sympathies aside, powerful forces in Congress and the nation prevented the United States from intervening in Spain. In January 1937, Congress extended the neutrality laws to include the Spanish conflict; the State Department stamped U.S. passports "NOT VALID FOR TRAVEL IN SPAIN." Such policies provided no assistance to the legal Spanish government, though Washington did permit some corporations, such as Texaco, to sell supplies to Franco on credit.

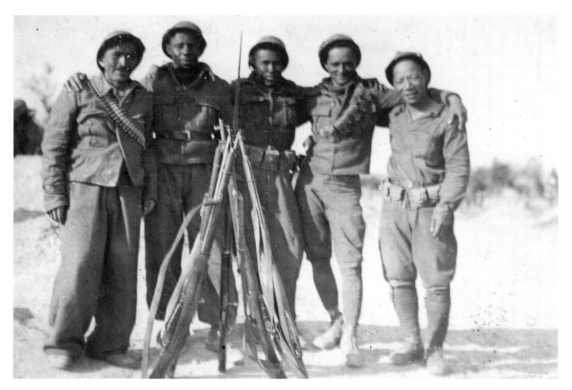

Americans Sterling
Rochester (second from
left) and Jack Shirai
(far right) in Spain with
volunteers from Chile,
the Phillipines, and
Cuba, ca. 1937.

Meanwhile, the Moscow-based Communist International called upon individual volunteers to assist the Republic. The first members of the International Brigades arrived in Spain in November 1936, just in time to thwart Franco's capture of Madrid and thus prolong the war. In the end, some 35,000 men and women from over 50 countries found their way to Spain and served either as fighting soldiers or as support personnel behind the lines. Among these would be nearly 3,000 civilian volunteers from the United States.

Congressional law could not prevent the clandestine recruitment of Americans eager to enter the fight. During the first week of November 1936, three Communist Party functionaries met in a small office in lower Manhattan to discuss the formation of a U.S. International Brigade. "Here was one nation standing up against the fascist dictators," recalled one of the three men, Ed Bender, in the accented voice of an immigrant from the Ukraine. "I felt honored to be asked. I felt that was something specific I could do in the fight against fascism in Spain." [5]

Word of the new brigade spread among the city's rank-and-file Communists, who composed the first group of 86 volunteers to sail for Spain aboard the *Normandie* on December 26, 1936. By the spring of 1937, recruiters had attracted about 2,000 men, enough to form two battalions in Spain, and more would follow. (The first group named its unit the Abraham Lincoln Battalion after the president who also defended a legally elected government during a civil war.) By then, the ranks had opened to non-communists—socialists, liberals, idealists—who would constitute about one-third of the 2,600 Americans who joined the fight. Others served as clerks, social workers, and drivers. Collectively they were known as the Abraham Lincoln Brigade.

Lincoln volunteers came from nearly every state, but overwhelmingly from the nation's big cities, particularly New York, the port from which nearly all departed for Spain. Some, such as Brooklyn College English instructor David McKelvy White, were the sons of the well-born; his father had been governor of Ohio. Most were children of the immigrant generation—Irish, Jews, Italians, Slavs, Greeks (over 70 European nationalities were represented in the ranks)—whose families had flocked to New York at the beginning of the century. For the many Jewish volunteers, Spain provided an opportunity to fight against the persecutors of their people in Europe.

The cause of Spain also appealed to a range of cultural progressives. Among the volunteers were Greenwich Village painters like Douglas Taylor and Deyo Jacobs; poets and writers like Edwin Rolfe and Alvah Bessie; students from City College, NYU, Columbia or, more likely, the school of hard knocks. There were labor organizers, taxi drivers, and cooks, like the Japanese American Jack Shirai, and scads of "unemployed." Nearly 90 were African Americans: as Harlem resident Vaughn Love explained, "I'd read Hitler's book, knew about the Nuremberg laws, and I knew if the Jews weren't going to be allowed to live, then certainly I knew the Negroes would not escape." [6]

The volunteers were not exactly young either: their median age was 28. They knew what the fight was about; they saw what fascism was doing in Germany and Italy, what it threatened to do in Austria, in Czechoslovakia, in Poland, what it had started in Spain. To be sure, most of the men and women who sailed from New York knew nothing about Spain, but that word—"Spain"—embodied the most passionate political cause of the decade, something for which men and women would risk their lives.

Nearly 800 of the U.S. volunteers died for the ideal of Spanish democracy. Ernest Hemingway wrote of them in 1938, "no men entered earth more honorably than those who died in Spain." [7] But the next year, Franco's troops finally entered Madrid, ending the war and establishing a cruel dictatorship that tormented antifascists for three-and-a-half decades.

The New York volunteers of the Abraham Lincoln Brigade are the most poignant example of the city's intense involvement in the Spanish Civil War. But as the essays in this volume show, these soldiers were by no means the only New Yorkers drawn to defend and assist Spain's elected government. While there was some support for the Francoist rebels in the city, during the Spanish war a powerful antifascist coalition emerged in New York, spanning both the Communist and Socialist parties, liberal "small-d" democrats, and the diverse ethnic communities, including the city's small but vocal Spanish immigrant groups. Moved by images of the war's violence—the bombing of civilians by Franco's air forces—New Yorkers carried collection cans into the subways or spread blankets on sidewalks and sang Spanish songs or organized soccer matches and basketball games to raise funds for Spain. In all the boroughs, labor unions, Spanish affinity groups, ethnic enclaves, and humanitarian aid organizations contributed money and material aid. The nascent field of photojournalism—the weekly magazine *Life* was born in 1936—brought gruesome images of the war right into the homes of New Yorkers, and in this pre-television era, the distant conflagration was lived with unprecedented immediacy in the city.

New York's artists, writers, and performers explored the war with intensity and often worked to support the beleaguered Republic. And as the casualties of the Spanish war mounted, Dr. Edward Barsky, a surgeon at Beth Israel Hospital, organized the American Medical Bureau to Aid Spanish Democracy and led the first delegation of U.S. medical personnel to assist soldiers and civilians alike. Among the recruits were nurses and medical technicians from the city's hospitals, many from Jewish and Italian immigrant families, as well as Salaria Kea, an African-American nurse at Harlem Hospital. Their efforts to save lives in Spain appeared frequently in news and feature articles in the New York press.

Today, the New York of the Spanish Civil War years seems both close and far away, simultaneously familiar and strange. The Empire State Building still stands tall on 34th and Fifth. The names of the city's streets and neighborhoods are more or less the same; many of the city's key institutions of the period—parks, newspapers, museums, hospitals, universities—are still functioning; New Yorkers with vivid first-hand memories of the war —including a few dozen Lincoln Brigade veterans—are still alive, now in their 70s, 80s, or 90s; their children, grandchildren, and great-grandchildren still live and work in New York, and they often know and cherish the family stories of their relatives from that other tumultuous time. And yet, despite this sense of intimate continuity, it also seems like the decisions and the deeds of so many of these ordinary New Yorkers, caught up in the most profound crisis of the 20th century, have almost been completely erased from public memory. Four decades of Cold War rhetoric, which tends to portray all of world history as an epic struggle between communism and liberal democracy, would seem to have no room for the complexities and nuances of the years leading up to World War II. The "greatest generation" seems to have sprung fully grown out of thin air on the morning after Pearl Harbor. This collection of essays, and the Museum of the City of New York exhibition that it accompanies, represent an attempt to recover through archival research a sense of the lived experience of those New Yorkers who, with a mixture of trepidation and courage, saw the gathering storm on the horizon—the rise of fascism. They chose to take action, in accordance with the dictates of conscience, and to the best of their abilities, chose to accept the challenge of being both New Yorkers and citizens of the world.

Endnotes

1 Daniel Kowalsky, *Stalin and the Spanish Civil War* (New York, 2004).

2 See Patrick J. McNamara, "Pro-Franco Sentiment and Activity in New York City."

3 James MacGregor Burns, *Roosevelt: The Lion and the Fox* (New York, 1956), 318-19.

4 Martha Gellhorn to Eleanor Roosevelt [1938], Box 1459, Franklin D. Roosevelt Library, Hyde Park, New York.

5 Peter N. Carroll, *The Odyssey of the Abraham Lincoln Brigade: Americans in the Spanish Civil War* (Stanford, 1994), 10.

6 Carroll, *Odyssey*, 18.

7 Ernest Hemingway, "On the American Dead in Spain," *New Masses* (February 1938).

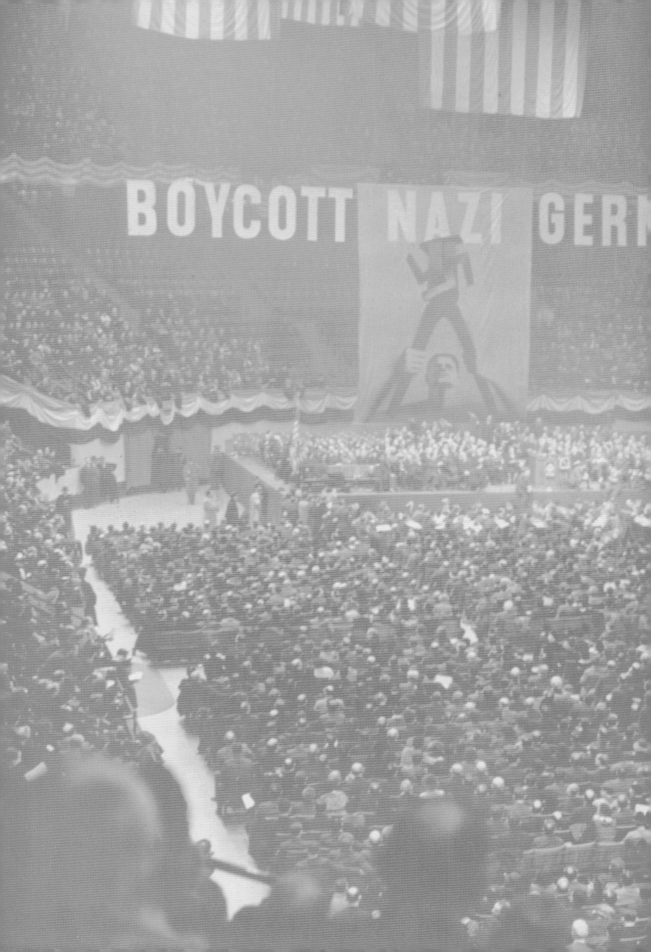

NEW YORK
AND THE
WORLD:
THE GLOBAL CONTEXT

BY MIKE WALLACE

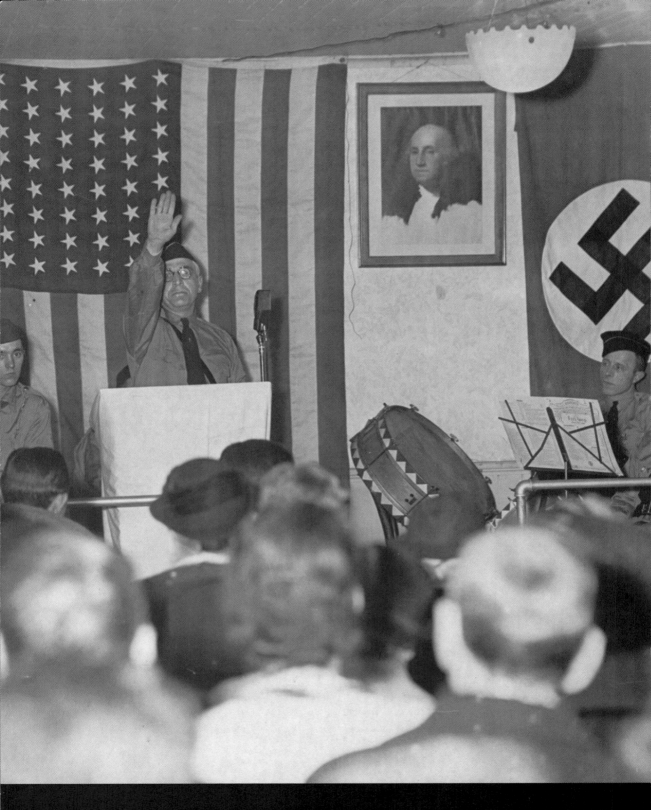

THE SPANISH CIVIL WAR WAS but one of a series of fronts on which New Yorkers grappled with the global rise of fascism during the early 1930s. Japan's invasion of Manchuria (1931), Hitler's ascension to power (1933), and Mussolini's invasion of Ethiopia (1935) triggered furious disagreements among Gotham's peoples over how to respond. So heated were these internal clashes over external affairs that the fascists themselves were heartened by the disarray. "Nothing will be easier than to produce a bloody revolution in the U.S.," said Joseph Goebbels, dismissing the United States as a threat to Nazi interests. "No other country has so many social and racial tensions. We shall be able to play on many strings there." [1]

The city was indeed divided along a multitude of fault lines—cultural and economic, racial and religious, and political and national. Nowhere were America's ethnic divisions more evident than in New York, where the 1930 census had revealed that of Gotham's nearly seven million souls, 74.3%—nearly three-quarters—were of "foreign stock." Among the pre-existing antipathies, newly exacerbated by foreign bellicosity and domestic depression, were those between—and among—Gotham's Jews and Germans, Italian Americans and African Americans, Chinese and Japanese, and Catholics and Protestants.

★

No sooner had Hitler taken power than some of New York's Jews audaciously set out to rein in the Nazi regime. At a March 18, 1933 meeting, a militant Jewish War Veterans unit in Brooklyn formally called for a national boycott of German goods, services, and shipping lines. On March 27th, the American Jewish Congress, led by Rabbi Stephen Wise, held a mammoth rally at Madison Square Garden, the first of many metropolitan parades and demonstrations denouncing the Third Reich, and his group later endorsed the boycott.

The Jewish community—at two million people, the largest single ethnic-religious element in town—was not without its own internal disagreements. The American Jewish Committee and B'nai B'rith hung back from the boycott and other aggressive initiatives. Its members were mainly second and third generation German Americans (while the Congress

chiefly represented more recently arrived Eastern European Jews) and many had relatives and associates in the Third Reich, some of whom—under Nazi duress—were frantically cabling New York urging rejection of militancy.

Nevertheless, the spirit of resistance spread rapidly among the city's Jewish grass roots. Ten thousand marched in Brownsville; Williamsburg protestors representing over 100,000 orthodox Jews vowed to take up commercial arms; and boycotters stepped up pressure against large New York City department stores, many of which were German Jewish-owned firms that, citing responsibility to shareholders, continued to sell German goods. Macy's president Percy S. Straus held out stubbornly. It was not until March 1934, after Socialist leader Norman Thomas had set up a picket line surrounding the giant outlet— "Macy's Buys German Goods," read the signs, "We Want No Fascism Here" —that Straus ceased dealing in German merchandise. Gimbels (as was its wont) swiftly followed suit. Three days later Woolworth's severed its German connection as well.

But Gotham's market clout, while substantial, was not sufficient to cripple Germany's export trade, and outside the metropolitan region the U.S. boycott movement never gained equivalent traction. Not until 1938, after the depredations of Kristallnacht, did the boycott movement take on larger life. In the interim, thousands of Jewish New Yorkers would find a new front on which to fight fascism—rallying in support of the democratically elected government of Spain against forces armed and backed by Hitler and Mussolini.

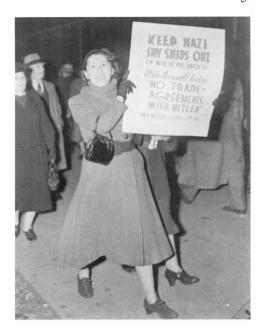

Woman protesting docking of German liner _Bremen_ in New York Harbor, November 14, 1938.

New Yorkers of German descent, predictably, had a very different response to the Third Reich. Having been the subjects of intense repression during World War I, most did not plan to invite a repetition by heiling Hitler's regime. Nor was the local German-American elite about to cede community leadership to the Nazi upstarts who established a noisome presence in Yorkville and elsewhere. (The German-American Bund even established recreational camps, such as Camp Siegfried, to which the Long Island Railroad ran special trains in the sweltering summer months, drawing tens of thousands to the Yaphank station to join in mass sing-alongs of the Horst Wessel Song, watch drill parades by storm trooper wannabees, and hear Bundesführer Fritz Kuhn lash the "Choos.")

Still, the promise that Hitler would reestablish the homeland's glory after the ignominy of World War I was intoxicating to many New Yorkers of German descent. Even the elites' hearts were warmed by many of Hitler's actions, and at the annual German Day celebration in 1935, Madison Square Garden was garlanded with swastikas, the Fuhrer was praised vociferously, and the proceedings were broadcast to Germany to demonstrate that the regime had substantial support in the city. Overall, however, most German-American New Yorkers stayed silent, not wishing to upset the assimilationist applecart, while some spoke out vigorously against Hitler.

★

In contrast, Mussolini's rise to power struck a real chord in New York's Italian-American community. Throughout the 1930s, the city's Little Italys were festooned with portraits of

Mussolini—his jaw-jutting visage beaming (or glowering) down from the walls of class-rooms and churches, bars and groceries, homes and clubs. At parades and communal celebrations, one heard cries of "Duce! Duce!" and saw forested arms upthrust in salute. This prideful nationalism lifted the spirits of Gotham's Depression-battered Italians, hungry for affirmation after decades of derision capped by an immigration law that all but barred *paesani*.

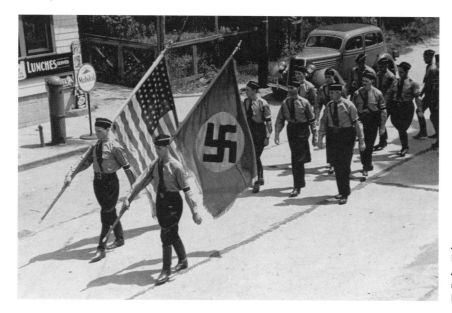

American Nazi Party (aka German-American Bund) marches on Long Island, 1937.

Ideologically, at least in the early 1930s, Mussolini demanded little of Italian Americans. The Bureau of Fascists Abroad peddled an export-only Fascism-Lite, which vaguely promoted abstract virtues like order, duty, and valor. The government's tourist office offered Italian Americans cheap group rates to see for themselves the splendors of the New Italy. Many New York *prominenti* were won over: businessmen like Wall Street financier Luigi Criscuolo, judges like Ferdinand Pecora of investigatory fame, and the heads of such fraternal organizations as the Sons of Italy and the Dante Alighieri Society (whose president told Mussolini the group was "proud of serving the Fascist revolution," and stood ready "to believe, to obey, to fight at your command") all supported the regime. Above all there was Generoso Pope, whose fleet of newspapers, flagshipped by *Il Progresso Italo-Americano* (the country's second largest ethnic daily, after the *Forward*), were completely at Rome's service.

But Pope hardly represented all of Gotham's Italians in the 1930s and opponents of Mussolini maintained a strong presence in New York's laboring and radical circles. On Columbus Day, 1934, as thousands paraded into Columbus Circle to listen to Governor Lehman under the aegis of *Il Progresso*, an equally large gathering assembled just across the street, at the base of the Maine monument, under the leadership of the United Anti-Fascist Committee—a constellation of unionists, socialists, Trotskyists, communists, and anarchists who lustily booed the official group. And Local 89 of the ILGWU—the Italian Dress and Waist Makers—helped convince the entire union to broaden its opposition to Hitler into an "anti-Nazi and anti-Fascist" campaign, which labor leader Luigi Antonini kicked off at a 1934 gathering where 20,000 unionists, most of them Italian, rocked Madison Square Garden with chants of "Down with Mussolini!" and "Down with fascism!"

The opposition to Mussolini was drastically undercut in New York, however, with Italy's invasion of Ethiopia, and Mussolini's announcement that he expected Italian Americans to back his grand design of forging an East African empire. "My order," he bellowed in 1934, "is that an Italian citizen must remain an Italian citizen, no matter in what land he lives, even to the seventh generation." This was a risky gambit; even Hitler hadn't sought this level of commitment to a foreign regime. But it worked. New York's Italians, swept up in the prospect of Mussolini's recapturing the splendors not only of Rome, but of the Roman Empire, rallied behind Generoso Pope to the imperial adventure.

Black Gothamites, in contrast, took up the defense of Ethiopia with an intensity of fraternal feeling unmatched elsewhere. Harlem nationalists saw Mussolini's threats as an

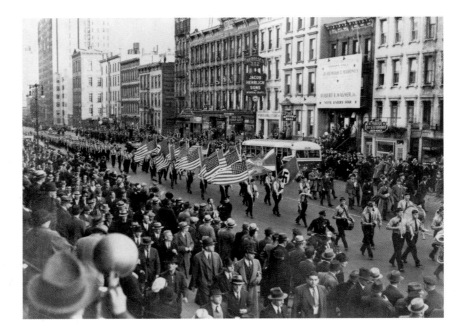

German-American Bund parading on East 86th Street, ca. 1938.

Dear Ma,

It's quite difficult for me to write this letter, but it must be done; Claire writes me that you know I'm in Spain.

Of course, you know that the reason I didn't tell you where I was, is that I didn't want to hurt you. I realize that I was foolish for not understanding that you would have to find out.

I came to Spain because I felt I had to. Look at the world situation. We didn't worry when Mussolini came to power in Italy. We felt bad when Hitler became Chancellor of Germany, but what could we do? We felt—though we tried to help and sympathize—that it was their problem and wouldn't affect us. Then the fascist governments sent out agents and began to gain power in other countries. Remember the anti-Semitic troubles in Austria only about a year ago. Look at what is happening in Poland; and see how the fascists are increasing their power in the Balkans—and Greece—and how the Italians are trying to play up to the Arab leaders.

Seeing all these things—how fascism is grasping power in many countries (including the U.S., where there are many Nazi organizations and Nazi agents and spies)—can't you see that fascism is our own problem—that it may come to us as it came to other countries? And don't you realize that we Jews will be the first to suffer if fascism comes?

But if we didn't see clearly the hand of Mussolini and Hitler in all these countries in Spain we can't help seeing it.

Together with their agent, Franco, they are trying to set up the same anti-progressive, anti-Semitic regime in Spain, as they have in Italy and Germany.

If we sit by and let them grow stronger by taking Spain, they will move on to France and will not stop there; and it won't be long before they get to America.

Realizing this, can I sit by and wait until the beasts get to my very door—until it is too late, and there is no one I can call on for help? And would I even deserve help from others when the trouble comes upon me, if I were to refuse help to those who need it today? If I permitted such a time to come—and as a Jew and a progressive, I would be among the first to fall under the axe of the fascists—all I could do then would be to curse myself and say, "Why didn't I wake up when the alarm-clock rang?" But then it would be too late—just as it was too late for the Jews in Germany to find out in 1933 that they were wrong in believing that Hitler would never rule Germany.

I know that you are worried about me; but how often is the operation which worries us, most necessary to save us? Many mothers here, in places not close to the battlefront, would not let their children go to fight, until the fascist bombing planes came along; and then it was too late. Many mothers here have been crippled or killed, their husbands and children maimed or killed; yet some of these mothers did not want to send their sons and husbands to the war, until the fascist bombs taught them in such a horrible manner—what common sense could not teach them.

Yes, Ma, this is a case where sons must go against their mothers' wishes for the sake of their mothers themselves.

So I took up arms against the persecutors of my people—the Jews—and my class—the Oppressed. I am fighting against those who establish an inquisition like that of their ideological ancestors several centuries ago, in Spain. Are these traits which you admire so much in a Prophet Jeremiah or a Judas Maccabbeus, bad when your son exhibits them? Of course, I am not a Jeremiah or a Judas; but I'm trying with my own meager capabilities, to do what they did with their great capabilities, in the struggle for Liberty, Wellbeing and Peace.

Now for a little news. I am a good soldier and have held several offices in the few months that I've been in Spain. I am now convalescing from a wound in my thigh received Oct. 13. I'm feeling swell now; I got such good treatment in the hospital that I've gained an awful lot of weight. Now, I'm at a seaside resort which was once inhabited by Franco and other swanks. In New York, when it got cold, we used to hear about people going to Florida, but who would ever have thought that I, too, would someday celebrate Thanksgiving (and Armistice day) by swimming and playing volley-ball, dressed only in tights?

I'd better stop writing or I'll have nothing to say next time. I've been writing to you regularly, thru the Paris address, which did not turn out very reliable. I only received one letter from you, which Claire typed the first week in September. Now all this will be changed; you can write me direct:

H. Katz
S.R.I. #17.1
Plaza del Altozano
Albacete, Spain

LETTER FROM VOLUNTEER HYMAN KATZ
TO HIS MOTHER, NOVEMBER 25, 1937.

affront to blacks everywhere; street-corner soapboxers harangued passersby on the need for global black unity against fascist militarism; and young Negroes took to calling themselves "Afro-Americans." Ethiopia had signal significance for many of Gotham's black church-goers as well, as one of the first countries in the world to adopt Christianity; secular Pan-Africanists argued that the safety and well being of African Americans was tied to the fate of Africa itself; and anti-imperialists insisted it was imperative to defend the one country that had maintained its independence as the continent got carved up. In February 1935, with unusual unity of purpose, twenty Harlem organizations, including communists, Garveyites, and church groups, formed a Provisional Committee for the Defense of Ethiopia. Its first public meeting, on March 7 at the Abyssinian Baptist Church, drew 3,000, and launched a campaign to raise funds for the beleaguered country, organize mass demonstrations against Mussolini's plans, and request intervention by the League of Nations and the Vatican.

Nationalist street-corner orators called for blacks to enlist in Ethiopia's army—calls which, by July, had reportedly netted nearly a thousand responses. But though Haile Selassie was glad to accept African-American volunteers, the U.S. government announced that such service would violate an 1818 law forbidding Americans from fighting under foreign flags. Despite this, a Garveyite Black Legion established a training camp in upstate

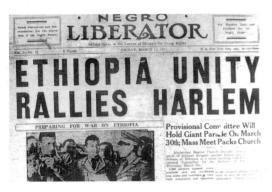

**Front page of the *Negro Liberator*,
March 15, 1935.**

New York, which allegedly drew some 3,000 volunteers, before Selassie, fearing to alienate U.S. authorities, effectively ended recruitment.

New York was ablaze with pro-Ethiopia activities in the fall of 1935. A host of interracial initiatives were launched, like the American Aid for Ethiopia, Committee for Ethiopia, and American Commitee on the Ethiopian Crisis. A Medical Committee for the Defense of Ethiopia assembled two tons of medical equipment for the Ethiopian army. In September, the American League Against War and Fascism sponsored a "Hands Off Ethiopia" rally at Madison Square Garden, with W.E.B. DuBois and the NAACP's Walter White among the featured speakers. And Langston Hughes penned "The Ballad of Ethiopia": "All you colored peoples / Be a man at last / Say to Mussolini / No! You shall not pass." The next spring, in reaction to fascist atrocities in occupied Addis Ababa, hundreds of blacks marched down Lenox Avenue smashing windows of Italian stores and battling police. When massive police reinforcements blanketed the neighborhood, the locals likened them to the army occupying Ethiopia.

But the city's Italians mobilized with equal speed, and greater effect. Pope told a post-invasion assemblage at Manhattan's Central Opera House that "we can be sure that Italy will triumph under the guidance of the Duce and will be greater and more feared in the future," and then set out to help make it happen. He organized a fundraising drive for the Italian Red Cross that in eight weeks raised half a million dollars from 350,000 local contributors and on December 14, he presented a check to the Italian Consul General at a 20,000 strong Madison Square Garden rally (preceded by a concert featuring Rosa Ponselle, soprano, and Ezio Pinza, bass). Four days later, at a mass meeting in the Brooklyn Labor Lyceum, Italian-American women, following in the footsteps of Italy's Queen Elena, offered up their gold wedding bands to be melted down for the cause. An estimated 100,000 rings (along with a shower of watches, crucifixes, and cigarette cases) were dispatched to Italy from New York,

New Jersey, and New England alone, nearly a ton of gold in all. And the Italian community had something far more useful to contribute—electoral muscle—which it deployed to help keep the U.S. "neutral," thus ensuring Mussolini's triumph.

★

Black New Yorkers had been among the first Americans to recognize fascism as a global threat, but when it came to Far Eastern fascism they were more ambivalent. African Americans, Langston Hughes noted, found a certain psychological solace in the existence of a free and independent non-white country—"a country of colored people," as DuBois put it, "run by colored people for colored people." Some of Gotham's black intelligentsia convinced themselves that the land of the Rising Sun could and would champion a coalition of the world's colored peoples—Chinese, Indians, blacks—against white imperialism and rushed to Japan's defense as it began its imperialist expansion. Other African-American New Yorkers, notably those on the left, insisted that Japan was no better than its allies Germany and Italy. Adam Clayton Powell, Jr., in his *Amsterdam News* columns, argued that blacks could not fight fascism in Ethiopia and Spain but not in China, while Paul Robeson said bluntly that Japan's record in China (and Korea) disqualified it from moral leadership of the non-white world.

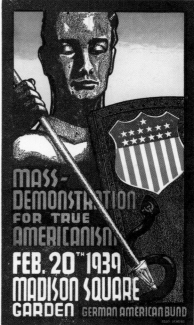

Poster for a 1939 Bund rally at Madison Square Garden.

New York's Chinese population of roughly 13,000 was likewise divided—along class, clan, and political lines—and not until the full-fledged Japanese invasion in 1937 did Chinese Gotham weld itself into a united front. In November, the first of many parades snaked through Chinatown, its 2,000 marchers representing almost every Chinese society, club, and tong in the city. Thirty women carried a huge Chinese flag into which bills and coins were hurled as the line inched forward through streets packed with cheering bystanders. The procession also featured a giant dragon that gobbled up financial offerings, and a huge banner on which dollar bills blazoned the slogan: "Fight against Japan to the Very Bitter End to Save China."

That these sentiments did not lead to battles with New York's Japanese community was primarily due to the latter's relative insignificance as a political force. Tiny and disorganized, it was composed overwhelmingly of single males who worked as house boys, laundrymen, and waiters, and lived in scattered communities: there was no core Japanese place in New York, no equivalent of Chinatown. Apart and aloof from this working-class world was an elite sliver of Japanese businessmen, rotating representatives of commercial houses or government agencies, who shunned their poorer compatriots, with whom they had no organic or economic ties.

In addition, the Japanese were well aware that many in the city sympathized with the Chinese as being, like the Ethiopians, victims of aggression. On October 1, 1937, some 10,000 people, including 2,000 Chinese, attended a Madison Square Garden rally with speeches from, among others, Rabbi Stephen Wise. The participants endorsed a boycott on all Nipponese manufactured goods. By 1938, when a *Fortune* poll found well over half the country backing the so-called "people's boycott," Woolworth's and other national chains had halted further orders of Japanese products, including silk. Famous actresses—

like Frances Farmer, starring at the Belasco Theater in Clifford Odets' *Golden Boy*, and the entire cast of Clare Booth Luce's *The Women*—let be it known they were performing in lisle cotton stockings.

★

Many of these conflicting currents came clashing together as New Yorkers responded to the crisis in Spain. Opponents of Hitler saw the war as a place to take a meaningful stand—more than half of the thousand New Yorkers who shipped out to join the Abraham Lincoln Brigade after the Communist International asked for volunteers in the autumn of 1936 were Jewish. New York communists also cultivated multinational opposition to fascism by creating cross-cultural solidarity campaigns in support of the Spanish Republic, as they had for China and Ethiopia. And African Americans and others saw the war as a direct continuation of the Abyssinian struggle on a different front. As a black character in a contemporary short story penned by an African-American brigadista said: "I wanted to go to Ethiopia and fight Mussolini. This ain't Ethiopia, but it'll do."

But for other New Yorkers, the principal issue in the Spanish Civil War was not the fight against fascism, but that against communism. Gotham's conservative Irish clergy in particular had worried about Red Republican anticlericalism as far back as the upheavals of 1848. And since 1917, when the Russian Revolutionaries had begun persecuting believers, Soviet Communism had been New York Catholicism's *bête noir*. The rise of fascist dictatorships troubled the Catholic hierarchy far less than the threats of anti-clericalism in the Soviet Union or in Mexico in the 1920s, due in large part to the fact that Mussolini—and later Hitler—signed formal treaties (concordats) with the Vatican that, supposedly, preserved the Church's institutional prerogatives. Pius XI came to terms with Il Duce in the 1929 Lateran Accord, and Mussolini's many concessions to Catholic interests played well in New York. Cardinal Hayes applauded the dictator as a man "unusually favorably disposed to the progress of the Catholic Church," and Fulton Sheen praised the accord for guaranteeing the Church's freedom to preach the gospel. The 1933 treaty with Germany similarly "guaranteed" freedom of religious association and the right to proselytize, in return for German Catholics dismantling their Center Party, a potential source of political resistance to Nazism.

Virtually from the Spanish war's opening days in 1936, therefore, most Catholic officials and publications in New York City, already hyper-sensitized by events in Mexico, responded to the violent anticlericalism, and growing Russian involvement, by unequivocally and all but unanimously supporting the Nationalist insurrection (though the Catholic laity was far more divided, and a significant minority backed the Loyalists).

The Church's stance in turn put it at odds (as so often in the past) with Gotham's Protestant community, especially its preeminent clerics, who were overwhelmingly on the anti-Franco side. In October 1937, responding to the pastoral letter issued by the Spanish hierarchy supporting Franco, renowned New York Protestant clergy and laity penned a denunciatory reply, including Harry Emerson Fosdick, pastor of Riverside Church, and Reinhold Niebuhr of Union Theological Seminary, who spoke that year about "the intimate alliance between Catholicism and fascism." Protestants were in the forefront of protests against the bombing of Guernica (a "monstrous crime") and led calls for President Roosevelt to lift the embargo on arms to Spain, which throttled Republican resistance while ignoring Franco's receipt of military aid from the fascists.

In response, Catholic leaders mobilized a massive lobbying campaign to influence Congress and the President, and it was their initiative that most forcefully registered with FDR. By May 1938, Harold Ickes reported, the President had become convinced that sending arms to the Republic would "mean the loss of every Catholic vote next fall." The embargo stayed in place. The Republic fell in 1939. And in the aftermath, New Yorkers turned out en masse to welcome the arrival of Picasso's *Guernica*, to salute the fallen and raise funds for the survivors.

The animosities that rent the city during the Spanish Civil War continued unabated during the next two years. Gotham's citizens turned to an even more acrimonious debate—similar to the one that had roiled the metropolis during the run-up to WWI—over whether, and to what degree, the United States should get involved in the European war that followed hard on the heels of the bloodbath in Spain. It would take Pearl Harbor to quiet the cacaphony and restore at least a surface harmony to New York City.

Endnotes

1 Arthur M. Schlesinger, Jr. *A Life in the Twentieth Century: Innocent Beginnings, 1917-1950.* (New York, 2000), 279.

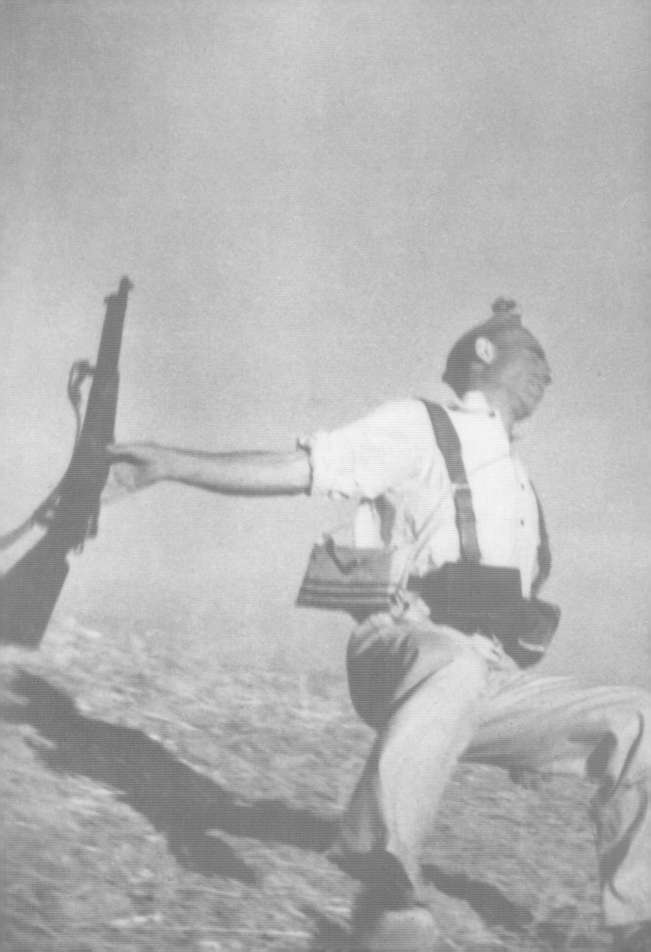

THE NEW YORK
PRESS
AND THE
SPANISH
CIVIL WAR

BY ROBERT W. SNYDER

FEBRUARY 14, 1939

15 CENTS

New Masses

LINCOLN BRIGADE NUMBER

ERNEST HEMINGWAY
On the American Dead in Spain

The Lincoln Brigade in Pictures
With Comment by Joseph North

FRANZ BOAS
Democracy and Intellectual Freedom

PREVIOUS SPREAD
**Muerte de un Miliciano
(Death of a Loyalist
Soldier), 1936.**

ABOVE
**"Lincoln Brigade
Number" of
New Masses,
February 14, 1939.**

HE JOURNALIST MALCOLM
Cowley, returning from a trip to Spain in 1937 that inspired a five-part series for
the *New Republic*, wrote that he was "more deeply stirred by the Spanish civil war
than any other event since the World War and the Russian revolution." To Cowley,
an editor at the magazine, it was a war of discipline and hierarchy against knowl-
edge and freedom. And high up in his thoughts about the war was how he had fol-
lowed the fighting through the New York City press.[1]

"I can testify for myself—and for many others too—that we devoured the news-
papers, buying half a dozen daily, from the morning *Times* at breakfast, through the
successive afternoon editions of the *Post* and the *World-Telegram*, to the bulldog edi-
tion of the *Herald Tribune* at eleven in the evening," he wrote. "We learned the hours
of the news reports over the radio and the political coloring of each commentator,
so as to reckon the truth about Spain by applying a coefficient of prejudice to his
statements."[2]

That "coefficient of prejudice" would have been applied to newspapers and mag-
azines that were neutral about or even hostile to the Spanish Republic. Memories
of New York in the 1930s may summon up images of the Popular Front and the
New Deal, of a city with a heart well to the left, but the newspapers and maga-
zines produced there were anything but unanimous about the struggle in Spain.
News and editorial columns displayed hostility to the Republic, support for U.S.
isolationism, disagreements over the best way to defeat Franco, lapses in coverage
of the war, and bitter disputes over the facts of the fighting. Reports from Spain
competed with other stories, both serious and foolish, for space on front pages: sit-
down strikes, Kristallnacht, purge trials in the Soviet Union, and the abdication of
King Edward VIII in Britain. All vied with the heroic image of the Spanish Republic

Manifesto of the Spanish Communist Party printed in the *Daily Worker*, December 10, 1939.

made famous by Robert Capa's gripping photographs of Loyalist soldiers in *Life* and Martha Gellhorn's detailed accounts of Spanish civilians under fascist bombardment in *Collier's*.

New York was, by the 1930s, the well-established media capital of America. Newspapers, magazines, and more recently radio were all dynamic parts of the city's culture, politics, and economics. New York radio shows and magazines were central to an increasingly national and even international news system, but they were not part of a uniform mass culture. The differences among publishers mattered. Indeed, they help to explain the dissonance between the city's political reputation and its press. William Randolph Hearst's *Journal-American* flayed the Spanish Republic as a nest of "Reds." Richard North Patterson's *Daily News* viewed Spain through the fearful prism of isolationism. *Time*, the national newsweekly owned by Henry R. Luce, covered the opening phase of the war in ways highly friendly to Franco. At the same time, differences among newspapers and magazines reflected real differences among communities of readers. For all of New York's liberalism, there was a strong strain of conservatism in the city that boiled over into news reports, letters to the editor, and efforts to influence coverage in ways favorable to Franco. Finally, New York journalists and political elites were divided among themselves on the question of Spain in ways that muted or muddled coverage of the conflict. [3]

By the 1930s, the code of objectivity—which stipulated that journalists should report facts stripped of personal viewpoints—was an established ideal in American journalism. The strength of this notion in newsprint was another matter. Radical newspapers, such as the *Daily Worker* and *Socialist Appeal*, along with mass circulation papers such as the conservative *Journal-American* and liberal *New York Post*, maintained an older vision that saw the newspaper as the voice of a political movement or party. Such publications cultivated readerships that were gatherings of the likeminded. Luce magazines—*Time*, *Life*, and *Fortune*—reserved the right to analyze

the news for readers. Even at *The New York Times*, with its promise to publish "all the news that's fit to print," correspondent Herbert L. Matthews pursued an interpretive journalism that supported the Spanish Republic and emphasized its strengths. His rival on the paper, William P. Carney, a religious Catholic disturbed by reports of murders of priests and nuns, covered the war in a manner deeply critical of the Republic. [4]

When this divided readership and divided press met the bitterly contested battles of the Spanish Civil War, there was little shared knowledge or experience that could sustain an agreed-upon set of facts. Indeed, the very facts of the war itself became subjects of dispute. The names accorded the different sides spoke volumes about publications. In Hearst's *Journal-American*, the war pitted Franco's "rebels" against the Republic's "Reds." In *The New York Times*, the struggle was between "insurgents" or "rebels," and "government forces" or "Loyalists"—the last a reminder that the Republic's forces were the loyal army of an elected government. In the *Post*, the fight was between "Loyalists" and "fascists." [5]

The inevitable confusion of war, censorship in the field (applied more vigorously on the fascist than the Loyalist side), and attempts to sway the judgment of journalists produced wildly contradictory accounts of events—sometimes within the same newspaper. The bombing of Guernica by German and Italian aircraft, for example, was covered in *The New York Times* initially as an atrocity aimed at terrifying civilians. A week later, the paper ran on the same page two contradictory articles. Carney's "Rebels Lay Fires to Guernica 'Reds'" treated as credible claims that anarchists, not fascist aviators, destroyed the city. On the same page, "Basques Indignant on Guernica Raid" by G.L. Steer, placed the Guernica episode in the context of other air attacks and cited priests in Guernica who blamed the assault not on anarchists, but on "'pajaros negroes,' [sic] or black birds, the current Spanish phrase for the great Junkers bombers the Spaniards know so well." [6]

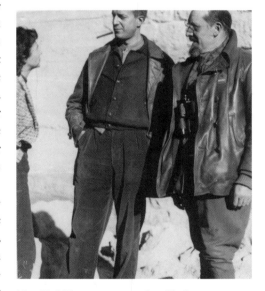

New York Times **correspondent Herbert Matthews (center) with Italian volunteer Umberto Galleani in Spain, ca. 1938.**

The priests of Guernica aside, in New York the hierarchy of the Roman Catholic Church pursued an aggressive campaign against reporters, like Matthews of the *Times*, who were deemed supportive of the Republic. Articles in the *Brooklyn Tablet* and *Our Sunday Visitor*, reports distributed by the press department of the National Catholic Welfare Conference, and advocacy efforts by Father Joseph F. Thorning, a Jesuit professor, praised the insurgents and attacked reporting that presented the Republic in a favorable light. Such efforts produced considerable debate inside the *Times* and a perception of Catholic power that ignored differences of opinion among Catholics. A 1939 Gallup poll of American Catholics showed that 39 percent favored Franco, 30 percent were pro-Loyalist, and 31 percent neutral. [7]

In this polarized atmosphere, readers gravitated to papers that confirmed their own view of Spain. Conservatives could turn to the *Journal-American* and liberals to the *Post*. Yet differences also appeared within the leftist press. The pages of the Communist *Daily Worker* extolled a Popular Front strategy that promoted the cen-

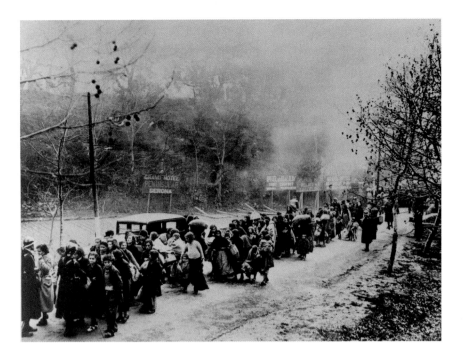

Weary refugees pour into France after the fall of Barcelona, 1939.

tral authority of the Republican government, strengthened Communist influence in that government, and emphasized winning the war over pursuing a social revolution within the Republic. It also vilified Trotskyists, whose *Socialist Appeal* opposed the compromises of the Popular Front and argued that the only way to win the civil war was to turn it into a revolutionary struggle. By 1937, false but damning phrases such as "Trotsky-fascist alliance" were common in the *Daily Worker*.

Conflicts also erupted within news organizations. Among the Luce publications, Laird Shields Goldsborough, foreign editor of *Time*, produced coverage that favored Franco. He was challenged, with no great success, by Republican sympathizers Archibald MacLeish of *Fortune* and Ralph Ingersoll, the general manager of *Time* who would later go on to found the left-liberal daily newspaper *PM*. *Life* ran articles sympathetic to Franco and articles sympathetic to the Republic—sometimes in the same issue. But its best work—the photography of Robert Capa, for example—favored the Republic. Capa's photograph of a Loyalist soldier at the moment of his death (which was for a time unfairly called a fraud) ran with an article that excoriated Spain's traditional ruling class and summed up the war in these words: "The reason for the civil war was simply that the people of Spain had fired their bosses for flagrant incompetence and the bosses had refused to be fired."[8]

At *The New York Times*, the rivalry between the pro-Franco Carney and the pro-Republican Matthews echoed through the paper. Matthews was particularly angry at the role of the *Times* bullpen, night editors who exercised great influence over what went into the paper and the content of individual stories. The *Times* of that day was jokingly described, according to Gay Talese, as a paper "owned by Jews and edited by Catholics for Protestants." Catholic editors dominated the bullpen. Over time, they deleted information that would have put the Republic in a favorable light and rewrote passages damning to Franco's cause. Once, in his coverage of the battle of Guadalajara, at a time when the scale of Italian intervention on Franco's side was

disputed, Matthews confirmed the presence in the battle of entire Italian divisions commanded by Italian generals. His report, as submitted, said: "The dead bodies, the prisoners, the material of every kind, the men who had occupied Brihuega and fled were Italian and nothing but Italian." The bullpen editors changed the passage to "Insurgent and nothing but Insurgent," then deleted the entire passage in subsequent editions. Matthews was furious. Despite the fact that Matthews enjoyed the friendship and support of *Times* publisher Arthur Sulzberger, this incident, and similar confrontations later, made Matthews an embattled correspondent for the length of the war. [9]

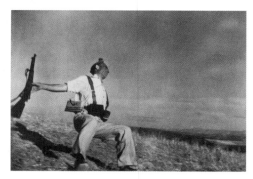

Yet he did not protest every change in his copy. Matthews was part of a circle of correspondents, including Gellhorn and Ernest Hemingway, which was strongly committed to the Spanish Republic and close to the International Brigades. Out of that grew an indifference to internal disputes within the Republic that might compromise its reputation. In May 1937 in Barcelona, anarchists and anti-Stalin leftists of the Partido Obrero de Unificación Marxista (POUM) fought and lost deadly street battles with government forces attempting to centralize control over the army and other state functions. Matthews' dispatch to the *Times* on the situation, written without benefit of witnessing the events, called the central government's victory "a bloodless triumph" and described the defeated forces as "anarchist opposition." Twice a censor in Madrid changed the phrase to "disguised Fascists" and "extremists." Matthews did not complain, and the phrases appeared under his byline in the *Times*. In the same vein, Matthews showed no inclination to pursue stories about disputes within the International Brigades or the death of Andrés Nin, leader of the POUM, at the hands of Communist agents. Matthews had shown himself to be a reporter of great physical courage in reporting from the front and great tenacity in making his case in the face of opposition at the *Times*. Yet whatever doubts or questions he had about infighting among Republican forces were saved for memoirs written years after the war. [10]

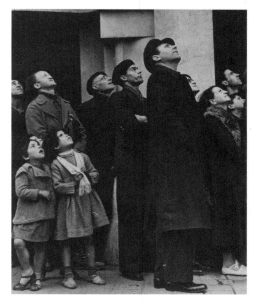

Muerte de un Miliciano
(Death of a Loyalist Soldier), 1936.
Photograph by Robert Capa.

Civilians watching an air battle over the city, which was being bombed heavily by fascist planes, as General Franco's fascist troops rapidly approached, Barcelona, January 1939. Photograph by Robert Capa.

The unresolved contradictions between Matthews and Carney's reporting, along with Matthews' own evasions of hard realities, produced a mixed picture of events in Spain. Far more important for confusion in New York over the war, though, were silences and evasiveness in the White House and City Hall. As students of the media have observed, news coverage closely follows the initiatives and debates of government. Where there is silence or confusion, news reporting is absent or uncertain. At the summit of the federal government, President Franklin D. Roosevelt offered no challenge to congressional neutrality laws that embargoed loans and arms shipment to Spain and sought to isolate the United States from the

war. There would be no dramatic U.S. initiatives in support of Spain covered on the front pages of *The New York Times*. [11]

Something similar happened in New York City. Mayor Fiorello La Guardia was a vigorous public foe of Adolf Hitler. His denunciations of Nazi Germany appeared often in *The New York Times*. Yet on the subject of the Spanish Civil War and of Benito Mussolini, who sent so many troops to Spain, he was comparatively quiet. Indeed, in 1937, the Socialist Party publicly asked the mayor to condemn Italian fascism with same force that he used to condemn German fascism. Such condemnations did not appear in the *Times* until after the Spanish Civil War was over. Mayor La Guardia, whose genius for invective made him a great newsmaker, had no great impact in the pages of the *Times* on behalf of the Spanish Republic. [12]

When the end came for the Republic, the New York press reacted with the same divisions that had appeared during the civil war. Hearst's *Journal-American* said that the "terrible but NECESSARY" war had saved Spain from communism. The *Daily Worker* anticipated a "fascist terror" in Madrid, while the *Socialist Appeal* concluded that it had been correct to argue that only a revolutionary war could defeat Franco. The *Daily News* and *Herald-Tribune* encouraged Franco to be merciful. The *New Republic* called the defeat "heartbreaking," but insisted that the fight against fascism go on. *Life*, in its photographs of refugees, did as much as any publication to document the painful death of the Spanish Republic. It also looked most squarely at the future when it concluded that the war in Spain that had just ended was but "a dress rehearsal for the next world war." [13]

Endnotes

1 See Malcolm Cowley, "To Madrid V: The International Brigade," *New Republic*, October 7, 1937, 233.

2 Ibid.

3 On American journalism in the '20s and '30s, see James L. Baughman, *Henry R. Luce and the Rise of the American News Media* (Boston: Twayne Publishers, 1987), 53–60. For a brief summary of the New York press in 1940 that helps to illuminate the immediately preceding years, see Paul Milkman, *PM: A New Deal in Journalism, 1940–1948* (New Brunswick: Rutgers University Press, 1997), 9.

4 On the rise of objectivity as an ideal in American journalism and its acknowledged presence by the '20s, see Michael Schudson, *The Sociology of News* (New York: W.W. Norton, 2003), 82.

5 See F. Jay Taylor, *The United States and the Spanish Civil War* (New York: Bookman and Associates, 1956), 117–118.

6 On the discrepancies in censorship, which varied over the course of the war but amounted to greater openness on the Republican side after the initial fighting at Madrid in 1936, see Dudley Quentin Althaus, "A Correspondent's Commitment: Herbert L. Matthews' Coverage of the Spanish Civil War," Master of Arts thesis, University of Texas at Austin, May 1984, 80–84. For overviews on the bombing of Guernica, see Gabriel Jackson, *The Spanish Republic and the Spanish Civil War, 1936–1939* (Princeton: Princeton University Press, 1965, 1972), 381–382; Helen Graham, *The Spanish Civil War: A Very Short Introduction* (Oxford: Oxford University Press, 2005), 71; and Phillip Knightley, *The First Casualty: From the Crimea to Vietnam: The War Correspondent as Hero, Propagandist, and Myth Maker* (New York: Harcourt Brace Jovanovich, 1975), 203–208. For the initial coverage of Guernica in the *New York Times*, see G.L. Steer, "Historic Basque Town Wiped Out; Rebel Fliers Machine-Gun Civilians," *New York Times*, 28 April 1937,

1. For the contrasting stories, see William P. Carney, "Rebels Lay Fires to Guernica 'Reds'" and G.L. Steer, "Basques Indignant on Guernica Raid," both *New York Times*, 30 April 1937, 8.

7 For efforts to influence the journalism of the conflict, see Taylor, *The United States and the Spanish Civil War*, 119–123. On Catholic opinion and advocacy, see J. David Valaik, "Catholics, Neutrality and the Spanish Embargo," *Journal of American History* v. 54, no. 1, June 1967, 73–75. For Catholic publications that published press criticism, see p. 84; for the Gallup poll, see p. 85.

8 On conflicts within the Luce empire, see Robert E. Herzstein, *Henry R. Luce: A Political Portrait of the Man Who Created the American Century* (New York: Charles Scribner's Sons, 1994), 98–99. For the quote, see *Life*, 12 July 1937, 19. For a persuasive account of the authenticity of the Capa photograph, see Richard Whelan, "Robert Capa in Spain," in *Heart of Spain: Robert Capa's Photographs of the Spanish Civil War* (New York: Aperture Foundation, 1999), 29–32.

9 See Althaus, "A Correspondent's
 Commitment," 76–85, 94–97, and, on the
 cuts and deletions, 98; also Knightley, *The
 First Casualty*, 200. For the Talese quote, see
 Gay Talese, *The Kingdom and the Power* (New
 York: World Publishing, 1966, 1969), 58.

10 On the May Days in Barcelona, see Jackson,
 The Spanish Republic and the Civil War,
 369–371; also Graham, *The Spanish Civil
 War*, 63–67, 101–102. On the events behind
 Matthews' article about the reorganization
 of the Republican government and the
 May Days, see Althaus, "A Correspondent's
 Commitment," 112–114; for the article
 itself, see Herbert L. Matthews, "Negrin
 Cabinet Unites Loyalists in Spain," *New York
 Times*, 23 May 1937, 63. On the silences and
 evasions of the Nin affair, see Jackson, *The
 Spanish Republic and the Civil War*, 403–404;
 on the silences of Matthews and other
 journalists who supported the Republic in
 the face of internal conflicts and violence on
 the Republican side, see Knightley, *The First
 Casualty*, 212–214; Caroline Moorehead,
 Gellhorn: A Twentieth-Century Life (New York:
 Henry Holt and Co., 2003), 125–126; and
 Althaus, "A Correspondent's Commitment,"
 129–131. For an example of Matthews'
 physical courage covering the war, see an
 account of his driving a car across a bridge
 under machine gun and artillery fire to
 disprove claims that it was firmly under
 Fascist control, Althaus, "A Correspondent's
 Commitment," 91–92. Althaus' thesis
 contains detailed accounts of Matthews'
 battles with *Times* editors on 98–106,
 123–128, 134–135, 143–147, and 153–156.
 Althaus also cites the unpublished 1971
 Princeton University thesis "The Politics of
 Journalism" by Robert L. Barber.

11 For general discussions of the importance of
 government action or debate in generating
 news coverage, see Schudson, *The Sociology
 of News*, 151–152; Robert M. Entman,
 *Projections of Power: Framing News, Public
 Opinion, and U.S. Foreign Policy* (Chicago:
 University of Chicago Press, 2004), 4.
 For the concept of indexing applied to the
 press and the Vietnam War, see Daniel C.
 Hallin, *The "Uncensored War": The Media
 and Vietnam* (New York: Oxford University
 Press, 1986). On the Roosevelt policies
 toward Spain, see David M. Kennedy,
 *Freedom From Fear: The American People in
 Depression and War, 1929–1945* (New York:
 Oxford University Press, 1999), 398–401.

12 My analysis is based on an electronic
 search of for articles on LaGuardia and
 Hitler, Nazis, Spain, Franco and Mussolini
 from May 1936 to May 1939. The search
 identified documents in the newspaper
 (everything from articles to index entries)
 where the name La Guardia appeared with
 the other names. While the identification
 of documents produces a count which is
 greater than the number of actual stories,
 the discrepancies are still illuminating:
 La Guardia and Franco, eight documents
 and no comments from La Guardia on
 the Spanish Civil War; for La Guardia and
 Spain, 17 documents and no comments
 from the mayor on the civil war; for La
 Guardia and Hitler, 298 documents; for
 La Guardia and Nazis, 350 documents;
 and for La Guardia and Mussolini, 20
 documents. For Socialist Party statements
 on La Guardia and Mussolini, see "Mayor
 Queried on Duce," *New York Times*, 11 March
 1937, 4 and "Socialists Denounce Mayor and
 Mahoney," *New York Times*, 13 October 1937,
 2. Of course, both Roosevelt and La Guardia
 eventually emerged as great opponents
 of fascism—but not in time to help the
 Spanish Republic.

13 For the statements in reaction to the end
 of the war, see "A Free Spain," *New York
 Journal-American*, 1 April 1939; see the
 headline "Fascist Terror…" in the *Daily
 Worker*, 29 March 1939, 1; for the assessment
 of the lessons of the war, see *Socialist Appeal*,
 4 April 1939; for reactions in the *News* and
 Herald-Tribune, see "End of the Spanish
 War," *Daily News*, 30 March 1929 and
 "The Fall of Madrid," *New York Herald-
 Tribune*, 29 March 1939, 22; for the
 "heartbreaking" quotes, see "Was Spain
 Worth Fighting For?", *New Republic*, 12
 April 1939, 265. *Life* ran a long photo essay
 on Loyalist refugees, both soldiers and
 civilians, in its issue of 2 February 1939.
 The quote is from *Life*, 10 April 1939, 20.

NEW YORK'S
AID TO THE
SPANISH
REPUBLIC

BY ERIC R. SMITH

ABOVE
Ambassador Fernando
de los Rios and
ILGWU leader Charles
Zimmerman with
demonstrators, ca. 1937.

AFTER THE SPAN-
ish Civil War erupted in July 1936, aid to help the embattled Spanish Republic became the most popular manifestation of antifascism in the pre-World War II period, and New York City was always the center of this activity in the United States. The public appeal of Spain reflected the obvious struggle between democracy and fascism. For over 2,000 Americans this struggle was significant enough that they volunteered to enlist in the Republic's International Brigades. Over a hundred others served as doctors, nurses, and ambulance drivers.

Yet most Americans did not join the Spanish army. In large part this hesitancy revealed fears of involvement in another European war like World War I. However, after it was obvious that Germany and Italy were supporting General Franco's rebellion against the Republic, a wide variety of U.S. citizens realized that more needed to be done. Many New Yorkers offered their skills, time, names, or money to the cause of Spain by participating in the movement to raise non-military relief aid for Spain's legitimate government.

"For the duration of the Spanish agony, New York was a city of stirring mass meetings, rallies, and fund raisings," recalled writer Albert Halper in his book *Good-bye, Union Square*. "In an attempt to conquer loneliness during this period, one went to the almost nightly mass meetings and rallies, one listened to fiery and accusatory speeches directed against Washington, one gave money when the chairman called for collections, and one returned to one's room or apartment drained, sickened, unable to sleep." Fred Hellerman, a member of the music group The Weavers, grew up in Brooklyn and remembered how one could not avoid seeing collection cans for Spanish aid around the city, especially in communities with heavy concentrations of communists. [1]

Republican Spain communicated its needs through its Washington embassy. Spanish Ambassador Fernando de los Rios visited New York frequently to meet with aid campaign leaders and speak at events. The Republic's initial requests were

for insulin, ampules of tetanus and diphtheria anti-toxins, as well as transfusion apparatuses. Medical needs were followed by civilian needs: milk (condensed and powdered), wheat and flour, beans, sugar, shoes, coats, raincoats, bandages, x-ray equipment, and various non-perishable items. Requests for medical personnel—doctors, nurses, and drivers—were also made. At the top of the Republic's needs were ambulances. It was in Spain that the first mobile hospitals—auto-chirs—were used on a military front. [2]

New Yorkers' importance to this relief effort is difficult to exaggerate. All of the primary aid organizations aiding the Republic resided there. Such figures as the ACLU's Roger Baldwin, the Rev. Herman Reissig, and Dr. Edward Barsky were among New York's activist core of Spanish aid organizers (and the latter also a volunteer to Spain; see chapter 4). Their work, along with that of the thousands of New Yorkers who filled Madison Square Garden, attended political rallies and fundraisers, protested the Italian and German consulates, and generally contributed to the construction of a culture of resistance to fascism, led the initiative for Spanish aid and promoted presciently a resistance that would become mainstream only after December 7, 1941, when Japan bombed Pearl Harbor, forcing the United States into World War II.

The New York-based organizations leading the campaigns were formed following the founding of Labor's Red Cross, a fund for Spanish relief initiated by Charles Zimmerman, president of the International Ladies Garment Workers' Union. This was followed by the liberal American Friends for Spanish Democracy (AFSD) and then the Medical Bureau and North American Committee, both of which began as AFSD committees. The Confederated Spanish Societies to Aid Spain brought together Spanish immigrants and some members of the Socialist Party. There were numerous smaller organizations throughout the city. All relief aid from across the United States and some from Canada passed through New York, and New York organizers were sent out to the remotest areas of the country to establish more branches of these organizations. [3]

From the earliest days of the Spanish conflict, New York labor unions, anarchists, socialists, communists, liberals, intellectuals, African Americans, and various immigrant groups joined the campaigns to aid the Spanish Republic. Aid activities included modern fundraising events like benefit basketball games. At the Hippodrome on Friday February 19, 1937, for instance, the ILGWU Local 22 women took on the ILGWU Local 19 women in a basketball match. That game was followed by the International Workers Order challenging the Furriers Union. Then the All Star Ex-Collegians met the All-Star Non-Collegians, a working class versus educated class match-up, all in the name of the Spanish Republic. Tickets for that night's three games went for as high as $1 and for as cheap as 35 cents. [4]

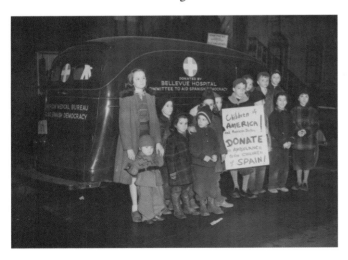

American children pose with an ambulance from Bellevue Hospital and a placard urging donations for Spain, ca. 1938.

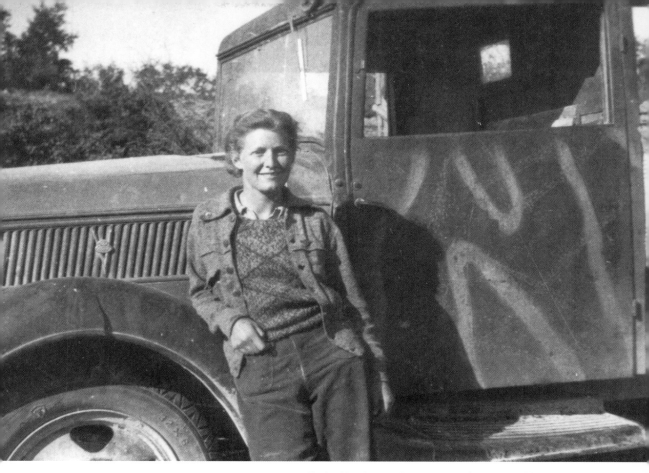

Evelyn Hutchins with her truck in Spain, ca. 1937.

I had driven a number of ambulances here around the city, taking them back and forth to the boat, and they were satisfied that I really could handle the cars. It was found that I could drive the car as well as, and better than, some of the fellows who were going.... Some fellows thought it was very funny that I should be there driving. I am little but I never made any attempt to swagger or act mannish. I acted just the way I always acted. I used to argue with them about it. They would say, "You are so little, what can you do?" And I would tell them, "I am just me." I was a girl, I was small and didn't weigh much but I was doing a job and wasn't that enough. They would like to take pictures of me next to my truck; because I was small they thought it was very funny. Some of them would say, "All I have to do is give one hard blow and you'll keel over." But the important thing was that the fellows who understood why I wanted to be there, why I had taken the job of driving which was the only

possibility of getting as close as I could to the actual fighting, they didn't think a girl should want to fight and have a machine gun instead of driving a car—these fellows were the fellows who took the thing seriously, and I found them to have a more serious and level headed attitude about things that happened.

EXCERPTS FROM INTERVIEW WITH EVELYN HUTCHINS, JULY 9, 1942 (TRANSCRIPT), DOLLARD PAPERS, ALBA COLLECTION, TAMIMENT LIBRARY, NEW YORK UNIVERSITY.

Evelyn Hutchins was one of only two women to serve in the 15th International Brigade. She returned to the United States in early 1939, and in March of that year joined nurse Ruth Davidow on a speaking tour of the southern states, aiming to further arouse American consciousness about Spain and the embargo against the nearly defeated Republic.

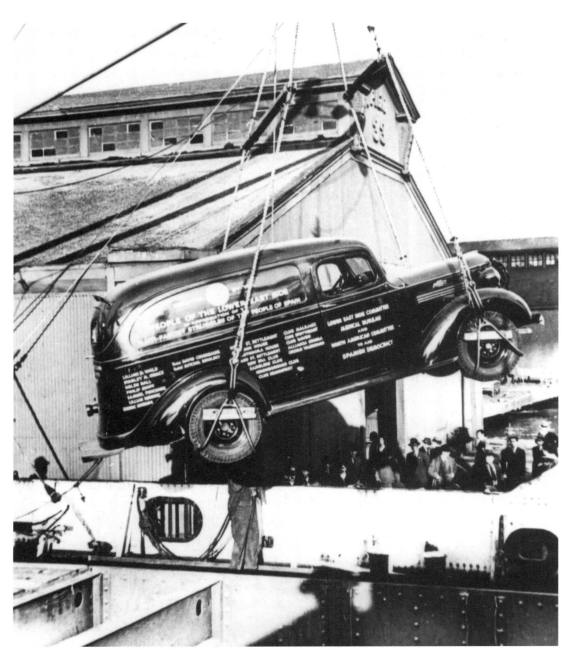

Some of the dozens of ambulances
shipped from New York to Republican
Spain, ca. 1937-38.

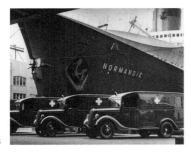
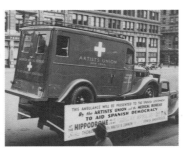
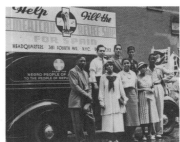

Workplace committees were also set up across the city. At Bellevue Hospital a committee of the Manhattan Chapter of the Medical Bureau was set up. Bellevue was also home to International Brigade nurse volunteer Fredericka Martin, and its committee raised $900 of a promised $2,500 to purchase a bullet-proof ambulance. [5]

Less formal gatherings also raised relief aid. A tea party at the home of George and Elizabeth "Betty" Marshall in October 1938, with Spain's liaison in Valencia Constance Kyle as guest speaker, brought out New York's liberal socialites. Some guests who were invited but could not attend the party are notable. They included Harry Rosenfeld of the local Board of Education, Anna Mascowitz Kross, a judge then running for the New York Supreme Court, A. M. Lamport, a bond investor, Edgar Bromberger, a city magistrate, and Mrs. Lehman, wife to New York's governor, Herbert Lehman. All sent their regards to the meeting. [6]

In August 1937, Adolph Zukor hosted a "Spanish fiesta" on his estate in Haverstraw, New York. The event was sponsored by the Rockland County Spanish Milk Fund and slated Spanish Ambassador Fernando de los Rios to speak. Eleanor Roosevelt endorsed the event along with New York Representative-at-Large Caroline O'Day, Edna St. Vincent Millay, and others. [7]

Jean Crawford and Franchot Tone held a private screening of the documentary *The Spanish Earth* at their home to raise funds for Spain. "The couple became convinced that the present Spanish government is one duly elected by the people of Spain and that democratic sympathies therefore should be with the loyalist cause," reported Leonard Lyons of the *New York Post*. Tone and Crawford reportedly purchased two ambulances for Spain with their own money. [8]

By far the largest and most publicized was the last major campaign before the Spanish Republic fell to Francisco Franco's army. This was the Relief Ship for Spain, which left New York in September 1938 aboard the *Erica Reed*. The Canadians donated 1,000 tons of wheat to the endeavor. African Americans in Harlem sent a fully equipped ambulance. All told, 5,000 tons of food, clothing, and medical supplies were shipped on the Relief Ship, a cargo valued at an estimated $250,000. [9]

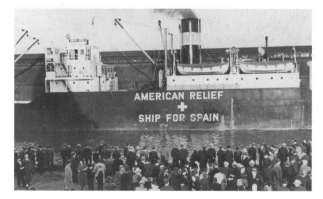

Relief Ship for Spain at port in New York, September 1938.

All of these events were intended to raise awareness of the crisis in Spain and the need to defend the Republic from the fascist intervention of Hitler and Mussolini's armies. Following the onset of hostilities in Spain the U.S. government instituted an embargo on military aid to the Spanish Republic, a move that was eventually codified into law and effectively aided the fascist rebels who were well equipped by Germany and Italy. The aid campaigners ultimately hoped to use the public awareness from their humanitarian efforts to force the government to lift the embargo on military aid to the Republic. In the meantime the humanitarian relief assisted civilians and soldiers affected by the fierce fighting across Spain.

The most visible contributions from New York—which were also the most requested items by the Spanish government—were ambulances. In New York many

unions and organizations instituted ambulance funds to purchase ambulances for Spain. The ambulances displayed the names of their donors and these included the Negro Committee to Aid Spanish Democracy in Harlem, the Sociedades Hispanas Confederadas in Brooklyn, the ILGWU, and many others. In this way, the ambulances announced the diversity of New Yorkers' involvement: labor unions, ethnic organizations, professional societies, and neighborhood clubs.

The campaigns also attracted many women volunteers. The executive boards of the American Friends of Spanish Democracy and the North American Committee included activists like Natalie Hankemeyer, Margaret Forsyth, and Eleanor Copenhaver Anderson. Mostly, however, women worked at lower level positions for the local Greater New York Committee; among them were Evelyn Ahrend, Felice Clark, and Ruth Davidow (who later went to Spain as a nurse). Evelyn Hutchins was singular in that she drove trucks around Manhattan to collect clothing for Spain as a way of demonstrating her automotive skill to the male leadership; by mid-1937, she had convinced them to send her to Spain as a driver. [See sidebar, p. 45.]

The most active New York supporters of Spanish aid were common workers. Some unions donated their labor rather than monetary gifts. "Since you and your friends are as much interested in helping Spain as we are, you make the repairing of shoes [to donate] as your special contribution, and... use some or all of the money you expect to raise at the Party to defray the expenses of a machine and a worker," wrote the North American Committee's Executive Secretary, Herman Reissig, to a Bronx shoemaker. Unions also set up their own Trade Union Committee to Manufacture Clothing for Spain, which became its own organizing body in mid-1937. [10] Other New York unions donated textile goods for Spain, funds for Spanish relief organizations, and in one case actually struck against a freighter bound for Franco-controlled Spain allegedly carrying bomb-making materials.

In September 1938, while Baltimore seamen were striking the Norwegian freighter *Titanian*, which they believed was carrying military supplies to Franco, New Yorkers picketed the Norwegian consulate. A week later, on September 7, the Brooklyn-based Scandinavian Seamen's Club of America struck on the *SS Gudvor*, another ship bound for insurgent Spain and also allegedly carrying chemicals. [11]

Meanwhile, the Trade Union International passed resolutions calling for boycotts on all goods going to fascist parts of Spain and demanded that Spain be allowed to defend itself. In late 1938, 49 locals in New York representing 82,732 members also adopted resolutions urging the lifting of the arms embargo on Spain. Organized labor was important enough to the Spanish Republic that in February 1938 the socialist syndicate Unión General de Trabajadores opened an office in New York City to more readily build alliances with U.S. workers.

After unions, the African-American, Italian, and Spanish-speaking communities in New York City were among the most active groups supporting the Spanish Republic. African-American activists, especially in Harlem, sympathized with the

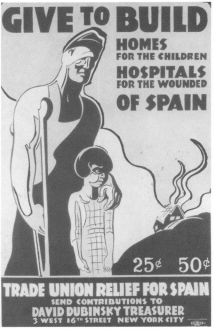

ABOVE
Broadside, ca. 1938.

OPPOSITE TOP
Hon. Marcelino Domingo and his wife standing among bundles of donated textiles awaiting shipment from New York to Spain, ca. 1938.

OPPOSITE BOTTOM
Bundles of textiles from the United States arriving and being sorted at a depot in France, en route to Spain, ca. 1938.

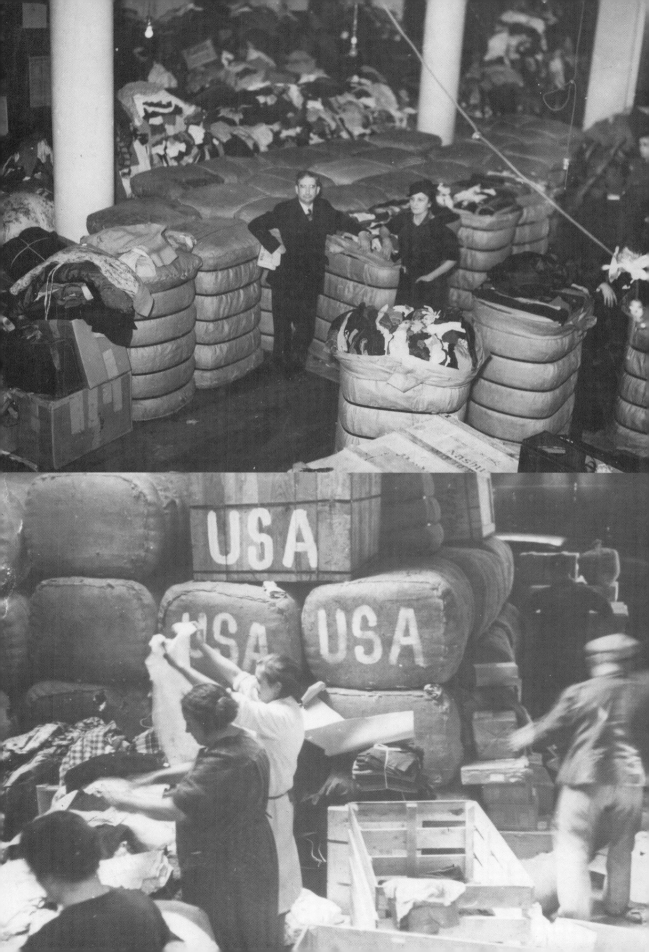

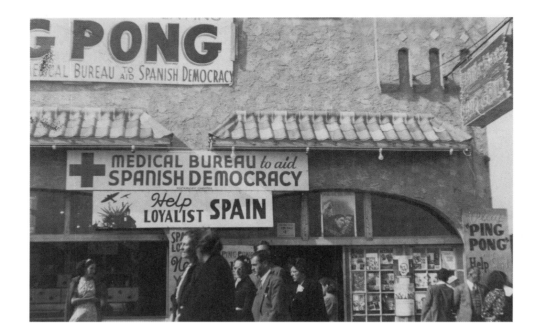

Headquarters of the Rockaway chapter of the American Medical Bureau to Aid Spanish Democracy advertise a ping pong fundraiser, ca. 1937.

Spanish cause. Fascist Italy had invaded Ethiopia in 1935 and Italy's involvement in Spain endeared the Republic's fight to the black community. A. Philip Randolph, president of the Brotherhood of Sleeping Car Porters, was "wholly sympathetic to the Spanish government" and the Porters' Secretary, Henry Coleman, even wrote the Senate Foreign Relations Committee encouraging an end to the embargo in May 1938. The Negro Committee was established to foster outreach. Although largely unsuccessful financially—raising a mere one percent of the total aid of the Medical Bureau and North American Committee to Aid Spanish Democracy—this component of Spanish aid brought together black and white Americans in an era of segregation.[12]

Immigrant groups, including Puerto Ricans, Mexicans, Finns, Germans, Italians, and Spaniards also aligned against Franco's insurgency. Particularly for the Italian-American population dissatisfied with Mussolini's fascist regime in Italy, and for the small population of Spaniards supportive of the Republic, the decision to offer aid against Franco's army was an easy one.

In the end, American Spanish aid organizations sent over $2 million—well over $30 million in today's currency values—in cash and material donations during the course of the Spanish conflict. Considering the Depression conditions of the time, this was a vast sum. Perhaps more importantly, the Spanish aid campaigns were waged in a climate of isolationism with few Americans interested in involvement in European affairs, and the Congress entirely resistant to calls for aiding the Spanish Republic. President Roosevelt, himself a New Yorker, feared a backlash and did not commit to assisting the Republic. The Americans who volunteered to help Spain confronted not just international fascism in its imperial mode, but their own country's apathy, at times hostility, to facing the growing threat.

Endnotes

1 Albert Halper, *Good-bye, Union Square; A Writer's Memoir of the Thirties* (Chicago, Quadrangle Books, 1970), 212–213; Robbie Lieberman, *"My Song is My Weapon": People's Songs, American Communism, and the Politics of Culture, 1930–1950* (Urbana: University of Illinois Press, 1995), 21.

2 Guy Emery Shipler form letter, Oct. 28, 1936, Minutes, Box 2, American Friends of Spanish Democracy, New York Public Library. The *Daily Worker* identified the International Labor Defense as the requesting organiza- tion. The Spanish counterpart to the I.L.D. was the Socorro Rojo. "Loyal Spain Needs Medical Aid Urgently," *Daily Worker*, Oct. 1, 1936; "New Shipment of Medicine Sent to Spain," *Daily Worker*, Oct. 24, 1936.

3 Trade Union Relief for Spain, *Accounting: Monies Raised and Expended, August 1936–April 1937* (New York: The Union, 1937); Conferencia Nacional de Sociedades Hispanas Confederadas de Ayuda a España, *Memoria del Congreso Nacional Celebrado Durante los días 6 y 7 de Noviembre de 1937 en la Ciudad de Pittsburgh, Pa.* (Brooklyn: The Sociedades, 1937); "12,000 Here Back Spanish Loyalists," *New York Times*, Aug. 19, 1936, 3; Stanley Payne, *The Spanish Civil War, the Soviet Union, and Communism* (New Haven: Yale, 2004), 147.

4 *Daily Worker*, "ILGWU Leader All for Sports," Jan. 4, 1937, 8; *DW*, "Sport Fans Rally to Games for Spain," Dec 6, 1936; *DW*, "Manhattan Stars in Game for Spain," Dec. 22, 1936, 8.

5 Feltenstein to CSI, Sept. 9, 1937, Folder Translations 2, Box 4, Part J, Spanish Refugee Relief Organizations (SRRO), Columbia University.

6 Marshall Tea folder, Box 2, Part M, SRRO.

7 Blanche Mahler to LaGuardia, July 28, 1938, General Correspondence, Box 1, Part M, SRRO.

8 "The New Yorker," *The New York Post*, September 16, 1937.

9 Braun press release, Sept 14, 1938, International Coordinating Committee 2, Part J, Box 5, SRRO.

10 Reissig to Mr. Ivanoff (Bronx) Feb 6, 1937, Misc. I folder, Box 15, Part B, SRRO.

11 "Ship Strike is Viewed as World Movement," *Baltimore Sun*, Sept. 14, 1938; "Alleged Munitions Ship for Spain Passes Capes," *The Sun*, Sept. 15, 1938; *Spanish Labor Bulletin*, October 14, 1938.

12 Olga Paz (Chicago NAC) to Bedford-Jones June 21, 1937, f. Chicago–United Youth Committee, Box 11, Part K, SRRO; Cable May 3, 1938, f. Embargo–Trade Unions, Box 7, Part E, SRRO.

"SOMEONE HAD TO HELP."

BY DR. EDWARD K. BARSKY

THE DECK SPACE RESERVED

for third class passengers on *S. S. Paris* is not very big but from it you can clearly see the skyline of New York as it piles up into the biggest castle in the world. But I could not look at it; I was too tired to see. I did not want to say good-bye again to anybody or to blink in the glare of flash-bulbs or to answer the questions of any more reporters. I went below and crawled into my dark berth, alone for the first time in the thirty seething hours. Let the others watch to see the last of our shores. My throat was sore from talking—and my clothes hurt my body which was sore from fatigue. It was too much trouble to undress, or to get a drink of water or even to pull up the blankets. There was that steamer smell of rubber, linoleum, clean greased engines and paint. For a second I thought about my fantastic situation and then, as if anesthetized, I fell into a dreamless sleep.

This was the afternoon of the sixteenth of January, and the engines which had begun to shake me gently were taking me to Spain. Nothing would have seemed more impossible to me three months before than that I should be sailing away to a country at war at the head of a medical mission. For I had been very busy; a typical New Yorker, I suppose. I was absorbed in my work. I had not time enough for my friends or for my family. Also I was supposed to be threatened by some sort of breakdown due to overwork. Afterward in Spain everybody had a good time laughing about it.

How had it started?

First of all there was an interest in Spain, a country trying, after years of black repression, to be a democracy, and in a measure succeeding. So much I had read in newsprint. Then the Spanish government had sent a delegation to beg for American help, American sympathy. I went to a meeting. Yes, that was the beginning.

Two persons, neither at all typical of a new Spain spoke movingly; a woman lawyer, and a Catholic priest from the Basque provinces. There were not many women who had become lawyers even in Republican Spain and persons who associate the Spanish Catholic Church with Fascism and nothing but Fascism forgot the Basque Catholic clergy who were solidly on the side of the people.

These two spoke to us in such a way that we saw a clear issue. A peacefully elected government made up of many factions trying to balance itself, trying to restore a measure of social justice, had been attacked by a perjured army, by generals who had first sworn alliance to the government and then enlisted foreign help against it. But their *coup d'etat* had failed. The people themselves had wanted to keep their newly won freedom. They fought desperately. Sometimes unarmed, men and women together, in overalls, untrained militia fighting machine guns with picks and stones. They fought for freedom. Not only the sort of freedom which was won for the United States of America when in 1778 [sic] the British fleet sailed away from the port of New York eastward down Long Island Sound—not as much freedom as that. In Spain they wanted only liberty to think each according to his conscience, not to starve in fertile fields untilled, to live un-menaced by secret police. This modest liberty, this democracy which the Spaniard had won legally at the polls without civil war, seemed as valuable to me as it did to them. Why should it be taken away by force, by foreign force?

The next thing I remember was that a group of us met at Dr. Louis Miller's house. Dr. Miller knew a good deal about American medical missions to various foreign lands. He knew about the services they had rendered and a little about their organizations. American medical practice, he said, was never more needed. Others spoke of the American Quaker relief work done in Germany during the famine which was the result of the blockade at the end of the Great War.

I was a member of a group of doctors who met together to talk about all sorts of things. One night at a meeting of this informal group we were talking about Spain. The government had almost no medical service. Somebody said,

"That sort of thing ought to be our meat."

The American Friends of Spanish Democracy had been formed. The North American Committee had been organized for the purpose of sending clothes and food to Spanish refugees. Then one October night at Dr. Miller's house the American Medical Bureau to aid Spanish democracy was born. It was under the auspices of this committee that all our work in Spain was conducted.

Soon we had a Purchasing and a Personnel Committee, for we envisaged the plan of sending a medical unit to Spain. Most of us were professional people; we had slender resources, yet the end of it was that we raised more than a million dollars. November and December were busy months. The work of raising money went on with enthusiasm. We had many meetings in New York and also in nearly all the big cities of the country. Our appeal was heard from Maine to Florida and west to the coast. There was much interest in Spain, all over the country. We set as our immediate objective the complete equipment of a seventy-five bed mobile hospital.

It was more difficult to find the personnel than equipment. Nurses and doctors of the type we must have were more apt to be busy people with jobs they could not leave. Yet in the end just these people came. They were motivated by the idea of service and willing to do their bit in this fight for democracy. To come with us these people were in some cases to give their health; some gave their lives; in all cases they gave their jobs.

"To come with us," but at this time I had no intention of going. I worked all day and we had meetings all night, sometimes two or three meetings, and then we finished the small hours in some coffee-house perfecting our plans.

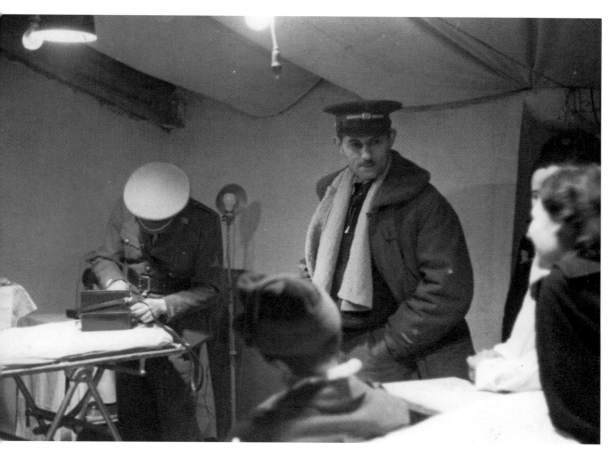

Dr. Barsky inside a hospital tent in Spain, ca. 1937.

Towards the end of December contributions began to fall off. We had to face the fact squarely that our plan of sending a seventy-five bed hospital to Spain looked beaten, for the present anyway. Yet we knew what time must mean in Spain. We felt that if we could once get that hospital across the seas and in action contributions would continue to support it. It would be something concrete. The hospital must sail: We still lacked essential equipment and essential personnel.

As head of the purchasing committee it was my job to figure out everything needed for this new kind of hospital. We had to buy everything; mattresses for the ward beds, surgical equipment, etc. etc.; in fact everything from a safety pin to a special operating room light running on dry battery. (Afterward, by the way, to be known as the "Light that Failed.") Lister bags for carrying water, etc., etc., etc., besides all sorts of special medications, serums, antitoxins. From the start we were very careful about paying our bills; we only paid those we had to pay!

It was my job as head of the personnel committee to see that we picked only the right sort of people. They must not be sentimentalists, yet we could take only persons ready to die if necessary for their convictions. Also, most essential, they must be persons of proven skill in their present professions. In the matter of chauffeurs, it meant nothing to us if a man could drive a car; he must also be an all round mechanic, perhaps an orderly, with the right stuff in him to make a nurse if necessary, and he must be young and healthy and mentally well-balanced. We had to have a pharmacist, and laboratory technicians. The nurses to be enlisted must be in better than average good health.

One type we had no particular use for and these came to us in droves: writers. We had a very impressive permit from the State Department licensing our work and permitting us to send personnel over-seas, and these literary gentlemen were anxious to ride on this magic carpet. The writers soon learned that in their particular capacity we had no use for them. But they, as might have been expected, were men and women of imagination and more, of histrionic ability. They came disguised as chauffeurs—it would usually turn out that they drove a car—as ambulance drivers, as mechanics, as male and female nurses and, I regret to say, sometimes as doctors. But we managed to pierce all these disguises. Perhaps it was no wonder that things went slowly or that we thought they did.

Things were now so retarded that our whole project hung in the balance. I was beginning to feel the strain of carrying on my practice and continued lack of sleep. There were so many things to worry about, even if I did get to bed. One thing was that we had not yet found the right man to head the expedition. I knew how much would depend on him.

One night after we had had three meetings and our contribution had been far less than we hoped, a small group of us talked frankly about our difficulties. We admitted to each other for the first time that the whole thing was still uncertain.

"Look here," somebody said, "we've got to go! The way to go is to go. We set a date right here. Tonight. When do we go?"

"Well, make it January sixteenth."

And then very solemnly we all shook hands and decided that the hospital would sail on that date. How, was another matter.

The outfit would sail. Things, as we had foreseen, moved along faster after we had made our big decision. But one important thing was still undecided. Who was to head the outfit? When late one night someone suggested that it might be myself, the idea at first seemed ridiculous. How could I even think about it?

"How can any of us?" they asked. Then somehow all at once I realized that I had been eager to go from the start, perhaps in some deep part of my mind I had known that I would go all along. Yet for days I could not get over my sense of surprise.

On the morning of the fifteenth of January the equipment which we had spent months collecting was in a warehouse, not yet completely packed, we had our personnel together, we had very becoming and serviceable uniforms—but we had no money. We could not sail without at least three thousand dollars—this was not extra money, you understand, it was to pay among other things for our third class passages and our food.

That night there was to be a mass meeting in the Manhattan Opera House and on the collection taken in our fate depended. The Spanish Consul was there, there were two bands and we wore our new uniforms with "A.M.B." (American Medical Bureau), on the arm-bands, for the first time. Everybody thought we were going to Spain; we hoped we were ourselves, desperately we hoped. And then when the tumult and the shouting died away we counted the collection.

We had between five and six thousand dollars and the next day we would sail for Spain!

The rest of that night was spent by doctors, nurses, pharmacists and laboratory technicians, in crating and packing the stuff in the warehouse. At one time we were afraid we would never get that done in time either but at last some bedraggled indi-

viduals who had been doctors and nurses got on the boat and we heard the whistle which meant all aboard for the Spanish Front.

Bands were playing and everybody waving and crying and cheering. It seemed that we would never, never leave that dock. When in the end we did, I went below and let the others watch for the Statue of Liberty.

One of the other doctors woke me up. He told me that on board were about ninety young men in plain clothes. It was whispered that they were gong to enlist in the Lincoln-Washington Brigade. My worries were now few as compared to the load I had been carrying but I had to see that our outfit did not openly fraternize with these men. We were a non-partisan unit. Also I was worried about a little box in my pocket. Just as the whistle blew a friend had opened my hand and put the little box in it.

"Here, Eddy, take this," he had said.

I opened the box. It contained about six grains of morphine. If I were to be caught with this contraband in my personal possession I could easily be returned to the United States—yet it was hard to throw away even this much of the stuff I knew would soon be very precious to us. I spent a good deal of time worrying over this trifle.

FROM DR. EDWARD K. BARSKY WITH ELIZABETH WAUGH, "THE SUR-GEON GOES TO WAR," UNDATED, UNPUBLISHED MANUSCRIPT IN ALBA COLLECTION.

Dr. Edward K. Barsky, a surgeon at Beth Israel Hospital in New York, was a founder of the American Bureau to Aid Spanish Democracy and headed the first U.S. medical team to go to Spain. He later served as head of the Joint Anti-Fascist Refugee Committee, tirelessly campaigning to alleviate the suffering of Spanish exiles. His refusal to identify supporters of that organization to the House Committee on Un-American Activities led to a jail sentence in 1950 for contempt of Congress and a suspension of his New York medical license.

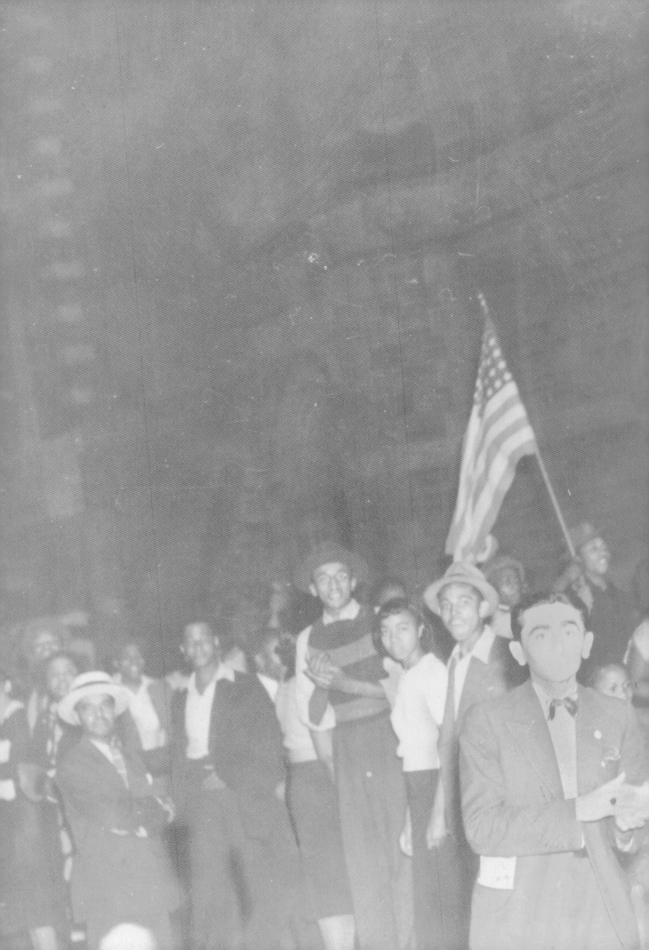

THE NEW YORK CITY LEFT AND THE SPANISH CIVIL WAR

BY FRASER M. OTTANELLI

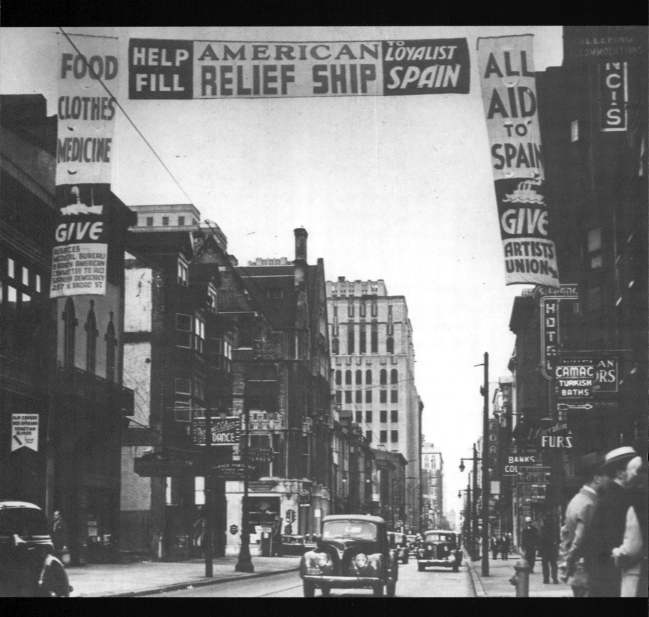

DURING THE SPANISH CIVIL
War no other city in the United States matched New York in the overall material and
political support for the Loyalist cause. Rooted in its working-class and immigrant
neighborhoods, the city's Left combined internationalist politics with a cosmopoli-
tan perspective. As Franco's army, with the material support of Nazi Germany and
Fascist Italy, rolled through the Spanish countryside, the slogan among anarchists,
Socialists, and Communists became, "Madrid will be the tomb of fascism." Spain
now symbolized the global fight against exploitation, oppression, and racism.

Foreign-born political exiles were some of the first to leave New York to fight
alongside popular militias in defense of the Spanish Republic. Most had fled
repressive governments in Europe and Latin America to settle in New York where
they blended into a supportive radical ethnic community. The battlefields of Spain
gave them an opportunity for armed and organized resistance against the spread of
fascism and at the same time offered the promise of redemption for their country of
origin. Among those who sailed from New York shortly after the military uprising were
Italian anarchist Michele Centrone and the Cuban Communist intellectual Pablo
de la Torriente Brau. For both men the decision to become "volunteers for liberty" [1]
expressed their identification with broad internationalist class-based labor and
political organizations, as well as their experiences as migrant workers and activ-
ists. Their separate but parallel experiences reached a tragic climax as Centrone was
killed on the Aragon front in August 1936 and de la Torriente Brau died in defense
of Madrid four months later.

From the onset of the fighting in Spain, New York's left mobilized in support
of Spanish Loyalists and hardly a week went by without a benefit event, a rally, or
a demonstration. Members of ethnic based left-wing organizations played a vis-
ible role in voicing public support of the Republic. In response to the bombing of
Guernica, over 300 Basques wearing traditional costumes demonstrated outside
the German consulate; Italian Americans from rival left-wing organizations set

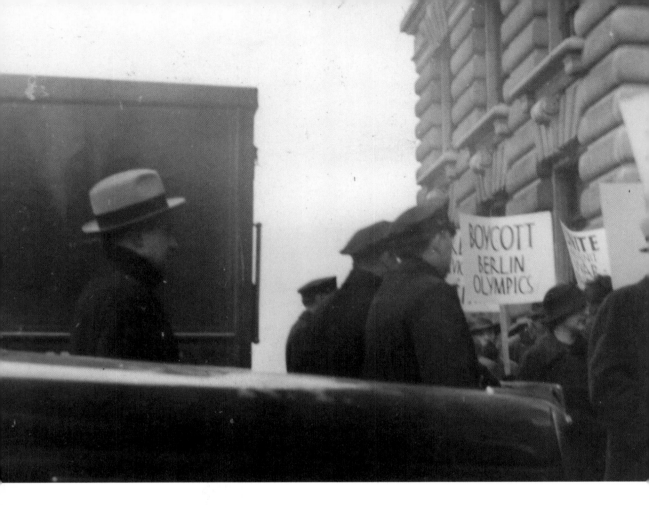

Demonstration against the 1936 Berlin Olympics outside the German consulate in New York, 1936.

aside their differences to picket Italy's consular offices at Rockefeller Center and on Lexington Avenue with colorful placards in support of the Spanish government, chanting antifascist slogans in Italian; they also joined with their African-American comrades to march through the streets of Harlem to protest fascist aggression in Ethiopia and Spain.

The anarchist movement mounted a campaign that vastly exceeded its small numbers as the city's English-language groups joined together with the various Spanish, Italian, Jewish, and Russian federations in support of their embattled Spanish comrades. The various factions of the Socialist Party—which ranged from traditional pacifist, to social-democratic and militant revolutionary—could not agree on a common course in relationship to events in Spain; while some called for no action and others for support of the dissident communist Workers Party of Marxist Unity (POUM) in Catalonia, Socialists in New York launched their own ill fated effort to recruit and finance 500 volunteers to be sent to Spain as the "Debs Column." Much more successful were the efforts of the International Ladies Garment Workers' Union. Relying mostly on New York's large Dressmakers Local 22 as well as on the efforts of other locals and individual union members, the ILGWU raised thousands of dollars for medical supplies and clothing for the Spanish loyalists.

The Communist Party (CPUSA) was the organization most actively involved in support of the Spanish Loyalists. By the mid-1930s domestic developments and international pressure made the CPUSA set aside its emphasis on revolution to embrace a policy known as the "Popular Front" based on a broad alliance with

socialist and liberal forces in defense of democratic institutions against fascism. For Communists, the struggle of the Spanish Republic against enemies supported by Hitler and Mussolini became the epitome of the contrast of the decade: the forces of democracy and social reform battling fascist rebel generals. At the local and national level, Communists were involved in fundraising activities, the recruitment of volunteers for the International Brigades, and the campaign against the extension of neutrality legislation to Spain. Speaking at the Coney Island Velodrome, the Communist leader Earl Browder warned that unless the United States changed its policy and "clasps hands with the peaceloving people of the world" to stop fascism, "bombs on Madrid" would be the prelude to "bombs on New York and San Francisco."[2]

The CPUSA's antifascism mirrored the perceptions of growing numbers of politically active liberals, noncommunist left-wingers, and unionists who provided the basis for the formation of the North American Committee to Aid Spanish Democracy, the most important and largest organization in support of democratic Spain. Founded in the fall of 1936, the North American Committee acted as an umbrella for groups directed at mobilizing specific constituencies such as the Medical Bureau, the Musicians, the Lawyers, and the Social Workers Committees, as well as the United Youth Committee, a city-wide youth group composed of representatives of the YMCA and YWCA, the Young Communist League, the American Sunday School Union, the Brooklyn Urban League, the Abyssinian Baptist Church, and the Junior Federation of Jewish Charities.

Throughout the war, the North American Committee launched several campaigns to send medical supplies, food, and ambulances to Spain, and it received substantial support from various New York City unions like the Teachers Union, the Bakery and Confectionary Workers Union, and the Fur Dyers. Yet the success of these campaigns rested mainly on a network of local neighborhood groups in all five boroughs and north into Westchester and Rockland counties. Volunteers

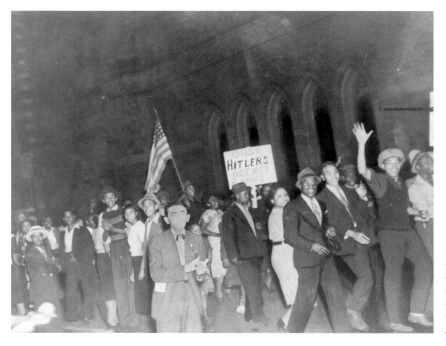

Harlemites in an anti-Nazi parade after Joe Louis's one-round victory over Max Schmeling of Germany, June 22, 1938.

canvassed local stores for food, medical supplies, and clothing. While women of the Spanish Workers Club on Madison Avenue or the Galician Center on West 4th Street gathered to sew and mend clothing, members of the ILGWU held "Spanish Help Parties" in private homes or benefit dances at 107 McDougal Street and, together with the Fur Workers, produced tens of thousands of garments. All the goods were dropped off in over 150 collection points housed in union halls, mutual aid societies, businesses, and private homes and from there were transported to a central warehouse in Manhattan, where other volunteers would pack them for shipping.

To raise funds and rally public support, left-wing organizations relied on a multitude of activities. Mass meetings were held at Madison Square Garden and the Hippodrome at which New Yorkers "speaking many different languages, but all cheering for democracy" paid tribute to representatives of democratic Spain and donated thousands of dollars including, in one case, a contribution from a policeman on duty. [3] On "Spain days," hundreds of New Yorkers took to the streets with collection cans to raise funds to pay for large shipments of food organized by the North American Committee. Pro-Communist Spanish-speaking mutual aid societies held a "Soccer game for Spain" between teams from union locals as well as a match that pitted an "All-Star Spanish" against a German team. Meanwhile, the "Game-for-Spain committee" organized a basketball tournament at the Hippodrome between "girls teams" of the ILGWU as well as an "all stars" game between the International Workers Order and the Furriers. In the summer of 1937 the "First Anti-fascist bull fight in the U.S." was held in Pleasant Bay Park. At the end of June 1938, the women's division of the medical bureau of the North American Committee organized an "old-fashioned village fair" on the Washington Mews, between Fifth Avenue and University Place to raise $10,000 for the Spanish Children's Milk Fund. *The New York Times* described "the unusual sight" of "the milking of a cow in a fenced barnyard opening on Fifth Avenue, with the Washington Arch in the background." The fair also featured a hog-calling contest, livestock exhibits, and dart-throwing against dummies of Hitler, Mussolini, and Franco. [4]

Groups and individuals offered their talents to raise money: musicians, puppeteers, magicians, even fortune tellers performed on the city's street corners to raise funds for Spanish relief or for cigarettes and other supplies for the members of the Lincoln Brigade. Benefit dances and "jitterbug jamborees" were held at the Savoy Ballroom in Harlem, at the Roger Smith Ballroom on 41st and Madison, and at Steinway Hall on West 57th, featuring performances by Benny Goodman and Art Fletcher. For a more traditional audience, the Gordon String Quartet performed music by Debussy and Beethoven, and "L'Oración del Torero" by the Spanish classical composer Joaquin Turina at Town Hall. Modern dancers Martha Graham, Hanya Holm, and Anna Sokolow combined forces with tap and, appropriately enough, Spanish dancers, for shows at the Hippodrome and at the Mecca Temple. The cast of Clifford Odets' Broadway show *Golden Boy* lent its talents for a benefit sponsored by the Friends of the Abraham Lincoln Brigade at the Belasco Theatre on 44th Street. At one event, the famous strip-tease dancer Gypsy Rose Lee told the audience "you might think my mind is on lifting my skirts. You're wrong—it's on lifting the embargo." [5] Appropriately, she became chair of the Clothing Division of the Spanish Refugee Relief Campaign.

OPPOSITE TOP
"Lift the Embargo" meeting at Madison Square Garden, ca. 1937.

OPPOSITE BOTTOM
Jitterbug Jamboree at the Liberty Bell Fiesta, Royal Windsor Hotel, West 66th Street, ca. 1938.

International in composition and in outlook, the Left in New York did its share to defend democratic Spain: perhaps as many as one thousand New Yorkers crossed the Atlantic to fight and at least a third of them never returned; city residents expressed opposition to fascism and support for the Loyalist cause by mobilizing to demand an end to U.S. neutrality and providing thousands of tons of clothing, food, and medical supplies for Spain's beleaguered population. Following the defeat of the Republic and throughout the long years of the Franco dictatorship working through organizations like the Joint Anti-Fascist Refugee Committee or the Veterans of the Abraham Lincoln Brigade, the city's left continued to express its support for a democratic Spain.

OPPOSITE TOP
Dartboard wall for "A Dart in the Heart" game at the Village Fair, 1938.

OPPOSITE BOTTOM
Dorothy Parker and child actor Dickie Van Patten at the Village Fair and milk drive in Greenwich Village, ca. 1938.

Endnotes

1 This is was the term commonly used to refer to the international volunteers who fought in defense of the Republic and was also the name of the multi-lingual publication issued for them in Spain.

2 Earl Browder, *China and the United States* (New York: Workers Library Publishers, 1937), 6-8.

3 *Daily Worker* and *The New York Times*, October 27, 1936.

4 *The New York Times*, June 29 and 30, 1938.

5 *Nation*, January 7, 1939, 36.

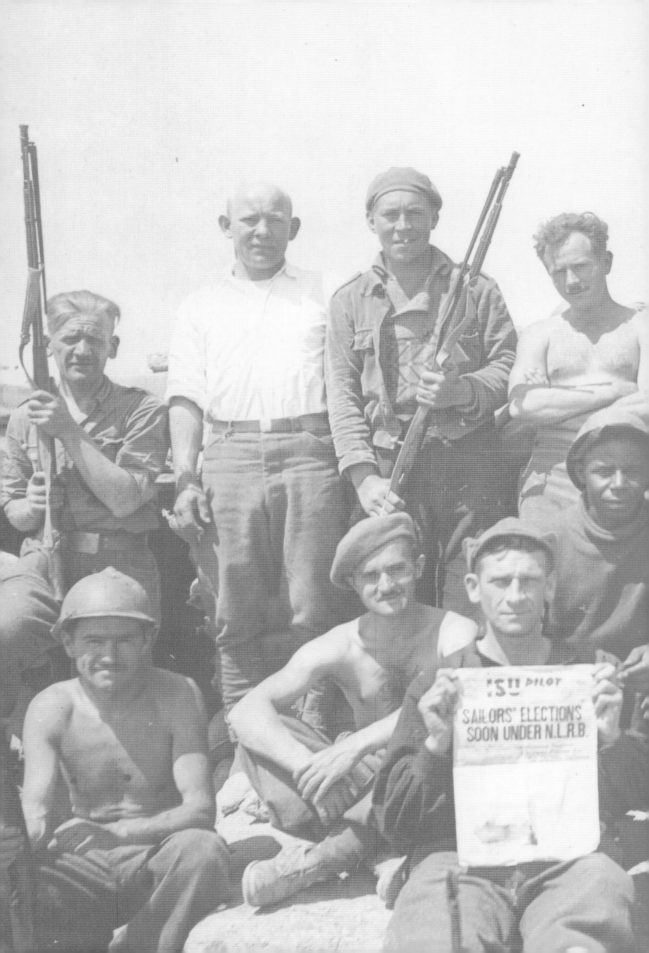

FROM
BROOKLYN
TO
BELCHITE:
NEW YORKERS IN THE
ABRAHAM LINCOLN
BRIGADE

BY JUSTIN BYRNE

N

EW YORK AND

New Yorkers were at the very heart of the Abraham Lincoln Brigade. [1] While firm figures remain an illusion, the best-informed estimates suggest that at a time when the city accounted for some 6 percent of the U.S. population, between a fifth and a third of the 3,000 Americans who served in Spain had been born in the city or lived there when they volunteered. [2]

The large presence of New Yorkers among the Lincolns was in part simply a question of logistics. They required only a subway ride or a walk down to the harbor to begin the journey that would take them to Spain. Recruitment had begun in New York City and remained intense—unsurprisingly, given the size of its population, its position as the natural point of departure for Europe, and perhaps most importantly, the strength of the antifascist movement in the city. All this, however, tells us nothing about the 800 to 1,000 men and women who left the five boroughs to serve in Spain, why they went, or why they stayed. To begin to answer these questions we must look at the ethnically, socially, and politically diverse traditions of left-wing activism that came together in the struggles of 1930s Gotham. It was from these unusually dense webs of social networks and movements that the Lincoln Brigade drew so many of its members and much of its collective strength.

PREVIOUS SPREAD
Seamen from around the world who shipped out of American ports, assembled at Jarama, Spain (site of the first battle in which Americans took part), early 1937.

OPPOSITE TOP & BOTTOM
People attending the Young Communist League convention at Madison Square Garden, 1939.

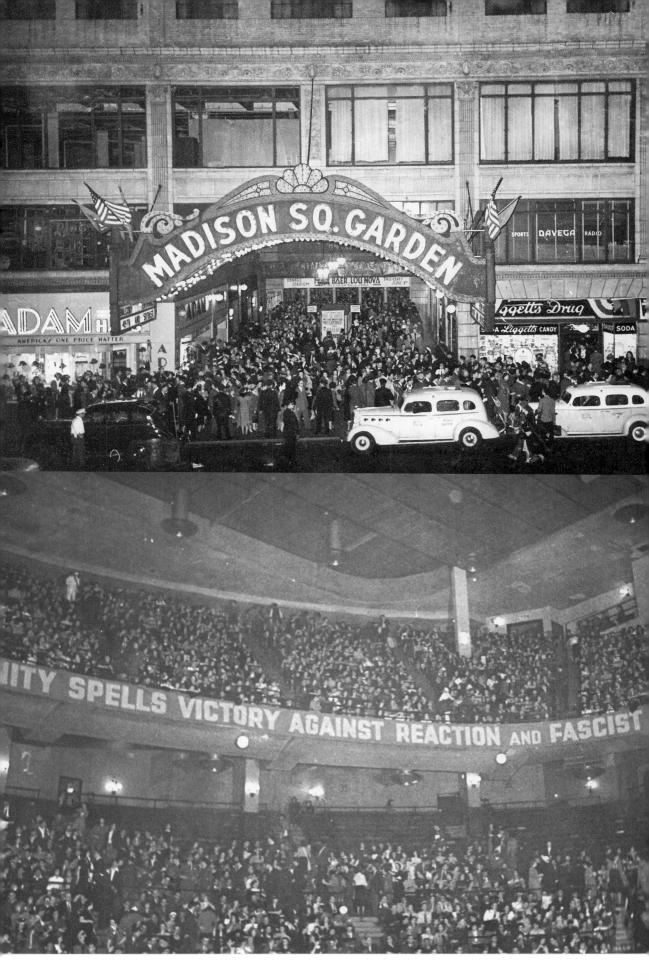

STRIKE TO-DA

FOR

REINSTATEMENT OF 21 EXPELLED STUDENTS

OUSTING OF PRES. ROBINSON

ALL OUT TO FLAGPOLE 11 A.M. TO-DAY NIP FASCISM IN CITY COLLEGE!

City College Strike Committee
National Student league
Student league for Industrial Democracy

ROTOGRAPHED, 817, B'WAY, N.Y

Strike flyer with drawing of City College president Frederick Robinson and Mussolini, November 1934.

ing their decision to leave, but they transmitted little sense of significant transnational Jewish identities or solidarities. For many foreign-born or first-generation Americans, Europe was a place best forgotten, assimilation the goal, and their identity firmly rooted in the largest Jewish city in the world, New York.

Hundreds of these volunteers were, like Shafran, a product of the city's vibrant Jewish radical community. This rested on networks of social, cultural, and political clubs, on institutions as varied as the Yiddish socialist daily the *Forward*, with a circulation over 250,000, and the Brooklyn Hebrew Orphan Asylum, home for shorter or longer periods to at least ten future volunteers. [7] The progressive summer camps Kinderland and Unity were other common reference points for many of New York's Jewish volunteers. However, the real focus of Jewish life in 1930s New York was the neighborhood, the distinctively Jewish areas that were home to so many of the volunteers.

I... was active in Brownsville, Brooklyn for some years.

The first time I spoke on a street corner was in 193[5], when Mussolini invaded Ethiopia. We spoke not only in Brownsville, a Jewish community, but also in Ocean Hill, basically an Italian community. And yes, even there, we found friends and sympathizers, but by far not the majority.

We took part in unemployed demonstrations—actions at Home Relief Bureaus—organized rent strikes—helped put furniture back into apartments when tenants were evicted. We picketed at Woolworth's demanding hiring of Black workers—we were arrested but continued these activities.

We took part in the electoral struggles and in Brownsville were successful in electing an assemblyman and state senator. (History tells us that Brownsville elected 5 Socialist Assemblymen in the '20s—all were thrown out after the election, but they were elected.) The first Birth Control Clinic was opened by Margaret Sanger in Brownsville. The trade union movement was strongest in Brownsville.

I am a little proud that I was the first to arrive in Spain from Brownsville. Quickly Brownsville sent more than 30 volunteers to Spain. I arrived in Spain in January 1937. Trained—if you can call shooting 5 rounds of ammo, training—with the original Lincolns at Villanueva de la Jara.

MORRIS (MOISHE) BRIER
UNDATED TYPESCRIPT
ALBA COLLECTION #143, BOX 2,
OTTO REEVES FOLDER.

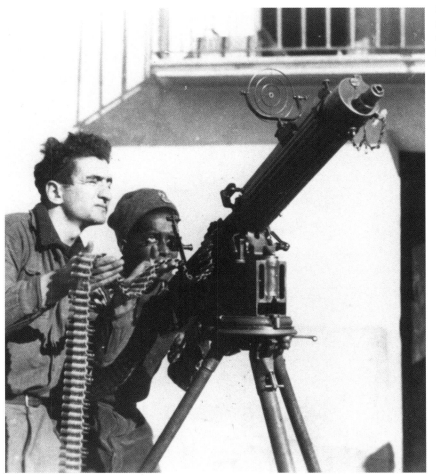

Volunteers Morris Brier (left) and Otto Reeves operating a machine gun in Spain, ca. 1937.

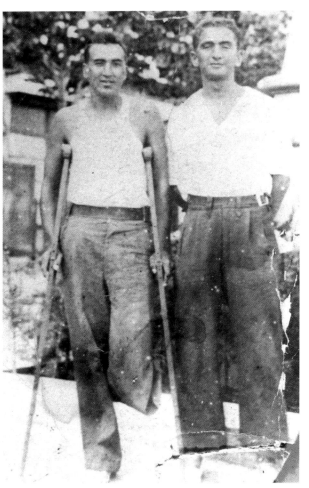

Volunteers Morris Brier (left) and Marc Haldane, ca. 1938.

These included the Lower East Side, but even more importantly the newer Jewish neighborhoods in the outer boroughs, and above all their poorer and more radical districts. Foremost among these was Brownsville, the most Jewish district in the city (80 percent of its inhabitants were Jews), and second only to the Lower East Side in terms of the number of families receiving welfare during the Depression.[8] Here, the large orthodox population, served by over 70 synagogues, coexisted with an unusually strong leftist community. Brownsville elected Socialists to New York State Assembly from 1915 to 1921 and an American Labor Party candidate in 1936.[9] As Maury Colow recalled, "nothing could be more political than growing up in Brownsville. My first recollections of the community are literally of picket lines.... I was literally born into the movement."[10] Other future volunteers turned to politics as teenagers coming of age in the Depression, when rent strikes, consumer boycotts, and resistance to evictions drew their strength from tight-knit community support and, increasingly in the mid-1930s, Communist leadership. Brownsville's proud claim to have been the home to 66 volunteers was probably exaggerated, but perhaps not much. In 1936 and 1937 dozens of tough Jewish boys like Colow, hardened in fights with police and home-grown racists and fascists, left Brownsville, Williamsburg, and the South Bronx for Spain.

New York's colleges were another bastion of Jewish youth culture in the city, and another hub of recruitment for Spain. At least 19 of the 22 volunteers from NYU were Jewish, as were no fewer than 75 percent of the 60 students, faculty, and alumni from City College, almost certainly the educational institution in the country with the largest number of volunteers to its name.[11] With free tuition and an 80-percent-Jewish student body, CCNY was where bright boys from Brownsville, Bensonhurst, or Yorkville went for their education. Branded the "Little Red School House" by the popular press, CCNY was in a state of political ferment in the mid-1930s, as students and faculty mobilized against the introduction of tuition fees, the student military training corps, and restrictions on the freedom of speech imposed by the arch-conservative college president Frederick B. Robinson. Campus politics led seamlessly into broader issues at home and abroad, and particularly opposition to imperialism and fascism. Tension at City College reached a peak when 21 students, including future volunteer Wilfred Mendelson, were expelled for disrupting a meeting given by a delegation of Italian Young Fascists in October 1934. Students responded by burning effigies of Robinson and Mussolini, and in March 1935,

formed a joint staff/student Anti-Fascist Committee. With the outbreak of civil war in July 1936, attention shifted to Spain, the subject of countless meetings, demonstrations, and student newspaper articles at City College, NYU, and colleges around the country. One of the 500 or more students, many of them from New York, who passed through the ranks of the Lincoln Brigade, Mendelson arrived at the front in early July 1938. He was killed at the Ebro just three weeks later.

While Jews were highly represented among New York volunteers, fewer than a dozen of the 90-odd African Americans known to have served in Spain had a clear link with the city. Apart from Harvard-trained, Harlem-based dentist Arnold Donowa, who progressed from fundraising for aid to Spain to service in the American Medical Bureau (AMB), or the former college football player, writer, and activist Vaughn Love, most were firmly rooted in the African-American working class. Like Tennessee-born Love, who arrived in 1929, "just in time for the Depression," others had moved to the city just a few years earlier in an often futile search for work, sharing experiences of sleeping rough, soup kitchens, exploitative casual work, and racial discrimination by employers, police, and judges. Love's political involvement sprang from the campaign to free the Scottsboro boys and became firmly rooted in Harlem. Other future volunteers gravitated towards the neighborhood, drawn by the exciting, liberating atmosphere of the undisputed capital of black America, then in a constant state of cultural and political effervescence. Harlem was the natural destination for Jimmy Yates (from Mississippi via Chicago) on his first night in the city. Later he would go there to listen to Adam Clayton Powell's powerful race-conscious sermons in the Abyssinian Church, to join thousands of Harlemites to celebrate Joe Louis's famous 1936 victory over "pure race" Max Schmeling, and to take part in mass demonstrations against Italy's invasion of Ethiopia in the months running up to the war in Spain. [12]

Yates's politics were rooted in experiences of racial oppression and resistance, but also in involvement with class-based politics of the Communist Party, the only one, in his words, to "recognize the reality of my life," the dual oppression of race and class. [13] Yates and his roommate Alonzo Watson, as well as other New York-based African Americans Crawford Morgan and Thomas Page, joined the Party in the mid-1930s after becoming involved in Communist-sponsored demonstrations in demand for welfare for the jobless, Unemployed Councils, and labor conflicts. Salaria Kea, the only African-American woman known to have served in Spain, was one obvious exception. A devout Catholic, moved by humanitarianism and a combative spirit forged in encounters of every day racism and involvement in the fundraising for Ethiopia, she would later say that when she left Harlem Hospital to go to Spain, she "didn't even know what a Communist was. I thought it was for white people only, like the Mafia." [14]

Kea was one of some 50 American women who served in Spain, all but two of them as nurses. One of the exceptions was Evelyn Hutchins, a dancer and night-school student who through sheer persistence managed to overcome the "chauvinism" of Lincoln Brigade recruiters to be taken on as a driver. Once there she put into practice skills picked up maneuvering trucks packed with aid supplies for Spain on New York Harbor [see sidebar, ch. 3]. New York was also the key recruiting ground for nurses, over half of whom came from the city. All but a few were Jewish and raised in the same neighborhood-based radical communities as their male counterparts, and

like them, most were single. They were on average a little older than the men, from whom they also differed in that they were all highly trained and qualified. In contrast to the male volunteers, moreover, they gave up good jobs (in private denominational hospitals like Beth Israel, Brooklyn Jewish, Montefiore, Mount Sinai, and Saint Vincent's, or public hospitals like Bellevue, Bronx, Harlem, and Hunter) to go to Spain.

Popular wisdom at the time and after maintained that, in comparison to the male volunteers, the nurses were "less political," but this does not appear to hold true for the New Yorkers among them. While the paths that took these women to Spain were as varied as those of male volunteers, they showed similar records of labor and political activism. More than half the New York nurses belonged to a trade union and a similar proportion to the Communist Party. [15]

The New Yorkers certainly included men and women of different political leanings—anarchists, socialists, and unaffiliated volunteers like Evelyn Hutchins, who considered herself simply an antifascist. For some, equally, politics were of secondary importance, their decision to volunteer determined by more personal circumstances and considerations. The gaps and self-selection in the sources mean that we inevitably know less about these volunteers, or about those who moved away from the Communist Party during or soon after the war. Nonetheless, it is equally evident that, as in the country as a whole, the majority of volunteers, probably three-quarters or more in the case of New York, came from within the Communist Party's sphere of influence. [16] This is hardly surprising, as the International Brigades were a Communist initiative and the CPUSA was responsible for the recruitment in the United States. Membership in the Party, the YCL, or one of the other labor, political, and cultural organizations under its aegis was the common thread that tied the different strands of New York radicalism. This was the link between Irish-American seaman Bill Bailey and student activist Wilfred Mendelson, between unemployed African-American Jimmy Yates and Maury Colow in Brownsville.

It is harder to know what this tells us about the volunteers' politics or their motives for going to Spain. For some, especially older volunteers, Marxism-Leninism remained the guide, the Soviet Union the model, and revolution the means to achieve it. Years later, long-disillusioned with the Party, Bill Bailey would recall with emotion the ceremony at which he received his membership card, the moment of his consecration to the revolutionary cause (which he never abandoned). There were others like him, but most volunteers from the Party and YCL seem to have worn their Marxism more lightly. Students aside, they were more likely to cite as formative political influences Erich Maria Remarque's *All Quiet on the Western Front* than *Das Kapital*. At a time when CPUSA leader Earl Browder was defining Communism as "20th-century Americanism," when the Party was effectively supporting the New Deal, the appeal of communism lay more in its practical struggle for unemployment relief, better conditions for labor, or antiracism, than in the promise of the future communist society.

Communists were above all activists. African-American Thomas Page spoke for many when he recalled that "as I understood events in that particular era, it was the Communist Party which did anything. Everyone else just talked." [17] It was this activism that impressed Bill Bailey down at the harbor, and which was a defining trait of himself and so many other Lincolns. In Brownsville, Williamsburg, Flatbush,

Bensonhurst, the East Bronx, or Astoria, the Communists and the YCLers were the people who protested evictions, hauled the tenants' furniture back upstairs once the police had gone, and organized the best dances. They were also the people who stood on picket lines, broke up meetings of the pro-Nazi Bund, panhandled on the subway to raise money for Spain, and in 1937 and 1938 volunteered for Spain.

What Marxism did give to those in and close to the Party was a profound sense of internationalism, of the connections between the local and the global. After the shift in Moscow's interpretation of fascism in 1935, this global consciousness helped give them an acute awareness of the threat posed by the events in Europe. Volunteers' letters are full of chillingly prophetic warnings of the threat that Mussolini and Hitler posed to world peace and to progressive causes everywhere. Indeed, antifascism was the lowest common denominator among the volunteers, the cause that bound them together, and, a multitude of other personal and political factors aside, ultimately what took them to Spain. Years later Maury Colow would recall deciding to go on a rooftop in Livonia Street, "part of Brownsville where we were raised and where we had all these battles with the police. I was up there with a group of people like me. We were aware that there was a real danger of fascism in our country and Hitler was

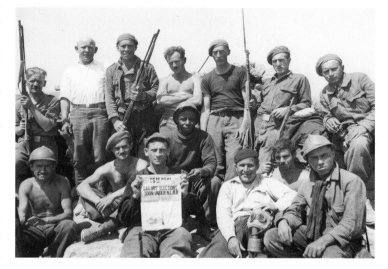

Seamen from around the world who shipped out of American ports, assembled at Jarama, Spain (site of the first battle in which Americans took part), early 1937.

gaining strength. When Spain exploded, we felt that it was the last step. That is, if Hitler could win Spain (and for us it wasn't Franco, it was always Hitler) there would be World War II. Anyway we got to talking. We knew there had been talk in the YCL, that they were recruiting. So we decided to go." [18]

Colow and his Brownsville buddies were not alone in making the decision to volunteer together. Jack Shafran and fellow Local 1250 activist Gerald Cook first tried to go together, offering their services to the Spanish Embassy in Washington. Comrades and roommates Jimmy Yates, Alonzo Watson, and Hermann Wolfowitz made the decision after a long discussion in their 12th Street loft. Bill Bailey left after receiving letters from seamen already in Spain. Evelyn Hutchins followed a number of close friends, her brother, and her husband; she recalled feelings of personal and political inconsistency knowing that others were fighting in Spain while she remained at home, a sense of guilt that was only relieved when she too left for the war. For many New Yorkers in particular, volunteering was both an individual and a collective decision, one made with friends and comrades and which could count on the approval and support of those in their wider circle. This surely helps explain why, like Colow, many veterans talk of the decision to go as natural, the only thing to do in the circumstances.

Once in Spain, for many, the common experience of war, the horror of Jarama, Brunete, Belchite, Caspe, the Great Retreats, and the Ebro forged loyalties, a shared

sense of purpose and identity among the volunteers more encompassing than anything brought from home. Nonetheless, these preexisting personal ties and networks remained important focal points of volunteers' loyalties, emotional support, and commitment. On arrival, volunteers naturally gravitated towards friends and comrades from home, their letters full of joyful encounters with familiar faces, news of the whereabouts and well-being of common acquaintances. Comparing arriving at the American training camp in Tarazona to walking into his union hall, Bill Bailey recalled, "There were all my friends: Robbie and Low-Life McCormick, Bill Howie, all these characters. You know, shaking hands. And so forth. So it was very good. I felt right back in the old fo'csle again, with a good crew. You know. You felt that nothing could happen to you as long as you were with that group...They are gonna protect you and you are gonna protect them." Bailey stayed with his friends, serving his time in Spain in what was known as the seamen's machine-gun company, a close-knit community famed for its disregard for the niceties of military hierarchy, a proud proletarian identity, and bold military prowess. Such pre-war friendships sealed in the trenches helped sustain volunteers in battle and gave rise to famous partnerships. One was formed by the diminutive Williamsburg duo Abe Smorodin and Jesse Wallach who fought together in the Canadian Mackenzie Papineau Battalion in every one of their unit's actions from Fuentes de Ebro in October 1937 to the Ebro in the summer of 1938. They were so consistently reliable in battle that their commanding officer took them off the list of those eligible for citation for bravery. [19]

The home front, the broad antifascist movement from which so many of them came, was vital too in sustaining the volunteers, materially and emotionally. The Lincolns' constant appeals for genuine American cigarettes were only outnumbered by their demands for more letters. They devoured and shared with each other news of family and friends, the "local dirt" sought by Wilfred Mendelson, "the stuff that will carry us back to the boardwalk rail or now on to the watermelon infested beach. Tell us about the boys you girls are dazzling...about the sun and the stars, the movies and ice-cream vendors." [20] They also sought details of strikes, protests, and organizational drives at home, reports on the progress of causes of which they still felt a part. This feeling of continued involvement with struggles at home, of being part of a much wider movement, allowed them to proffer advice and chide their correspondents on to greater efforts, as well as underpinning their own commitment to the fight. In this way too New York was an enduring collective presence in Spain. The ties that bound the New Yorkers to each other and to their supporters back home help explain not just why they went, but why, perhaps even more remarkably, they stayed.

Endnotes

1 Following conventional usage, and the veterans themselves, the "Lincoln Brigade" is used here to refer to all the American volunteers who served in Spain in any capacity, whether as military or medical personnel in the American Medical Bureau. There never was a military unit called the "Lincoln Brigade". The term comes from the "Abraham Lincoln Battalion," the first unit manned largely by Americans.

2 Like virtually all aspects of the International Brigades history, there is no accurate statistical information on the New York volunteers. All figures given here are based on estimates found in existing sources and studies, notably Rosenstone, Robert, *Crusade of the Left: The Lincoln Battalion in the Spanish Civil War* (New York, Pegasus, 1969) and Carroll, Peter, *The Odyssey of the Abraham Lincoln Brigade: Americans in the Spanish Civil War* (Stanford, Stanford University Press, 1994). Essential reading too is Nelson, Cary and Jefferson Hendricks (eds.), *Madrid 1937: Letters of the Abraham Lincoln Brigade from the Spanish Civil War* (New York, Routledge, 1996).

3 Carroll, *The Odyssey of the Abraham Lincoln Brigde*, 79.

4 Bailey, Bill, *The Kid from Hoboken: An autobiography* (San. Francisco, Bill Bailey, 1993); Rosenstone, *Crusade of the Left*, 101–102.

5 Rowe, Jason, "From The Picket Line to the Front Line: The New York City Department Store Workers' Union and the Fight for Spain" (unpublished paper, 2005).

6 Prago, "Jews in the International Brigades in Spain," *Jewish Currents* reprint (Feb 1979), 4–6, 16–17, cited in Gerassi, *The Premature Antifascists: North American Volunteers in the Spanish Civil War 1936–1939, An Oral History* (New York, Praeger, 1986), 3–4; Carroll, *The Odyssey of the Abraham Lincoln Brigade*, 17.

7 Carroll, *The Odyssey of the Abraham Lincoln Brigade*, 17.

8 Wenger, Beth S., *New York Jews and the Great Depression: Uncertain Promise* (New Haven, Yale University Press, 1996), 84–85.

9 *The WPA Guide to New York City* (New York, Pantheon Books, 1982; first ed. 1939), 498–500.

10 Gerassi, *The Premature Antifascists*, 25.

11 Chea, Nancy, "The City College of New York Volunteers in the Lincoln Brigade. From Global Activists to Local heroes" (unpublished paper, 2005); Davison, Melissa, "From Campus to Combat: New York University Students in the Spanish Civil War" (unpublished paper, 2005).

12 On the African-American volunteers, see Collum, Danny Duncan (ed.) *African Americans in the Spanish Civil War: "This Ain't Ethiopia, But It'll Do"* (New York, G.K. Hall & Co, 1992).

13 Yates, James, *Mississippi to Madrid: Memoir of a Black American in the Abraham Lincoln Brigade* (Greenboro, NC, Open Hand Publishing, 1989), 97.

14 Collum (ed.), *African Americans in the Spanish Civil War*, 82.

15 Hunt, Sarah, "New York City Nurses Who Volunteered in Spain" (unpublished paper, 2005), 13.

16 On the political breakdown of the Lincolns and the proportion of Communist volunteers, see Rosenstone, Crusade of the Left, 112–13; Carroll, *The Odyssey of the Abraham Lincoln Brigade*, 19; Gerassi, *The Premature Antifascists*, 11.

17 Collum (ed.), African Americans in the Spanish Civil War, 88.

18 Gerrasi, *The Premature Antifascists*, 48.

19 Rolfe, Edwin, *The Lincoln Battalion*, (New York, Veterans of the Abraham Lincoln Brigade, 1939), 12.

20 Letter dated July 17, 1938, quoted in Rosenstone, *Crusade of the Left*, 224.

NUEVA YORK:

THE SPANISH-SPEAKING
COMMUNITY RESPONDS

BY JAMES D. FERNANDEZ

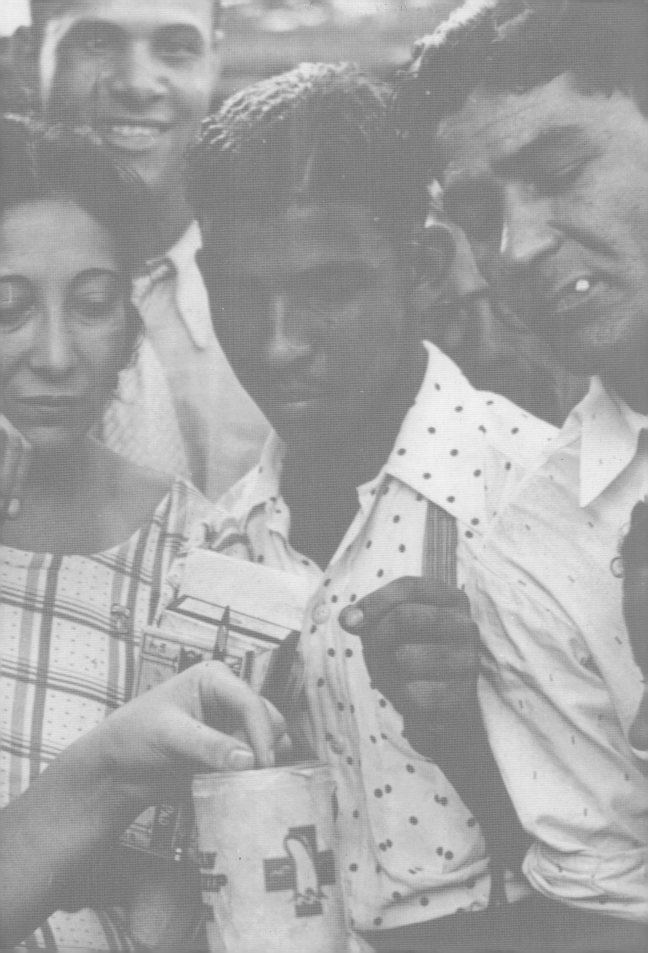

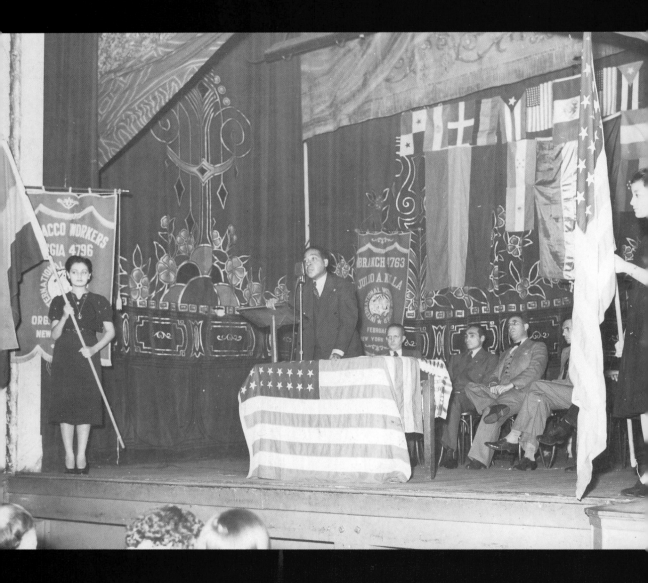

Collecting change in Spanish Harlem for the Relief Ship for Spain, ca. 1938.

Labor organizer and Puerto Rican activist Jesús Colón speaks about Spain to members of the IWO's Spanish Section during an event at the Park Palace, October 1938.

N THE EVENING OF JULY 28, 1938, after putting her two young boys to bed, Mary Bessie looked down to the street from her walkup apartment at 25 State Street in Brooklyn Heights. What immediately caught her eye on the sidewalk below was the huge headline of a paper on a newsstand: "LEALES EN GANDESA." The headline, referring to the advance of Loyalist troops on a fascist-controlled town in Catalonia, was of particular interest to this young mother, and she knew enough Spanish to decipher it. Her husband Alvah, a volunteer in the Abraham Lincoln Brigade, was at that very moment taking part in the battle for Gandesa. But of course the headline in this Spanish-language daily was not addressed primarily to readers like Mary Bessie, but rather to the members of the significant—and growing—community of Spanish speakers in the city. [1]

Ironically, the involvement of Hispanic New Yorkers in the Spanish Civil War is a rather neglected topic. Though Hispanic surnames are prominent on the list of volunteers in the Abraham Lincoln Brigade (perhaps as many as 10 percent), surprisingly little is known about this group; we know more about the motives and activities of Jewish or African-American brigadistas, for example. But the prominent visibility of these three Spanish words on that Brooklyn street provokes a number of questions: Who were the Spanish-speaking and Spanish-reading New Yorkers in the late 1930s? How did they perceive, and react to, events in Spain? How did the war in Spain—and, more broadly, the antifascist movement—affect and even shape Spanish-language communities in the city? To begin to outline answers to these questions, let's open up a copy of that issue of *La Voz: Diario Democrático Avanzado* from July 28, 1938, and have a look inside. [2]

★

While there had been a small but visible Hispanic presence in New York throughout the 19th century—businessmen, political exiles, and workers among others—it was the aftermath of the Spanish-Cuban-American War (1895–1898) that changed the scale of that

presence. U.S. control of Cuba and Puerto Rico (beginning in 1898) and the granting of citizenship to Puerto Ricans (in 1917) were important milestones in the history of Latino migration to the United States. By 1938, approximately 200,000 speakers of Spanish were living in New York City.

The author of *New York Panorama* (1938) mentions four "Spanish-speaking districts or barrios" in the city: East Harlem, Washington Heights, the Brooklyn waterfront (from Red Hook to Brooklyn Heights), and the area by the Manhattan foot of the Brooklyn Bridge (around Cherry and Roosevelt Streets). Though the generic term "Spanish" was often used to refer to all Spanish speakers regardless of their country of origin, in fact, Spanish-speaking New Yorkers formed a heterogeneous group in the late 1930s, as they do today. This diversity is duly reflected in the pages of the city's two Spanish-language dailies of the time, *La Prensa* and *La Voz*—the paper whose headline Mary Bessie noticed on that hot Brooklyn night. In both of these papers, a news report from Puerto Rico might appear alongside an item about politics in Cuba, or beside an update from the war in Spain. At the time, Puerto Ricans represented the largest and fastest-growing group of Spanish speakers in the city by far; Cubans were the next largest group; in the late 1930s, there may have been about 25,000 Spaniards in New York City. [3]

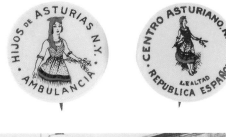

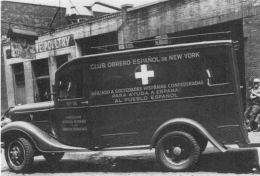

TOP
Pins from the Asturian Cultural Center in New York illustrate its efforts on behalf of Republican Spain.

BOTTOM
Ambulance donated to Spain by East Harlem's Club Obrero Español, ca. 1938.

But it would be a mistake to imagine that these groups were neatly segmented and compartmentalized, or to imagine that these papers provided news from Puerto Rico for Puerto Ricans, from Spain for Spaniards, etc. In fact, what one can see clearly even on the pages of this single issue of *La Voz* are the multiple affiliations of each one of the city's Spanish speakers, who are simultaneously New Yorkers, hispanos (the term apparently favored at the time for referring to people of Hispanic heritage living in New York), natives of this or that Spanish-speaking country, and citizens of the world. The reader of *La Voz* on July 28, 1938 was presumably interested in the spectacular suicide of John W. Ward (who the day before jumped off the cornice of the 17-storey Gotham Hotel) and the score of the Yankees game (7–5 over St. Louis); the announced divorce of Lupe Vélez and Johnny Weismuller; as well as the implementation of the Chaco Peace Treaty between Bolivia and Paraguay; the hopes for an armistice between Japan and China; the "wave of terror in Palestine;" and, of course, the rise of fascism in Europe.

Even before the 1930s, the different components of the city's Spanish-speaking community had lived in close contact: in the *barrios*, in the trades (cigarmaking and construction in particular), on the waterfront, in the restaurant business, in union halls, and in neighborhood cultural and social organizations. Moreover, many of the Spaniards residing in the city had come to New York after significant stints in either Cuba or Puerto Rico. Three features of our July 28, 1938 issue of *La Voz* stand out because they neatly illustrate this commingling and show how the Spanish Civil War may well have accelerated the formation of a distinctive New York Latino identity. These sections in the paper exemplify how the war in Spain came to influence some of the most intimate aspects of the daily lives of these New Yorkers: their vacations, their leisure activities, and their civic/social associations. It would seem that this "civil war" raging 3,000 miles away was lived with palpable immediacy by many of the city's hispanos.

First, this issue of *La Voz* features several advertisements for "Las Villas," which were boarding houses or hotels in the Catskills area of the Hudson valley catering to the city's Hispanic population. Ranging from small working farms that, to supplement their income, took in summer boarders, to full-scale resorts, these "villas" offered Spanish and Latin American cuisine to their guests ("cocina a la española y criolla"), who, like the city's other ethnic groups, sought fresh food, clean air, and refuge from the city's summer heat. But these vacation spots were by no means escapes from the political commitments and activism of the city's Spanish speakers. Our issue of *La Voz* congratulates and thanks the New York City day visitors of "Villa Asturias" who, during their excursion to the countryside, participated in a fundraising raffle for Spain—the prize was a live lamb donated by a local farmer! And just a few days earlier, on July 23, a number of the larger villas (Villa Nueva, Villa García, Villa Madrid, Villa Rodríguez, and El Cortijo) had joined with the Friends of the Abraham Lincoln Brigade to organize a Spanish Fiesta in Plattekill. An assembly of 350 vacationers was addressed by Lini Fuhr, one of the first American nurses to volunteer to go to Spain; the film *Heart of Spain* was viewed; and $275 was collected to aid the Loyalist wounded.

La Voz also conscientiously covered the programming at the three Spanish-language theaters/cinemas in Manhattan—the Hispano, the Granada, and the Latino— which were important gathering spots for most of the city's Spanish speakers throughout the 1930s. These venues offered a mix of live theater, film screenings, and other diversions; our July 28 issue of *La Voz* reviewed a wrestling match between a Basque and a Russian that had taken place a few days before at the Teatro Hispano. The films screened were a mix of the commercial fare of Spanish, Mexican, and Argentine cinema, with an occasional movie from the nascent U.S.-based Spanish-language film industry. These theaters—and others in the city, like the Cameo on 42nd Street—would also feature documentaries about the war in Spain. The taut ideological climate of the summer of 1938 can be gauged by a curious event reported in *La Voz*, *La Prensa*, and *The New York Times*: when the Teatro Hispano announced the premiere of *Morena Clara*, a film starring the Spanish actress Imperio Argentina, pro-Loyalist New Yorkers picketed the theater because the star was known to be a supporter of Franco. The management's argument—that the film had been made during the Spanish Republic by a production company loyal to the country's elected government—failed to persuade the picketers, who forced the theater to withdraw the film from the program.

For our purposes the most telling page of *La Voz* from July 28, 1938 is the section titled "Sociedades al día." A daily feature of the paper, this section announced and reviewed the

TOP
Members of the IWO's Spanish Section march in an antifascist parade in New York, ca. 1938.

BOTTOM
Certificate sent from the city of Valencia to the Confederated Spanish Societies in New York commemorating their efforts on behalf of the Republic, September 1938.

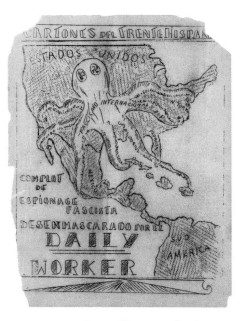

Illustration from *Frente Hispano* on fascist spy activity in the Americas, May 15, 1937.

activities of dozens of civic organizations—mutual aid societies, social clubs, and workers' groups—that had been formed by the city's Spanish-speaking communities. The number and diversity of these associations is astounding: on the pages of *La Voz* one can follow the activities of, for example, the Club Cubano Julio Antonio Mella in Washington Heights; the Grupo Antifascista del Bronx; Brooklyn's Grupo Salmerón; the Sociedad Naturista, which founded the Spanish Camps on Staten Island; or the Frente Popular Español de Queens. There are clubs made up of emigrants from several of the regions of Spain—Andalucía, Asturias, the Basque Country, Catalonia, and Galicia—as well as from a number of Latin American countries, most prominently Puerto Rico and Cuba. While some of these groups were formed in response to the Spanish Civil War, many others were not; it is remarkable to see how the Spanish Civil War came to color and shape the activities of virtually all of these bodies. After 1936, the picnics, soccer matches, excursions to the countryside, dances, raffles, and social events of these groups became invariably linked to the struggle against fascism and the desire to help Spain's Loyalist forces. On that single day, July 28, 1938, we learn of a Cuban club based in Manhattan celebrating a farewell party for a Spanish woman, Ernestina González, who was about to return to Spain after a fundraising trip to New York; of the José Díaz Branch of the Communist Party of the Bronx screening a film about Spain; and of the Ateneo Hispano of Brooklyn finishing its plans for a major fundraising picnic/fiesta to be held later that week in Ulmer Park in the Bath Beach section of Brooklyn.

During the war, most of these local associations banded together to form an umbrella organization called the Sociedades Hispanas Confederadas de Ayuda a España. This New York-based national pan-Hispanic confederation intensified the collaborations among the diverse, smaller groups and helped organize several major events, such as the July 19, 1937 rally in Madison Square Garden, attended by over 20,000. The amount of money raised during the course of the war in support of Republican Spain by the Sociedades Confederadas was second only to the Medical Bureau and North American Committee to Aid Spanish Democracy.

★

La Voz was a paper deeply sympathetic to the cause of the Spanish Republic; it would be a mistake to consider a single issue of a single newspaper as an impartial representation of the city's Spanish-speaking communities. There were also pro-Franco Hispanics in the city during the war; the Casa de España, with headquarters in the Park Central Hotel, was their primary organization. Among the founding members of the Casa de España were the Spaniards Ramón Castroviejo, a distinguished eye surgeon at Columbia-Presbyterian Hospital (who would carry out the first successful human cornea transplant), and Benito Collada, owner of El Chico nightclub on Grove Street in the Village (who would help popularize the "rumba" in the New York music scene). Other pro-Franco supporters were drawn from the worlds of business, journalism, and shipping, and included people from Puerto

Rico and Latin America. Nonetheless, even though at its peak the Casa de España might have had several hundred members, its leaders would at times complain bitterly about how the vast majority of Latinos in the city were pro-Republican: "we can count the real supporters of our movement on the fingers of two hands," was how Dr. Castroviejo would put it. [4]

Hispanos in New York City have always lived in relatively close contact, in part because of linguistic and cultural ties. In the late 1930s, a powerful new link among many of these heterogeneous groups was forged: a deep concern over the rise of fascism. Though there was support for the fascist insurgents among some New York Hispanics, by and large, the city's Spanish speakers mobilized en masse and across national lines in support of the Loyalist forces in Spain. During this period, older ties among different Latino groups in the city were reinforced, and new alliances were formed, among Latino groups and between those groups and other segments of New York's ethnic-based progressive civil society. As is clear from even this brief overview of a single issue of that single newspaper gleaned by Mary Bessie on that Brooklyn newsstand, many New York Hispanics were deeply involved in the city's antifascist movement and, interestingly, it would seem that 1930s antifascism played an important and enduring—if often overlooked—role in the evolution of the Spanish-speaking communities in the city. By way of example: In 1946, a group of Puerto Rican nationalists in New York would establish a weekly journal titled *Liberación*. The publication's founding editor would be Aurelio Pérez, a veteran of the Abraham Lincoln Brigade, and its masthead would read: "Por la libertad de España, Puerto Rico, y demás países oprimidos"—"supporting the liberty of Spain, Puerto Rico, and other oppressed countries." But that is another story, another paper on another newsstand, waiting to be opened.

Endnotes

1 I would like to thank Tom Bender, Arlene Dávila, Gail Malmgreen, and Mike Wallace for their helpful comments on drafts of this essay, and Lacey Sugarman for her exemplary work as research assistant. NYU's Council on the Humanities has generously supported my work on Spain in New York City. The Mary Bessie anecdote is drawn from a letter she wrote to her husband in Spain, which is published in *Alvah Bessie's Spanish Civil War Notebooks*, edited by Dan Bessie (Lexington: University of Kentucky, 2002).

2 The full run of *La Voz* (1937–39) can be found on microfilm at the main branch of the New York Public Library.

3 *New York Panorama*, a Federal Writers Project initiative, contained essays with photographic illustrations (New York: 1938).

4 For more information on pro-Franco activities in New York, see Chapter Ten ("The Falange in the United States") of *Falange: The Secret Axis Army in the Americas* by Alan Chase (New York: Putnam, 1943), and "Proyección de la Falange en los Estados Unidos (1936–39)" by Francisco A. Blanco, in the webzine "Rastroria": http://www.rumbos.net/rastroria/rastroria01/falangeusan1.htm.

PRO-FRANCO SENTIMENT AND ACTIVITY IN NEW YORK CITY

BY PATRICK J. McNAMARA

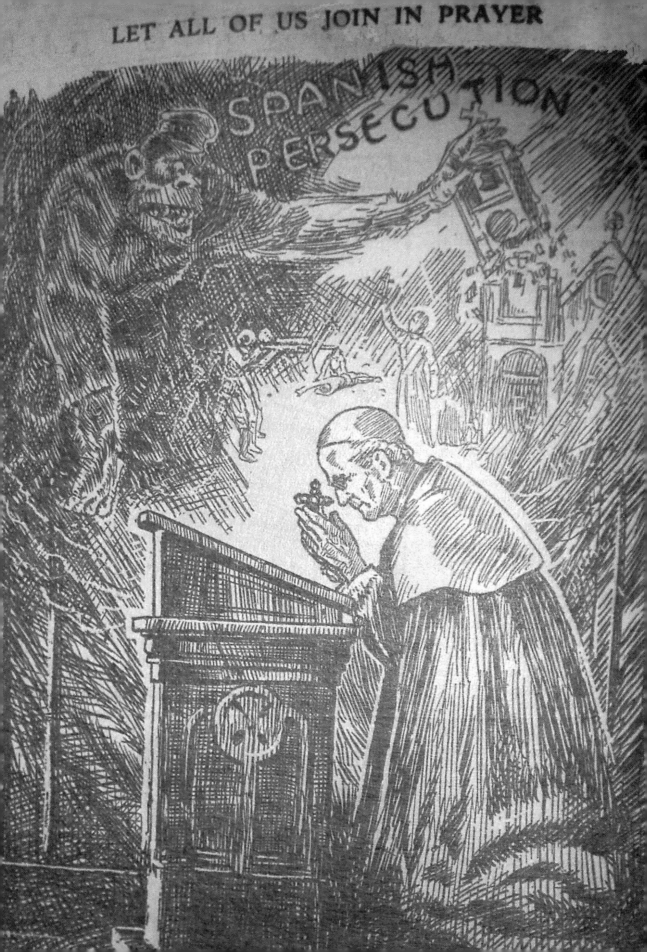

I

N NEW YORK, THE SPANISH Civil War exacerbated long-standing tensions between the city's Catholic and Jewish communities. For both groups, Spain represented the fight against an ideology that threatened their very existence. [1] For Jewish New Yorkers, that threat was the spread of fascism, whereas for their Catholic neighbors it was an anticlerical leftist government helping to further the march of world Communism. [2] By 1936, everyone agreed that totalitarianism was a menace that no one could safely ignore, but New York's two largest religious bodies were diametrically opposed as to which version was less ignorable.

New York's pro-Franco movement was not an exclusively Catholic affair. In that pre-ecumenical era, Protestant, Jewish, and Catholic anticommunists joined together at anti-Loyalist rallies, boycotted pro-Loyalist businesses, and opposed political candidates who favored the Spanish Republicans. [3] Nor were all Catholics equally enthusiastic for Franco. Dorothy Day, the pacifist founder of the Catholic Worker Movement, and George N. Shuster, editor of *Commonweal*, an independent lay Catholic journal, argued that neither side could be fully endorsed in good conscience. [4] Still, Catholics did take a leading role in the city's pro-Franco movement right from the start. In his history of American anticommunism, Richard Gid Powers notes that the "American Roman Catholic Church would be the backbone of American anticommunism for most of the movement's history." [5]

In July 1936, a few days after war broke out in Spain, Father Francis X. Talbot, S.J., editor of the Jesuit magazine *America*, called a meeting in Manhattan that was attended by the city's Catholic journalists, the purpose of which was to determine a common editorial position on Spain. Present at the meeting was a member of

PREVIOUS SPREAD
Father Charles Coughlin, 1938 (detail).

OPPOSITE
"Let All of Us Join in Prayer." Drawing published in the Brooklyn Tablet, July 1936.

General Francisco Franco's *junta*. For Talbot, the war was a fight against "the anti-Christian propaganda and practices of the Loyalist government, composed as it is of Communists, anarchists, syndicalists, and atheistic groups in Spain." In the event of a victory, Talbot warned his readers, the Loyalists "would not stop until the whole of Spain were Sovietized." Talbot justified his position by arguing that "collaboration with Fascism is possible for the Catholic Church; a collaboration with Communism is absolutely impossible for the Catholic Church." [6]

Across the river in Brooklyn, Patrick F. Scanlan played a leading role in stirring up pro-Franco sentiment and activity in New York. Editor of the *Tablet*, the Diocese of Brooklyn's official organ, Scanlan was the foremost anticommunist in the American Catholic press for over half a century. During his 51-year editorship (1917–1968), the paper achieved a nationwide circulation, due mainly to Scanlan's unequivocal stances on the various issues of the day, religious and political. Never one to shy away from controversy, Scanlan was a staunch supporter of Father Charles E. Coughlin (and later of Senator Joseph McCarthy), a wary critic of the New Deal, and an unabashed foe of modernity inside and outside the Catholic Church. [7]

Right from its founding, Scanlan expressed his dislike for the Spanish Republic, which he labeled "a villainous anti-Catholic government." [8] During the war years, scarcely a week passed without at least one article relating the latest Loyalist atrocities: the execution of priests and nuns, the destruction of churches, and the general disestablishment of the once-powerful Spanish Church. Prominently featured editorial cartoons reinforced this theme. A July 1936 drawing titled "Let All of Us Join in

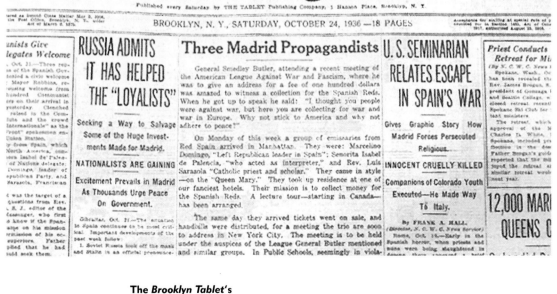

The *Brooklyn Tablet*'s
October 24, 1936
front page featured
three prominent stories
on Spain.

Prayer" featured a bishop kneeling while a King Kong-like gorilla labeled "Spanish Persecution" rips the steeple off a church and a priest defiantly waves a crucifix in front of his firing squad. [9] For Scanlan, the war assumed an apocalyptic dimension, as a "fight between the pagan and Christian philosophies of life." [10]

The *Tablet*'s "Reader's Forum" regularly featured letters from anti-Loyalist watchdogs relaying which unions were raising funds for the Loyalists, which radio programs were endorsing the Republicans, and which school teachers were criticizing Franco. Scanlan encouraged the readers to action. The *Tablet* even established its own Spanish Relief Fund that raised $40,000 for the Nationalists. Scanlan encouraged his readers to oppose the lifting of the embargo and was apparently quite successful. A January 1939 survey found that in 24 of the Brooklyn Diocese's 25 largest parishes, priests preached from the pulpit against the embargo repeal, literature for a "Keep the Spanish Embargo Committee" was distributed in the parish, and anti-repeal petitions were circulated among parishioners. [11]

Father Charles Coughlin, 1938.

Father Edward Lodge Curran, President of the International Catholic Truth Society (ICTS), was a Brooklyn priest and close friend of Scanlan who also took a prominent role in New York's pro-Franco movement. Known as the "Father Coughlin of the East," Curran was a frequent speaker at anticommunist rallies nationwide. Through the ICTS, he published several pro-Franco pamphlets that were widely distributed. If anything, Curran was even more lavish in his praise of Franco, insisting that the *Generalissimo* offered, "peace and love and forgiveness to those who, deceived by Russian propaganda, are at present against him." The Loyalists, he wrote, "hate religion. Therefore, they outrage nuns, murder bishops and priests, and burn inoffensive Church buildings. Communism is the enemy of religion. The Loyalists are dominated by Communists." The Nationalist cause, he insisted, was the "cause of all opposed to the godlessness, the immorality, the tyranny, the brutality, the bigotry, the dictatorship of Communism." [12]

For both Scanlan and Curran, the Spanish Civil War was a sore spot. They resented what they regarded as the secular press's misrepresentation of the war. Scanlan was particularly critical of what he considered a lack of Jewish concern for the plight of the Catholic Church in Spain, as well as Jewish support for the Loyalists. In March 1937, he wrote: "It is rather galling to find vociferous and misrepresentative Hebrews championing... Caballero while they denounce Hitler." [13] In one front-page editorial he asked "why it is so infamous to restrict certain liberties of 600,000 Jews in Germany and not at all obnoxious to hold in slavery millions of other people in... Spain." After Albert Einstein endorsed a pro-Loyalist rally,

Is This Democracy?

General Francisco Franco has put an end to "democracy" in Spain. He has put to flight the Communist hypocrites who caused the death of more than a million persons in an effort to tie Spain to the anti-Christian bull-wheel of Moscow.

No longer will Spanish "democrats" burn churches, tie nuns together in kerosene-soaked pits, massacre bishops, priests and ministers, mow down hundreds of thousands of innocent men, women and children just because they were Christians.

No longer need the American columnists, kept newspapers, paid Red agitators, Washington internationalists weep for "Spanish democracy," for it is now only a dark, red spot in history.

But, remember, Mr. and Mrs. American, the battle for "democracy" is not over. The same elements who gloried at the murder of Christians in Spain are now working overtime to bring the same sort of "democracy" to America. The United States is their last stand.

Beware the word "democratic" in its new meaning. Instead of standing for liberty, its purport is physical and spiritual death.

———

One Hundred Thousand Dollars are needed to carry Father Coughlin's weekly broadcasts through the summer months. THAT SUM IS NEEDED WITHIN THE NEXT FEW WEEKS—or summer broadcasting cannot be assured. In order to keep his contracts with his privately formed chain of stations (after the subversively inclined national networks barred him) Father Coughlin MUST broadcast every Sunday of this year.

As a reader of SOCIAL JUSTICE and believer in the principles for which Father Coughlin is fighting, YOUR FINANCIAL HELP IS NEEDED NOW. Whether you can afford $1, $2, $3, $5 or $10, $20, $50 or $100, your aid is sorely needed.

Remember—Father Coughlin has NO BACKERS except his millions of friends and radio listeners. SOCIAL JUSTICE is absolutely devoid of advertising revenue, and is, therefore, devoid of advertising control. Many excellent accounts have been turned down in order to preserve this freedom. For this reason, Father Coughlin and SOCIAL JUSTICE can tell you the TRUTH.

Father Coughlin's broadcasts belong to YOU. They are your medium of FACTS about America.

WILL YOU HELP YOURSELF TO MORE TRUTH?

SOCIAL JUSTICE PUBLISHING CO., INC.
Royal Oak, Michigan.

I wish to contribute to the 1939 Summer Broadcasting Fund so that Father Coughlin may continue to spread principles of genuine Americanism.

I hereby pledge the sum of $_____ which I am enclosing herewith or which I will send in two equal monthly remittances on or before April 15 and on or before May 15.

My Name Is _____

My Address Is _____

City or Town _____ State _____

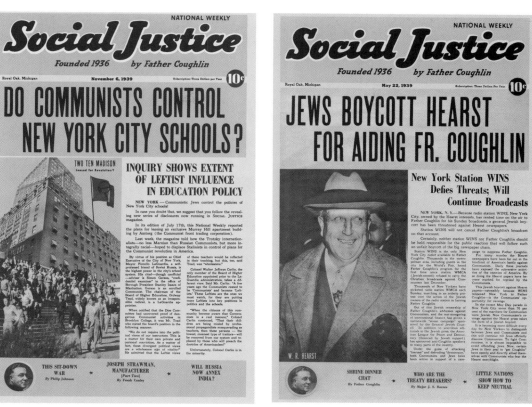
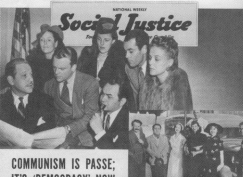

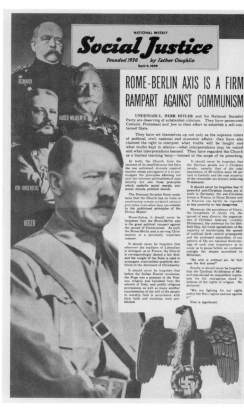

Scanlan suggested that he return to Germany, "where persecution might again impress him with its heinousness." Scanlan's comment in July 1939 that the real issue in Spain was "anti-Christianity and not anti-Semitism, which scarcely exists," led the Brooklyn *Jewish Examiner* to label him "America's number one Jew-baiter." [14]

In his classic study of Depression-era New York City, *Neighbors in Conflict*, Ronald Bayor notes that while the *Tablet* was "ostensibly a Catholic newspaper, it actually represented a mainly Irish viewpoint." Scanlan represented the feelings of many of his fellow Irish Catholic New Yorkers who felt that the city's Jewish community was not as hard hit by the Depression as the Irish were. Bayor correctly notes that the anticommunist movement was a way to settle longtime ethnic rivalries. [15] Catholic historian James T. Fisher correctly notes that Scanlan's anticommunism was fueled by an "absolute obsession with Catholic-Jewish conflict" in 1930s New York. [16]

DO NOT ATTEND THIS GARDEN MEETING

This is a Fascist Rally

Money raised here will buy Bombs to kill Women & Children of Spain.

Friends of Spain - Washington Heights Section

Although the majority of Irish New Yorkers had arrived in the middle-to-late 19th century, by the 1930s many of them still lived in the lower middle-class level. On the other hand, Jewish immigrants and their children attained a comparable, if not higher, status in a much shorter period of time. This advancement was evident at the economic, and to some extent, the social level. David O'Brien writes that the lingering resentments and resulting tensions "were felt for years and came to the fore in the thirties." Both Scanlan and Curran would become ardent supporters of Father Charles Coughlin's Christian Front movement in New York during the years 1938–1940. [17]

In the years following the war, Scanlan continued to maintain a pro-Franco stance. He called for a change in American foreign policy toward Franco. In 1946, the *Tablet* printed a pro-Franco pamphlet titled *Facts About Spain*, written by the Catholic historian William T. Walsh, which sold 80,000 copies. In 1949, when Dr. Bryn Hovde, President of the New School for Social Research, was nominated for the Presidency of Queens College, Scanlan led a successful campaign against him, citing Hovde's earlier pro-Loyalist stance as grounds for his disqualification. [18] On Columbus Day in 1951, the Spanish government made Patrick F. Scanlan a Knight Commander of the Order of Isabella the Catholic. Until his death in 1983, Scanlan never rescinded his support for the Franco regime. [19]

PREVIOUS SPREAD
Father Coughlin's *Social Justice* frequently discussed Communism and occasionally focused on Spain. Clockwise from left page: issues from April, May, November 1939.

ABOVE
Flyer distributed by Communists outside a May 19, 1937 meeting of the pro-Franco American Committee for Spanish Relief at Madison Square Garden.

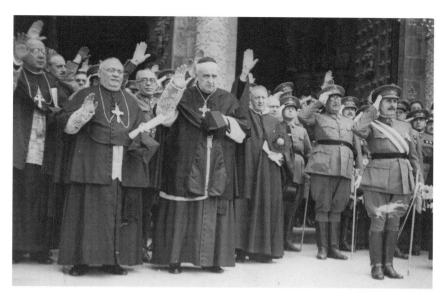

**Church officials
and generals in Spain,
ca. 1939.**

Endnotes

1 For the Jewish response see Robert
 Singerman, "American-Jewish Reactions
 to the Spanish Civil War," *Journal of Church
 and State* Vol. 19, No. 2 (Spring 1977),
 268–269, 272.

2 For the Catholic assessment of Spain
 see Robert M. Darrow, "Catholic Political
 Power: A Study of the Activities of the
 American Catholic Church on Behalf of
 Franco During the Spanish Civil War,
 1936–1939" (Ph.D. dissertation, Columbia
 University, 1953); J. David Valaik,
 "In the Days Before Ecumenism: American
 Catholics, Anti-Semitism, and the Spanish
 Civil War," *Journal of Church and State* 13
 (Autumn 1971), 465–477.

3 On American Jewish anticommunism
 during the Spanish Civil War see Richard
 Gid Powers, *Not Without Honor: The History
 of American Anticommunism* (New York:
 The Free Press, 1995), 137–39.

4 For Catholic opposition to the war see
 J. David Valaik, "American Catholic
 Dissenters and the Spanish Civil War,"
 Catholic Historical Review, Vol. LIII, No. 1
 (January 1968), 540–543.

5 Powers, *Not Without Honor*, 51.

6 José M. Sánchez, "The Spanish Civil War
 and American Catholics," in Michael
 Glazier and Thomas J. Shelley, eds., *The
 Encyclopedia of American Catholic History*
 (Collegeville: The Liturgical Press, 1997),
 1346; F. Jay Taylor, *The United States and the
 Spanish Civil War* (New York: Bookman
 Associates, 1956), 61; Rodger Van Allen,
 *The Commonweal and American Catholicism:
 The Magazine, the Movement, the Meaning*
 (Philadelphia: Fortress Press, 1974), 61;
 Valaik, "American Catholic Disssenters,"
 539; David J. O'Brien, *Public Catholicism*
 (New York: Macmillan, 1989), 181.

7 The most complete treatment of Scanlan
 is Patrick J. McNamara, "A Study of the
 Editorial Policy of the Brooklyn Tablet
 Under Patrick F. Scanlan,
 1917–1968" (M.A. thesis, St. John's
 University, 1994). See also Joseph W. Coen,
 Patrick J. McNamara, and Peter I. Vaccari,
 *Diocese of Immigrants: The Brooklyn Catholic
 Experience, 1853–2003* (Strasbourg: Éditions
 du Signe, 2004), 99–101.

8 *Tablet*, August 17, 1932, 6.

9 This illustration is reproduced in *Diocese of
 Immigrants*, 100.

10 *Tablet*, August 15, 1936, 1. See also *Tablet*,
 August 22, 1937, 11.

11 For the survey see Darrow, "Catholic
 Political Power," 212.

12 Edward Lodge Curran, *Franco: Who is
 He, What Does He Fight For?* (Brooklyn:
 International Catholic Truth Society, 1937),
 44; 7–8; Edward Lodge Curran, *Spain in
 Arms* (Brooklyn: International Catholic
 Truth Society, 1936), 3–4.

13 *Tablet*, March 13, 1937, 2, quoted in Valaik,
 "In the Days Before Ecumenism," 470.

14 *Tablet*, July 8, 1939, 9; July 17, 1939, 2. See also
 Ronald H. Bayor, *Neighbors in Conflict: The
 Irish, Germans, Jews and Italians of New York
 City, 1929-1941* (Second Edition) (Urbana:
 University of Illinois Press, 1986), 105;
 Valaik, "In the Days Before Ecumenism,"
 472.

15 Bayor, *Neighbors in Conflict*, 92.

16 James T. Fisher, *The Catholic Counterculture
 in America, 1933–1962* (Chapel Hill:
 University of North Carolina Press, 1989),
 85–86.

17 David J. O'Brien, "American Catholics and
 Anti-Semitism in the 1930's," *Catholic World*
 204, (February 1967), 275.

18 McNamara, "A Study of the Editorial
 Policy," 106–107; Darrow, "Catholic
 Political Power," 212.

19 Alden V. Brown, *The Tablet: The First Seventy-
 Five Years* (Brooklyn: The Tablet Publishing
 Co., 1983), 33; Powers, *Not Without Honor*,
 134.

NEW YORK VISUAL ARTISTS

AND THE

SPANISH CIVIL WAR

BY HELEN LANGA

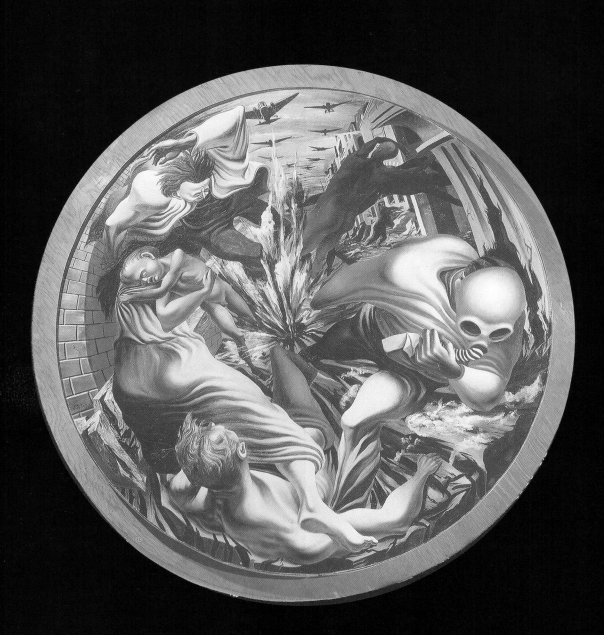

Untitled (peasant militia),
Eitaro Ishigaki, oil painting,
as reproduced in *New Masses*,
December 15, 1936 (detail).

Bombardment, 1937-38,
Philip Guston, oil on canvas.

NEW YORK VISUAL artists with leftist sympathies strongly supported efforts to preserve Spain's democratic government when it came under attack by Franco's troops in 1936; they continued to agitate for its survival and for an end to America's embargo on military assistance to the embattled Spanish defenders through fundraising campaigns, exhibitions, and potent visual images until the Republican government surrendered in 1939. The energy to undertake such activism was generated by their recent successes in gaining federal work-relief for artists through the establishment of the Works Progress Administration's Federal Art Project (WPA-FAP) in 1935, and in developing several militant organizations to demand fair treatment for these new federal workers and to promote democracy and artists' rights in the larger society.

The national Artists' Union (AU) was formed in New York in 1935 by the same artists who agitated to gain work-relief programs and then found employment on the WPA-FAP. Along with efforts to institute permanent federal support for the arts and more secure conditions for federal artist-workers, Union members discussed current politics and rallied to support Republican Spain. The Artists' Union raised funds to send two fully equipped ambulances, with its logo emblazoned on their sides, to the American base hospital outside Madrid.[1] Thirty-five national AU members went to Spain as fighters, translators, drivers, and nurses, and more than half were killed; among the New York contingent were Paul Block, who died in Spain in 1937, and Phil Bard, Mildred Rackley, and Joseph Vogel, who all returned to continue organizing and making art.[2] Bard was sent back to America after an incipient heart attack. Rackley worked as a secretary-translator for Dr. Edward K. Barsky, head of the American Medical Bureau, and as a hospital administrator; on her return to New York, she was elected the only woman vice-president of the Artists' Union in 1938.[3] Vogel, like many other leftists, went on his own initiative (most likely with Communist Party clearance) and was circumspect later in discussing his experiences with interviewers.[4] The Artists' Union produced its own newspaper, *Art Front*, which published news, essays, and photographs from the Spanish front; this became a significant source of information for artists who wanted to make art that addressed the war's heroism and suffering.

A second important national artists' organization that took up the Spanish cause was the American Artists Congress (AAC), founded in 1935 by leftist activists. This group represented artists with a wide range of professional stances and political views, but antifascism, opposition to American racism, and support for Spain were high on its activist agenda. The Congress held four annual meetings with concurrent exhibitions between 1936 and 1940, and produced several additional art shows, two of which specifically addressed themes connected to the Spanish Civil War. The first, titled "To Aid Democracy in Spain," was held in October 1936 and the second, "In Defense of World Democracy: Dedicated to the Peoples of Spain and China," took place in December 1937. [5] The latter included 127 works by American artists, as well as etchings by Pablo Picasso from his series "The Dreams and Lies of General Franco," and antifascist drawings by schoolchildren in Madrid. [6]

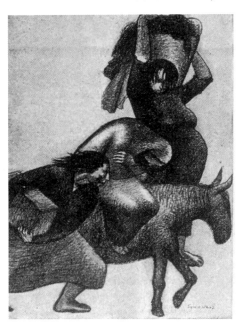

FIGURE 2
Untitled (peasant women refugees), Sylvia Wald, drawing, as reproduced in *New Masses*, September 14, 1937.

Although many works listed in the catalog for this show are lost or unlocated, their titles, such as *Bombing Terror*, *Burial of a Spanish Volunteer*, *Rape of Spain*, *Defending Fallen Loyalists*, and *Spanish Refugee*, give a sense of the artists' interests. These themes appeared repeatedly in images created by leftist artists throughout the war's duration. It is unclear whether the work by Philip Guston titled *Bombardment* is the painting shown here (1937–38, Figure 1), or an earlier study; in either case, it must have been one of the most stunning and powerful works in the show. Guston centered his image on an explosion that hurls the bodies of adults and children forward and backward into space as if they will land at the viewer's feet or as if we ourselves will be sucked into its violence. [7] The figures whirl in terrifying chaos while more airplanes appear ominously in the sky overhead, dramatizing the visceral intensity of a war that many leftists feared would lead inevitably to a wider international conflagration.

The American Artists' Congress also helped the (U.S.-based) Spanish Refugee Relief Committee to bring Picasso's painting *Guernica* to New York as a fundraising exhibition. First seen by the public at the Spanish Pavilion at the Paris World's Fair in 1937, the enormous painting (11 x 25') was shipped to the United States later that spring and one hundred people attended an opening at the Valentine Gallery on May 4, 1937. Two thousand more saw it during its three-week showing in New York, during which the AAC sponsored two symposia with leading artists to discuss its significance. [8] Visual artists devised other innovative tactics to persuade the public of the importance of the Spanish Civil War and raise money for medical and relief organizations. Artists from the New York American Artists Congress went out on street corners to paint militant posters on the spot and sell them, they hoped, to intrigued passersby. [9] They also contributed works with Spanish Civil War themes to exhibitions put on by both the WPA-FAP and by independent organizations and galleries.

Artists on the left made their views on Spain visible in another, more unusual venue: the pages of the Communist-affiliated journal *New Masses*. In 1935–36, *New*

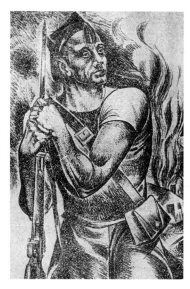

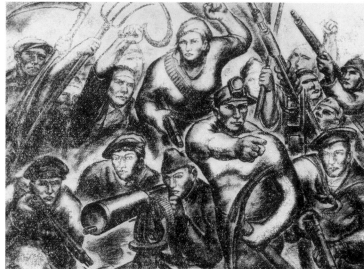

FIGURE 3
Untitled (soldier with gun),
Michael Lenson, lithograph,
as reproduced in *New Masses*,
September 14, 1937.

FIGURE 4
Untitled (peasant militia),
Eitaro Ishigaki, oil painting,
as reproduced in *New Masses*,
December 15, 1936.

Masses' editors had reformed its earlier proletarian, anticapitalist stance to support the inclusive political agenda required by the Party's Popular Front against war and fascism. Unlike many other left/liberal magazines, *New Masses* was surprisingly supportive of visual arts; the editors reproduced not only political cartoons but also drawings, prints, and paintings in its pages, along with muckraking political analysis, contemporary fiction, and theater, music, and art reviews.

The art works that *New Masses* published throughout the 1930s were created independently rather than being commissioned to illustrate specific articles; instead artists and writers addressed varied social justice themes from parallel leftist perspectives. Artists faced few stylistic constraints and their representational choices ranged from proletarian realism to Cubist- and Surrealist-inspired modernism. Visual art placed next to a text created a complementary resonance that intensified factual and emotional meanings and reinforced the significance of issues the journal wished to emphasize. Such pairings can be seen repeatedly with images and texts referring to the Spanish Civil War. For example, Muriel Rukeyser's poem "Mediterranean," which presented her experiences visiting Spain for the People's Olympiad in 1936 and her evacuation when the Civil War broke out, was published in the September 14, 1937 issue. [10] The text was accompanied by three independently developed art works: a drawing by Sylvia Wald on the first page (Figure 2) and lithographs by Henry Simon and Michael Lenson on the two following pages. Wald's and Simon's works both referred to the victimization of women peasants, while Lenson's image (Figure 3) portrayed a stoic resistance fighter, leaning meditatively on his bayonetted rifle while village houses behind him are consumed by flames. His pose suggests not the elation of victory but the sorrow of participating in a struggle in which so many became victims. Eitaro Ishigaki's idealistically dramatic painting of Spanish peasant fighters (Figure 4), reproduced in black and white in the December 15, 1936 issue, celebrates the zeal of the Republican Spanish

FIGURE 5
Spanish Landscape, 1938, Federico Castellón, lithograph.

militias. But it also suggests the difficulties they faced in acquiring arms: the men hold weapons that include pitchforks and scythes as well as rifles and a machine gun. This image of military determination in the face of great odds reinforced the point of John Strachey's article "The Zero Hour," which warned that the Spanish war could bring Europe to the brink of international conflict.[11] Art works that suggested militancy or suffering without specific reference to the Spanish conflict were also effectively combined by *New Masses* editors with more explicit texts. For example, in the December 1, 1936 issue, an uncharacteristically militant painting by Raphael Soyer titled *Workers Armed* was reproduced at the beginning of an article by James Hawthorne titled "Spain's Darkest Hour."[12] Each of these pairings demonstrated to readers that both writers and artists on the left cared passionately about Republican Spain's survival.

Unfortunately, few of these paintings and prints with Spanish Civil War themes have been preserved in museum and private collections, and most of the works reproduced in *New Masses* are now unlocated. Wealthy collectors did not usually want such works, and those exchanged among the artists themselves, or purchased by sympathetic leftist and liberal patrons, disappeared during the McCarthy era or were discarded by heirs who did not recognize their value. Yet enough works remain to give us a sense of the dramatic, deeply felt, and powerfully represented experiences of visual artists who were engaged with both the idealism and the tragedy of Republican Spain.

The themes of these works tend to fall into several dominant categories: landscapes showing the terrible destruction of the Spanish countryside and peasant

communities, images of women and children as the vulnerable civilian victims of military actions, works that valorize the brave commitment of peasant militias and International Brigade troops, and those that enunciate American activist politics as artists protested aerial bombings in Spain and demanded that the arms embargo be lifted.

In a lithograph simply titled *Spanish Landscape* (1938, Figure 5), Federico Castellón depicted the anguish of seeing one's land destroyed by war. Born in Altamira, Spain, in 1914, Castellón moved to Brooklyn with his family in 1921. From 1934 to 1936, he used a fellowship from the new Republican government in Spain to travel through Europe. On his return to New York after the war started, he created several poignant lithographs in which the landscape's paths, fields, and rocky hills, rather than buildings or people (although they are marginally present), seem to be shattered, twisted, and cracked by the violence of war. Several other artists, such as Jack Markow and George Picken, also produced prints that foregrounded the dreadful destruction of the landscape itself, as fertile rural valleys were blasted into wastelands of barbed wire, bare twisted trees, and abandoned war materiel.

Jacob Kainen's 1938 print *Spanish Landscape with Figures* (Figure 6), turns instead to the human costs of war by emphasizing the terrible victimization of Spain's peasant families. Kainen was one of the leading printmakers at the New York Graphic Arts Division of the WPA-FAP and later became curator of prints at the National Gallery of Art in Washington, D.C. Here he empathetically evoked the shock and grief of women and children alone in a landscape laid waste by bombardment. The younger woman's grief-stricken pose and the stoic, dazed silence of the standing

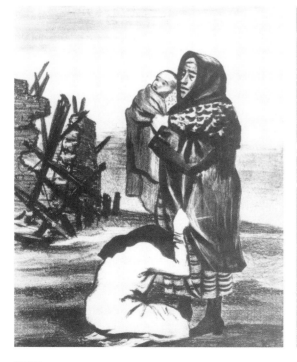

FIGURE 6
Spanish Landscape with Figures,
1936-37, Jacob Kainen, lithograph.

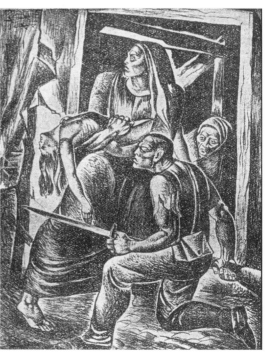

FIGURE 7
**Untitled (peasants), Michael Lenson, lithograph,
as reproduced in *New Masses*, April 12, 1938.**

maternal figure all suggest tragic, terrifying alienation; only the baby's survival offers hope for the future. *New Masses* published numerous other lithographs and drawings portraying women and children as war's victims, a theme that surely encouraged support for Spain's homeless refugees.

A few artists combined the themes of peasant victims and militant fighters. In an untitled lithograph published in *New Masses* in April 1938 (Figure 7), Michael Lenson, a New York artist who contributed several prints to the journal, depicted a peasant woman carrying a dead girl into a house where other people huddle in fear of further violence, although one muscular, grimly determined male fighter defiantly points his rifle through the broken doorway. [13] This image might simply depict the danger to peasant families who failed to flee their homes, but it may also protest the horrific results when Nazi planes, in alliance with Franco's army, bombed Spanish towns such as Guernica, a theme that was taken up by several artists such as Philip Guston [see Figure 1], Boris Gorelick, and Anton Refregier.

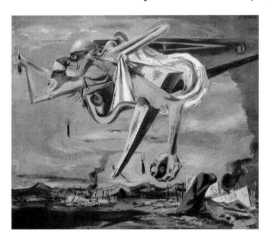

FIGURE 8
***Guernica*, 1937, Anton Refregier, oil painting.**

Their works also demonstrate that art sharing the same theme could be quite varied stylistically. Guston's painting conveys a persuasively detailed realism despite its whirling perspective. Lenson's lithograph is marked by slight modernist simplification and angular deformation of the figures' shapes, yet it retains a convincingly readable visual character. Gorelick and Refregier turned to more modern Cubist- and Surrealist-inflected styles to convey the horror of war and the victimization of the Spanish people. Boris Gorelick, one of the most innovative American printmakers in the 1930s, was employed at the New York Graphic Arts Division. He frequently explored Surrealist and abstract effects in his prints; this is obvious in *Bombing* (1937–38), where he utilized a reverse white-on-black lithographic technique called *manière noire*. While an eerily abstracted head on the left weeps to see tiny distorted figures whirled around in a maelstrom of destruction, an attenuated gesturing figure in the foreground, perhaps the artist himself, reaches out as if wishing to stop the violence. Anton Refregier, known for his murals and other political works during the 1930s, used Surrealist effects somewhat differently to create an even more disturbing painting (Figure 8). Now titled *Guernica*, this work was reproduced in *New Masses* in 1937 with the title *Fascists Over Spain*. [14] Refregier's image summons up the brutality of aerial bombing attacks by constructing a monstrous two-headed figure in the sky, with features reminiscent of Hitler and Mussolini, a gasmask suspended from its body, and arms holding a knife and a rock. These symbols of pain and destruction are reinforced by the tiny bombs that fall menacingly toward a landscape covered with wrecked houses and dead bodies. Refregier's fury at such attacks comes across vehemently in his painting through its insistence on the grotesque viciousness of those who perpetrated such events.

By contrast, New York artists tended to represent those who fought to defend Spain's democratic Republic as idealized, heroic figures, set into situations that emphasized courageous proletarian resistance or the grim terror of military combat.

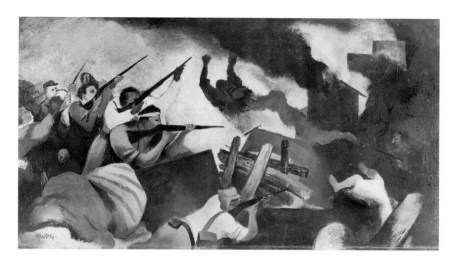

FIGURE 9
The Defenders, William Gropper, drawing, as reproduced in *New Masses*,
August 25, 1936.

Earlier leftist valorizations of working-class militancy reappeared in the Spanish
Civil War era, as we have seen in Eitaro Ishigaki's painting of Spanish peasant
fighters [see Figure 4]. Ishigaki was one of several Japanese artists living in New
York during the 1930s. He and his wife, writer Ayako Ishigaki, were both mili-
tant Communists, and he created many large, ambitious paintings with idealistic
themes of revolutionary struggle and proletarian valor. This work is typical of his
approach: numerous muscular male fighters stare resolutely out of the canvas,
brandishing their weapons, while an inspiring female figure, part goddess of liberty
and part peasant rebel, raises her fist over their heads in the classic gesture of revo-
lutionary leadership.

FIGURE 10
Untitled (fighters), Chet La More, lithograph, as reproduced in *New Masses*, May 4, 1937.

FIGURE 12
New Women of Spain, Elizabeth Olds, drawing, as reproduced in New Masses, November 24, 1936.

William Gropper, already famous in the 1930s as a political cartoonist, was increasingly praised for his oil paintings; he had three solo exhibitions in 1936 and was awarded an important mural commission from the Treasury Section program. In *The Defenders* (Figure 9), which was also reproduced in *New Masses* in the March 9, 1937 issue, he portrayed embattled Republican forces who shelter behind a makeshift barricade while firing into the smoking ruins of a Spanish town. [15] Gropper used telling details to insist on the individuality of almost every person shown, while expressively conveying the terrifying conditions in which Republican troops sought to gain victory and avoid death. Yet his partly abstracted painting technique, with generalized areas of color defining the simplified figures, and several awkward details, such as the woman falling backwards on the right, were demeaned by some leftist critics, who also expressed concern about Surrealist representations. [16]

Chet La More's stark lithograph of advancing fighters (Figure 10), published in *New Masses* in May 1937, presents an even more terrifying view of military action. [17] Three male figures, drawn with crude black outlines, are set against a simple stippled background where rough white scratching suggests the haze of artillery smoke. The viewer quickly realizes that despite their determined stances, they are moving blindly to oppose an unseen enemy. This seemingly simple print vividly evokes the complex mix of idealism, courage, and sheer terror that shaped masculine combat on the Spanish front.

Women, however, rarely appear in these images other than as victims or peasant liberty goddesses; they do not participate in militia actions, drive ambulances, nurse the wounded, or cook meals for exhausted troops, despite their actual contributions to both the Republican militias and the International Brigades. [18] Instead one finds numerous variations of the allegorical female figure who rises idealistically above her male comrades, as in Ishigaki's painting [see Figure 4], to personify courage, hope, and victory. Was the inclusion of this militant female figure derived from Delacroix's famous painting *Liberty Leading the People*? Did she perhaps evoke the influence of

OPPOSITE PAGE: FIGURE 11
Untitled (Spanish Front), William Gropper, drawing, as reproduced in New Masses August 25, 1936.

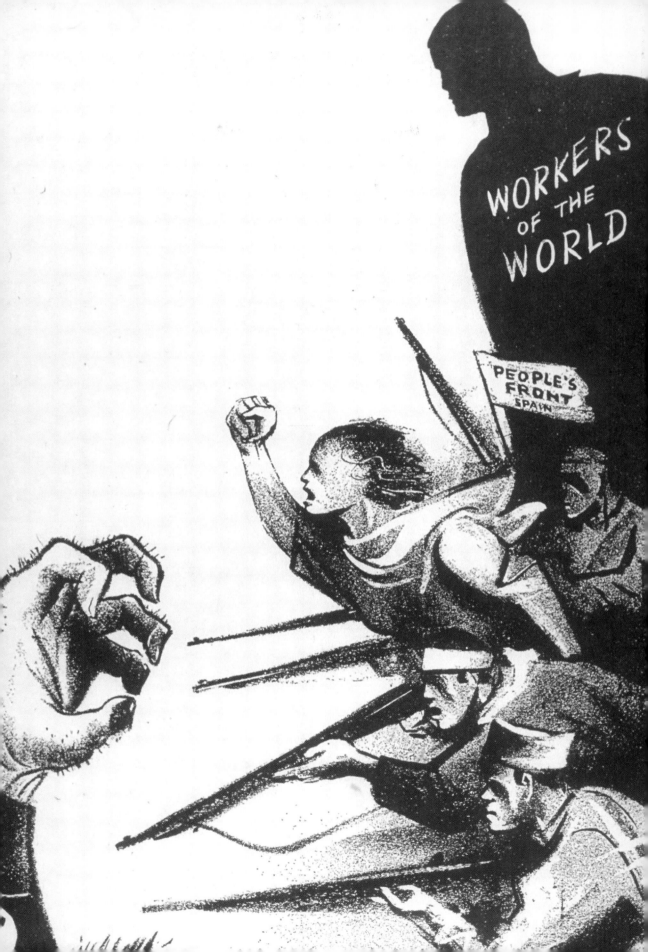

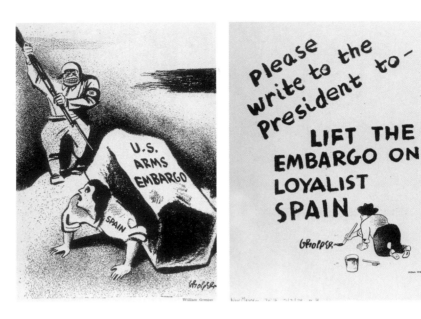

FIGURE 13
Untitled (crushed Spain), William Gropper, drawing, as reproduced in *New Masses*, April 12, 1938.

FIGURE 14
Untitled (Lift the Embargo), William Gropper, drawing, as reproduced in *New Masses*, February 7, 1939.

Communist leader Dolores Ibárruri, known as *La Pasionaria*, whose exhortatory radio broadcasts encouraged the Spanish resistance movement? [19] Variants of this trope of female courage loom up in several drawings by Bill Gropper: one published in *New Masses* in August 1936 shows her leading soldiers of the People's Front in Spain (Figure 11), while another takes up a similarly inspiring position in *They Shall Not Pass*, printed in the *Daily Worker* in September. [20] She strides forward again in a painting by Abraham Harriton, *Fighting for Spanish Democracy*, reproduced in New Masses in January 1937. [21]

Only one work, a drawing by Elizabeth Olds titled *New Women of Spain* (Figure 12), published in *New Masses* in November 1936, depicts real women who played such a crucial role in sustaining Spanish Republican forces. [22] Olds, a leading printmaker in New York who worked as a non-relief artist at the Graphic Arts Division, contrasts a group of young women wearing modern clothing and proudly holding rifles with three older women in traditional garb who watch them uneasily. The artist conveys both youthful idealism and traditionalist anxiety, as well as the tension generated when young women broke with expected feminine norms to defend their freedom alongside male peers.

America's refusal to arm Republican Spain despite increasingly desperate pleas for assistance deeply frustrated and troubled leftist artists. Two political drawings by Bill Gropper published in *New Masses* suggest the urgency of protests against the Neutrality Acts. The first, in April 1938 (Figure 13), portrayed a woman's figure personifying Spain crushed under a huge stone labeled "U.S. Arms Embargo" and about to be bayonetted. [23] By early 1939 this image accurately reflected the state of Spain's last Republican defenders. Leftists yet again demanded an end to the embargo, and Gropper himself penned an anguished visual plea in the February 1939 issue of *New Masses* (Figure 14). Across the full page he was normally allotted

OPPOSITE TOP: FIGURE 15
Aftermath, 1938, **Phil Bard, lithograph.**

OPPOSITE BOTTOM: FIGURE 16
Vision, 1939, Joseph **Vogel, lithograph.**

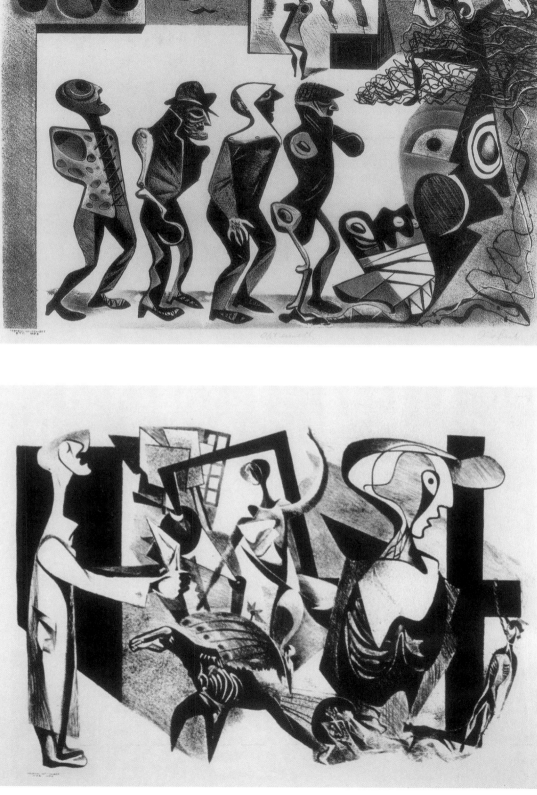

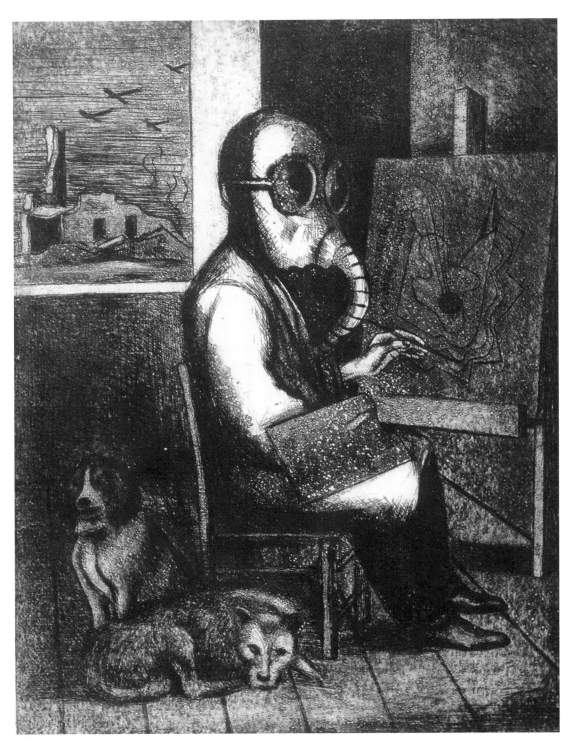

FIGURE 17
Tranquility, 1936,
Joseph Leboit, etching
and aquatint.

for his weekly drawings, he lettered large words: "Please write to the President to lift the Embargo on Loyalist Spain." Underneath he drew a small kneeling self-portrait with a bucket of paint beside him, as if he had painted these words on a sidewalk. [24] But despite leftist protests, the embargo was not lifted. Madrid, the center of anti-fascist resistance, was captured by Franco's army at the end of March 1939. It was difficult for many American leftist artists to acknowledge the finality of Franco's victory in Spain, and the difficulty was compounded by confusion over the political rivalries that disrupted leftist military alliances. But these conflicts were not discussed in the Soviet Communist-affiliated press and the subject was not raised at all in visual images. [25]

Throughout the war, the question of whether opposition to fascism required artists to spell out their political views in their works remained contentious. Some, such as Stuart Davis, who held leadership roles in several militant artists' organizations and served as editor of *Art Front*, insisted that abstraction in itself was a radical contribution to political change and disdained the idea that revolutionary art must literally illustrate revolutionary concepts or events. [26] Adopting a somewhat different perspective, Boris Gorelick, Joe Vogel, and Phil Bard maintained that artists interested in modernist pictorial vocabularies could still produce works addressing specific political themes, even if the resulting images were only minimally intelligible to most viewers. This conviction resulted in some of the most powerful modernist artworks related to the Spanish Civil War, such as Phil Bard's *Aftermath* (1938, Figure 15) and Joe Vogel's *Vision* (1939, Figure 16). Both lithographs convey a deeply felt anguish about current social and political experience, but the details needed to connect this emotion to specific events are difficult if not impossible to extricate from the abstracted Surrealist elements.

Taking a different stance, Joseph Leboit addressed this issue in his 1936 etching and aquatint titled *Tranquility* (Figure 17). Mocking artists who remained safe in their studios during a time of political crisis, he portrayed a resolute painter, wearing a gas mask and ignoring the bombers flying outside his window while working calmly on a nonobjective design. Leboit's print sardonically condemned both isolationist disdain for international politics and artists who refused to respond to current events in their work. At a time of outright military aggression and national reluctance to intervene in foreign conflicts, Leboit asks his fellow artists whether focusing only on their own interests is sufficient. For those artists who did confront the anguish, hope, and terror of the Spanish Civil War, the answer is found in visual images that carry their passion and commitment into the 21st century.

Endnotes

1 Francine Tyler, "Artists Respond to the Great Depression and the Threat of Fascism: The New York Artists' Union and its magazine *Art Front* (1934–1937)," unpub. diss. New York University (1991), 277.

2 Peter N. Carroll, *The Odyssey of the Abraham Lincoln Brigade: Americans in the Spanish Civil War* (Stanford: Stanford University Press, 1994), 79 and 337. See also Francine Tyler, "Artists Respond," 276–77. See Tyler for more on Paul Block, 279.

3 For Rackley's career, see Carroll, 80–81 and Helen Langa, *Radical Art. Printmaking and the Left in 1930s New York* (Berkeley: University of California Press, 2004), 217 and 300, n.59.

4 For Phil Bard, Mildred Rackley, and Paul Block, see Carroll, 79–82. Liz Seaton interviewed two sources who dispute earlier accounts that Bard was wounded; see Elizabeth Seaton, "Federal Prints and Democratic Culture: The Graphic Arts Division of the Works Progress Administration Federal Art Project, 1935–1943," unpub. diss. Northwestern University (2000), pp. 163–166. When Joseph Vogel was interviewed for the Archives of American Art in 1965, he refused to discuss his time in Spain, saying that he was merely an illustrator, that his assignment happened by accident, and that most men who went to Spain were trying to solve their own life problems. Despite Vogel's continuing commitment to leftist politics and social justice, both the shadow of McCarthyism and the political obtuseness of the interviewer seem to have raised his guard in this section of their

discussion. See Betty Hoag, interview with Joseph Vogel, Archives of American Art, January 1965: http://archivesofamericanart. si.edu/collections/oralhistories/transcripts/ vogel65.htm (accessed 2006).

5 See *Artists Against War and Fascism: Papers of the First American Artists' Congress*, with an introduction by Matthew Baigell and Julia Williams (New Brunswick, N.J.: Rutgers University Press, 1986; first published in 1936 as *Papers of the First American Artists' Congress*).

6 Exhibition Brochure, "An Exhibition in Defense of World Democracy: Dedicated to the Peoples of Spain and China," organized by the American Artists Congress, December 1937. Lena Gurr Papers, Archives of American Art, Smithsonian Institution, Reel 4947.

7 Bram Dijkstra argues that Guston may have been responding here to the tragic bombing of Guernica, but the fact that the man on the right wears a gas mask makes this seem unlikely. Reported instances of military bombing of Spanish towns were not limited to Guernica, as Dijkstra notes, and any of these could have inspired Guston's painting. See Bram Dijkstra, *American Expressionism: Art and Social Change 1920–1950* (New York: Harry N. Abrams and the Columbus Museum of Art, 2003), 227.

8 Alfred Barr, director of the Museum of Modern Art in New York, offered to reimburse the Spanish Refugee Relief Committee for shipping costs, and the painting was sent across the country to Los Angeles, San Francisco, and Chicago to secure yet more funding for relief efforts. For more discussion see Herschel Chipp,

"Guernica: Once a Document of Outrage, Now a Symbol of Reconciliation in a New and Democratic Spain." *ArtNews* 79:5 (May 1980), 108–12.

9 See *New Masses* 29:1 (September 27, 1938), 18 for discussion of the street corner poster campaign.

10 See Muriel Rukeyser, "Mediterranean," *New Masses* 24:12 (September 14, 1937), 18–20. The People's Olympiad was an international antifascist event intended as an alternative to the 1936 Olympics, which were to be held in Nazi Berlin. *Mediterranean* was first published as a pamphlet to raise funds for the New York Writers and Artists Committee of the Medical Bureau to Aid Spanish Democracy in 1937.

11 Eitaro Ishigaki, untitled painting (unlocated) and John Strachey, "The Zero Hour," *New Masses* 21:12 (December 15, 1936), 11.

12 Raphael Soyer, *Workers Armed* (1936) and James Hawthorne, "Spain's Darkest Hour," *New Masses* 212:10 (December 1, 1936), 3.

13 Lenson's print accompanied a text describing a meeting of American activists (including Ralph Pearson, representing the American Artists' Congress) with State Department officials to ask the government to exempt the Spanish Loyalists from the Neutrality Acts so that they could buy arms.

14 Anton Refregier, *Fascists Over Spain*, reproduced in *New Masses* 23:7 (May 11, 1937), 20.

15 William Gropper, *Defenders* [sic], *New Masses* 22:11 (March 9, 1937), 17.

16 For discussion of Gropper's style and relation to Communist critics, see Andrew Hemingway, *Artists on the Left: American Artists and the Communist Movement 1926–1956* (New Haven: Yale University Press, 2002), 138–140. For questions of whether Surrealism was an appropriate tool for leftist artists, see Langa, *Radical Art*, 42–76.

17 Chet La More, Untitled lithograph (fighters), *New Masses* 23:6 (May 4, 1937), 9.

18 Women originally fought in militia groups associated with the anarchists, the POUM (Partido Obrero de Unificación Marxista, or Workers' Party of Marxist Unity, a Trotskyite party), and the Communists, as well as segments of the former National Police and workers' militias. After an internecine struggle to take over many of these groups, the Communist Party barred women from the front lines. See "Spain: A Country Study; Chapter I. Historical Setting," in *Country Studies: Area Handbook Series* (Library of Congress/ Federal Research Division), December 1988, http://lcweb2.loc.gov/frd/cs/estoc.html (accessed March 2003).

19 American leftists knew of La Pasionaria's role. See "La Pasionaria Addresses American Women," *New Masses* 24:11 (September 7, 1937), 19.

20 William Gropper, Untitled drawing (Workers of the World and People's Front, Spain), *New Masses* 20:9 (August 25, 1936), 11; "They Shall Not Pass," *Daily Worker* (September 4, 1936).

21 This arresting image was paired with an article by Theodore Draper titled "Behind the Lines in Spain." Abraham Harriton, *Fighting for Spanish Democracy*, *New Masses* 22:5 (January 26, 1937), 15.

22 Elizabeth Olds, *New Women of Spain*, *New Masses* 21:9 (November 22, 1936), 4.

23 William Gropper, untitled drawing (Spanish victim), *New Masses* 27.3 (April 12, 1938), 3.

24 "Mobilization Notice!" *New Masses* 30:6 (January 31, 1939), p. 3; William Gropper, untitled drawing, *New Masses* 30:8 (February 14, 1939), 4.

25 See Ralph Bates, "Forging Catalonian Unity," *New Masses* 22:5 (January 26, 1937), 19. Bates discusses the struggle among factions of the Spanish left over the timing of a social as well as a political revolution and attacks the POUM militias as Trotskyite betrayers of Communist unity.

26 See Langa, *Radical Art*, 68–72 on tensions among artists about radical stylistic and thematic choices.

MUSSOLINI MOLA HIT

FA

On October 4, 1936, occurred one of
most savage single incidents of the
...sh war. Hundreds of children were
...ng in the sun in the Puerta del Sol.
...y, waiting in line for their rations,
...their mothers. Suddenly the roar of
...s was heard—huge Fascist bombing
...s cast a cloud over the sky—without
...ng, huge aerial bombs hurtled into
...midst of the women and children!
...reds of tiny, innocent children, like
...pictured below, were mutilated, torn,
...ered! There could have been no ex-
...for this most bestial of fascist bestiali-
...no Loyalist troops were within half a

mile of the scene—.
branded it for what it
deliberate fascist rage an..
tion against innocent
CHILDREN for fascist l...
engagements.

IMAGES AT WAR:

PHOTOGRAPHS OF THE SPANISH CIVIL WAR IN NEW YORK CITY

BY JUAN SALAS

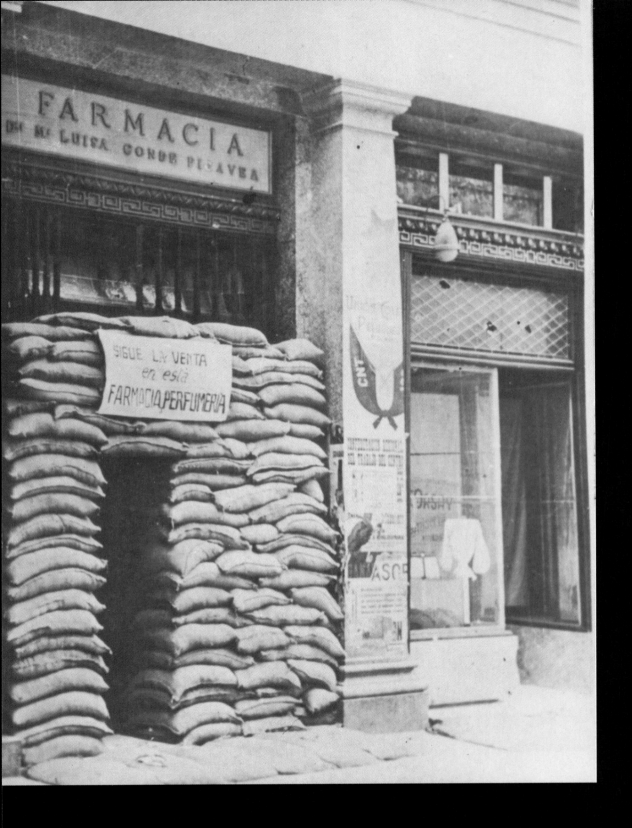

"GOOD PICTURES

of the Spanish civil war are rare," wrote the editors of *Life* magazine in the December 7, 1936 issue. And yet, before long, the Spanish conflict would become the most photographed event of its time. All major publications in New York City sent staff or hired photographers in the field to cover the war. The Spanish war became an important milestone in the history of photojournalism and propaganda. Photographers gained mobility and saw more. Smaller and lighter cameras enabled them to get much closer to the action and to capture powerful and disturbing images. New graphic publications—such as *Life*, founded in November 1936—brought these pictures into the living rooms of thousands of New Yorkers. The ubiquity and force of these images gave photography an unusually active role in the Spanish Civil War; far from just representing the conflict, photography was deliberately used by both sides in an attempt to affect the outcome of the war.

Although photographs from previous wars had been mostly staged to compensate for technical limitations, [1] the photographs published during the Spanish Civil War were perceived as inherently legitimate. They were viewed as candid testimonies of the events they represented. Imbued with the power of truth, photography became an essential way to document events that were polarizing the media and their audiences. In New York City, the center of the American publishing industry and a major node of political activity, photography became a powerful weapon of propaganda for the contenders in the war as they struggled to win over the "hearts and minds" of New Yorkers.

The extensive use of photographs from the Spanish war in New York City's mainstream daily newspapers created a sense of urgency, which was heightened even further by the ever-increasing speed of wired and radioed photography. In fact, the first images of the war published by *The New York Times* were accompanied by the history of their transmission to the city. The editors were proud to be able to offer readers photographs of events that had happened on the other side of the Atlantic just a few hours earlier. On July 23, 1936, the caption for one of the first photographs, fresh from the Spanish front, was eloquent: "As Civil War raged…this photograph was rushed to Bordeaux, France, telephoned to London, and thence radioed to New York." Photographic technology was becoming newsworthy in its own right and was used effectively to attract increasing numbers of readers. New Yorkers experienced this distant war with remarkable immediacy, thanks, in large part, to the technological innovations that were changing how images were captured, transmitted, and received.

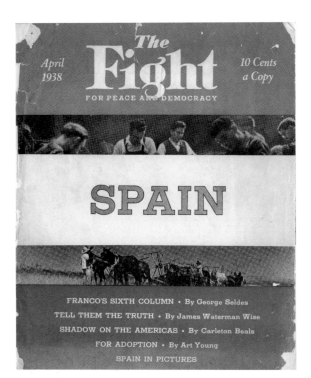

The Fight for Peace and Democracy, April 1938.

The first photographs from Spain published by major newspapers presented portraits of the protagonists of the military revolt and of Spanish Morocco, where the insurrection had started. As the attacks on major cities intensified, the focus of the images shifted to urban scenes of devastation and to shots of streets defended by civilians against the attack of the military rebels.

During the first months of the war, the photographers and editors of the New York press were compelled to grab the interest of the public by showing the most striking aspects of the conflict. In a war that was proving to be unlike any previous war, the media managed to create identifiable references for their audience, consolidating stereotypes about Spain already established in New York's popular culture. Spanish women fighters, the *milicianas* who patrolled the streets of Madrid and Barcelona, were featured repeatedly in the press. The *Herald Tribune* from July 25, 1936 offered a photograph of some of these women, who had proven to be pivotal in the defense of the young democracy. *The New York Times*, on October 4, 1936, published a photograph of a group of milicianas, identifying them as "The Tiger Women of Spain." The photograph's caption read: "La Passionaria's Battalion of women, who give no quarter and are sworn to track down Rebels, photographed under the red flag before dispersing for a 'man hunt' in Madrid. They are the followers of Dolores Ibárruri. […] and the oldest is only twenty." In similar images these groups of women were called the "Carmens" of Spain, integrating them effectively within the stereotype of fierceness and independence assigned to Spanish women from the 19th century in American culture. In the 1930s, these new Amazons had become communists and anarchists.[2]

Beyond the exoticism of some of the mainstream media's illustrations of the conflict,[3] a flood of very different images also emerged in New York publications as essential tools for propaganda. The Left embraced the cause of the Spanish Civil War like no other foreign event since the Russian revolution. Mobilized around the fight against the embargo that the United States had placed on Spain, dozens of associations and political parties published newsletters, bulletins, pamphlets, and leaflets to campaign for the Loyalist side. Though photographic reproduction was an expensive process that not all organizations could afford, many were able to publish photographs as part of their attempt to show New Yorkers why it was imperative to lift the embargo and send help to Spain.

During the first months of the war some images published by the mainstream media had focused on the burning of churches by supporters of the government; such photographs had a devastating effect for the Republican cause. Religion thus became a central point of contention of the propaganda efforts on both sides of the conflict. *News of Spain*, a biweekly bulletin produced in New York by the Spanish Information Bureau (an organ of the Spanish government), published in every issue portraits of famous Catholic intellectuals and members of the clergy supporting the Republic. The front cover of the March 5, 1938 issue showed a photograph of high ranking members of the Spanish church and rebel generals greeting their followers with the fascist salute. The same issue prominently featured a photograph of bystanders browsing Bibles in a stand at Barcelona's annual book fair, conveying a sense of civility and tolerance in that Republican-controlled city, far removed from the anticlerical horrors attributed to the government. *News of Spain*, as the organ of the Spanish government, showed a more traditional approach to photography aimed at transmitting a sense of civic responsibility.

Robert Capa contributed to *News of Spain* a photograph of monks peacefully reading a newspaper in their monastery at Amorabieta in the Basque country under Loyalist rule. The situation of the Basque church was used repeatedly as an example of peaceful relations between the Leftist government and the Church. To further advance the point that the Republican government was not anticlerical, the newsletter featured a photograph of the "Loyalist army at mass," officiated by a Basque priest in the open air, for those soldiers who "fought Nazi-Fascist invasion." On the following page, a photograph of Francoist troops exhibiting Nazi swastikas was part of the effort to show New Yorkers the ideological proximity of the rebels to Hitler and the active role that Nazi Germany was playing in the conflict.

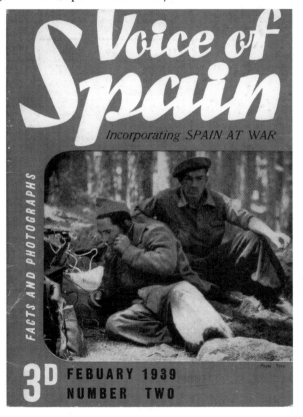

Voice of Spain, February 1939.

The efforts of the Spanish government to protect the artistic patrimony of the country under attack became another element in the war of images. Emphasizing the respect of the Loyalists for religious art, *News of Spain* published several photographs of Republican soldiers salvaging paintings and sculptures from churches destroyed by Franco's bombs.

The Spanish government seemed to believe that to fight U.S. isolationism, it would have to distance itself from what were perceived as communist practices or tendencies. Many of the images disseminated in New York seem to form part of this strategy. The caption for a photograph showing storefronts in Madrid read: "The customer must be protected. Behind sand-bagged store fronts, Madrid shoppers spend 2,000,000 pesetas a day," illustrating the government's respect for small business. In a more explicit caption of a street scene photographed in Madrid, the editor stated "A drugstore—not a dug-out. 'Business as usual' reads the sign over the entrance of this pharmacy." Aware of American concern for its own economic interests in Spain, *News of Spain* also published a photograph of a rural scene with a Ford company billboard clearly identifiable in the background, as if to assure U.S. audiences that the Spanish Republic was indeed a good customer.

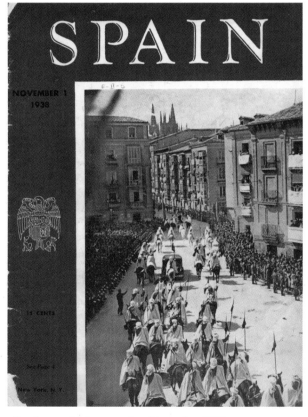

Pro-Franco *Spain* magazine, November 1938.

All publications created to support the cause of democratic Spain emphasized the government's effort to educate and protect the children affected by the war. Photographs of children being fed and nurtured by the Republic were routinely opposed to images of infant victims of the bombs of Franco, Hitler, and Mussolini. The special issue on the war that *The Fight for Peace and Democracy* published in New York in April 1938 tried to enlist support for the humanitarian aid undertaken by Americans to help children in Loyalist Spain. Three photographs under the title "What's to become of the Children?" showed images of a Popular Front school, a little girl dressed as a *sevillana* drinking milk, and a young boy playing a typical Spanish instrument, the *bandurria*, suggesting that with the help of its American friends, the future and traditions of a democratic Spain could survive.

Images of dead children were shown in many instances as the ultimate abomination of Franco's war against civilians. Significantly, the magazine *Spain*, the organ of the United Youth Committee to Aid Spanish Democracy, published a special issue devoted entirely to "The Spanish War in Pictures: Latest Photos of Spain's Fight for Democracy." The issue ended with a desperate appeal to the moral sensibility of the readers, a plea that makes explicit the assumption that the contemplation of these images could and should lead to action: "You have seen. What will you do?"

In contrast to the government of the Republic, Franco's Spain did not really need New Yorkers' help. [4] Support from Hitler and Mussolini, combined with the politics of appeasement and the work of the Non-Intervention Committee proved to be enough to secure the victory of the rebels. But there were rebel sympathizers in New York City and they had the funds to publish a voluminous and profusely illustrated magazine. Pro-Franco *Spain* was a lavish, large format publication meant to attract the support of Americans with spiritual and economic interest in the country. The photographs used to convey their ideas centered on representations of major Spanish classical works of art and images of rural landscapes devoid of any traces of war. They were photographs in the pictorialist style that had been popular during the first decades of the century and that would later characterize the official photography of the regime for nearly four decades. [5] The magazine published images of the north of Spain, assuring potential tourists of the safety of the situation at the summer resorts on the coast, adding that the old pilgrimage road to Santiago de Compostela had once again been conquered from the infidels. Astonishingly, every issue of the magazine devoted the entire second page to advertise Spanish sherry: "There is about sherry from Spain a warmth and good fellowship unmatched by any other of man's potations. [...] Compared with the other fine things in life, even the best sherry exacts but a meager toll for the pleasure it brings."

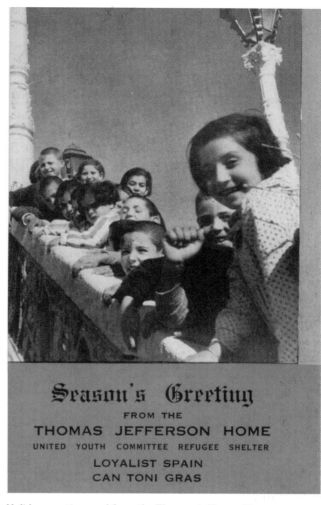

Holiday greeting card from the Thomas Jefferson Home, a "colony" for children displaced by the war, ca. 1938.

The formal contrast between these static and bucolic images circulated in New York by the fascist rebels and the kind of imagery disseminated in New York by supporters of the Republic reflected the schism between two irreconcilable Spains. Among the city's politicized artists, the conflation of photojournalism and certain avant-garde artistic practices had not only produced a new type of image, it had also transformed the way those images could be presented. The graphic design of pro-Loyalist *Spain* or *Photo-History* managed to translate Spanish events into a powerful series of collages that strove to cause an immediate impact on the audience. Different elements taken from reality could be brought together to create simple and powerful messages. Nazi bombs, children crying, and the faces of the perpetrators were laid out on the same page, presenting an unavoidable image of the war in Spain, and, it would seem, demanding some kind of moral response from the viewer. The visual innovations and political efficacy of these photomontages perme-

ated to other artistic fields, as shown by Picasso's determination to use exclusively black and white colors and allusions to graphic publications in his 1937 *Guernica*.

Of course not all the images received from Spain were published or exhibited. The traffic of personal photographs remained limited but had a potent effect on the lives of those who received them. Among the private photographs sent home by American volunteers, there is a picture sent as postcard by volunteer Nathan Wiesenfeld, recently wounded by shrapnel in the head, leaning against a modern sculpture in a Spanish interior. On the back of the postcard he wrote: "Sid, you might have received a report that I am dead, (killed in action) this photo ought to refute it.... Down but not out." [6]

Similar portraits were taken by photographers of the Abraham Lincoln Brigade of American volunteers fighting in Spain. These photographers documented the experiences of the volunteers of the fifteenth International Brigade during the war. When these photographs arrived in the U.S., brought by a returning soldier or mailed home, they acquired meaning beyond their documentary value for those who received and saw them. [7] As a kind of life certificate, the photographs brought home the realization of the imminence of death for those fighting in Spain and became pressing reminders of the need for an active and persistent home front fighting to lift the U.S. embargo in order to keep Spanish democracy alive, to keep young American antifascists alive, to stop the expansion of fascism and Nazism in Europe and the United States.

Endnotes

1 Herbert Mathews wrote that as much as 90 percent of the pictures from the Abyssinian war were faked. Quoted in Jorge Lewinski, *The Camera at War*, (New York: Simon & Schuster, 1978) 82.

2 The Spanish government used foreign fascination with women fighters to its advantage. Virginia Woolf in *Three Guineas* quotes one of the books published in Madrid that were sent as propaganda to intellectuals abroad describing the life of one of these women. "The eyes deeply sunk into the sockets, the features acute, the amazon keeps herself very straight on the stirrups at the head of her squadron.... This woman, who has killed five men—but who feels not sure about the sixth—was for the envoys of the House of Commons an excellent introducer to the Spanish War." See *The Martyrdom of Madrid, Inedited Witnesses*, by Louis Delaprée (Madrid, 1937), 34–36, quoted in Virginia Woolf, *Three Guineas* (New York: Harcourt Brace Jovanovich, 1938) 177–178, fn 15.

3 Photographs of Moorish troops were another constant during the first days of the war.

4 There were galas organized to raise money for Franco's cause but only a small percentage of the funds ever reached Spain. As Marta Rey Garcia shows, the amounts were comparatively insignificant to the money raised by supporters of the Loyalist government. See her *Stars for Spain: La Guerra Civil Española en los Estados Unidos*. (A Coruña: Ediciones do Castro, 1997), 156–168.

5 As Publio López Modéjar notes in *150 Years of Photography in Spain*. (Madrid: Lunwerg Editores, 2000) 173, official photography under Franco was fundamentally anachronistic: "After a fierce struggle between the old and the new, the future, once again, was the past."

6 Abraham Lincoln Brigade Archives, Photo Collection 36, Series XIII: Neil Wesson, b. 2, f. 65, Tamiment Library, New York University.

7 The photographs taken by the Photographic Unit of the XV International Brigade were brought to the United States by sergeant photographer Harry Randall at the end of 1938. They are now part of the photographic collection of the Abraham Lincoln Brigade Archives at Tamiment Library, New York University.

NEW YORK

NOVELISTS AND POETS

RESPOND TO THE

SPANISH

CIVIL WAR

BY ALAN WALD

AT THE DAWNING of the Great Depression, New York City was not merely the command center of the United States publishing industry; Manhattan was also evolving into the headquarters of burgeoning left-wing movements fueled by the deepening social crisis. Such a heady mix of culture and radical politics was incendiary. By the mid-1930s, the stage was set for a profound response to the outbreak of civil war in Spain. Moreover, the impact of the Republican cause on cultural workers was not confined to the years of the war itself, 1936–39. For poets and novelists, the "Crusade" against fascism in Spain abided as a potent subject reverberating in imaginative literature throughout the rest of the 20th century.

As early as the 1932 presidential election campaign, there were notable signs of a growing attraction to the ideas of Marxism and socialism among celebrated as well as aspiring novelists and poets. A New York-based organization, the League of Professional Writers for Foster and Ford, boasted a long list of authors who supported the Communist candidates. These included Sherwood Anderson, Erskine Caldwell, Countee Cullen, John Dos Passos, Langston Hughes, and Edmund Wilson. [1] After 1935, the trend initiated by these writers was augmented by many others who felt an attraction to the broad "Popular Front" coalition that communists had forged with liberals and socialists. New York City was the center of operations for cultural activities of the Popular Front.

In Manhattan, the weekly *New Masses*, staffed by Party members and supporters, and the League of American Writers, led by cultural workers sympathetic to the Party's outlook, were the most militant vehicles for the expression of the belief that the call for unity against fascism was the absolute priority. Such a view, more or less

PREVIOUS SPREAD
Langston Hughes (left) and volunteer Edwin Rolfe in Spain, ca. 1938.

OPPOSITE
Playright Lillian Hellman speaking to WMCA radio, no date.

"...the Spanish Civil War was now in progress and the Depression was still on. The world was being shaken up, and through one of those odd instances which occur to young provincials in New York, I was to hear Malraux make an appeal for the Spanish Loyalists at the same party where I first heard the folk singer

Leadbelly perform. Wright and I were there seeking money for the magazine which he had come to New York to edit."

FROM RALPH ELLISON, SHADOW AND ACT (NEW YORK: RANDOM HOUSE, 1966), 163.

shared by liberal magazines such as *The Nation* and *New Republic*, precariously simplified the political crisis in the Spanish Republic and tended to produce a naiveté about the unfolding events in the USSR. Yet it was an honorable goal that elicited a collective idealism and altruism rarely seen in artistic communities. A genuine yearning for democracy in Spain was the glue that held together literary talents that were otherwise highly individualistic. As Allen Guttmann states in *The Wound in the Heart: America and the Spanish Civil War* (1962), "The Communists did lead the way in organizing the committees and the congresses.... But those who joined the committees and went to the rallies were not, for the most part, seeking to advance the Bolshevik cause."

While the Popular Front view exercised incontestable authority on the literary left in New York, alternative analyses were advanced in smaller radical literary publications produced in the city. *Modern Monthly* and the post-1937 *Partisan Review*, among others, held the heretical belief that antifascism and a social revolution should be combined; the editors were also suspicious of the aims and activities of the Soviet Union and the parties that followed its leadership. As an alternative, these publications championed the views of those such as the leaders of the POUM (Workers Party of Socialist Revolution), an independent Marxist organization in Spain, and the exiled Bolshevik Leon Trotsky. Although adherents of the Popular Front excoriated these dissidents as conscious or passive agents of fascism,[2] actual sympathy for Franco was virtually unknown in New York literary circles.

Distinguished writers were enticed to New York City for conferences that hailed the Spanish Republic. Illustrative of the spirit of the times was Ernest Hemingway's decision to give his first public lecture at the June 1937 American Writers Congress; the climactic point in his talk was about the cause of Spain. Moreover, like Hemingway, many writers visited Spain as an expression of support to the cause: Erskine Caldwell, Malcolm Cowley, John Dos Passos, Theodore Dreiser, Martha Gellhorn, Lillian Hellman, Josephine Herbst, Langston Hughes, and Elliot Paul.[3]

"History was going our way, and in our need was the very life-blood of history. Everything in the outside world seemed to be moving toward some final decision, for by now the Spanish Civil War had begun, and every day felt choked with struggle. It was as if the planet had locked in combat. In the same way that unrest and unemployment, the political struggles inside the New Deal, suddenly became part of the single

pattern of struggle in Europe against Franco and his allies Hitler and Mussolini, so I sensed that I could become a writer without giving up my people.

FROM ALFRED KAZIN, STARTING OUT IN THE THIRTIES (NEW YORK: RANDOM HOUSE, 1965), 82-83.

In 1938, the League of American Writers published *Writers Take Sides*; through the presentation of scores of political statements, the volume corroborated that there was stunning support for the Spanish Republic. Furthermore, several New York City publishing ventures were aimed at promoting solidarity among writers for the Spanish cause in specifically literary modes. In 1937, the League of American Writers arranged the publication of the Vanguard Press edition of *...and Spain Sings*, edited by M. J. Benardete and Rolfe Humphries. The book was comprised of 50 pro-Republican poems by Spanish authors translated into English by writers such as William Carlos Williams, Stanley Kunitz, Millen Brand, Muriel Rukeyser, Willard Maas, Edna St. Vincent Millay, and Ruth Lechlitner. [4]

In concert with International Publishers, a house allied with the Communist Party, the Marxist critic Alan Calmer edited *Salud! Poems, Stories and Sketches of Spain by American Writers* (1938). The collection showcased brief writings by authors who had volunteered to serve in the International Brigades, visited the Spanish battlefields, and others who showed sympathy for the Popular Front cause: James Neugass, Edwin Rolfe, David Wolff (a pseudonym for Ben Maddow), Sol Funaroff, Prudencio de Pereda, Kenneth Rexroth, Norman Rosten, Edward Newhouse, Kenneth Fearing, Erskine Caldwell, John Malcolm Brinnin, Vincent Sheean, and Joseph North.

Almost 15 years after the defeat of the Republic, Spanish Civil War veteran Alvah Bessie edited *The Heart of Spain: Anthology of Fiction, Non-Fiction and Poetry* (1952), and at the time of his death Bessie was acting

ABOVE

***Writers Take Sides*, published by the League of American Writers, 1938.**

BELOW

Alvah Bessie (center) and other members of the Hollywood Ten entering a Washington D.C. courthouse, 1950.

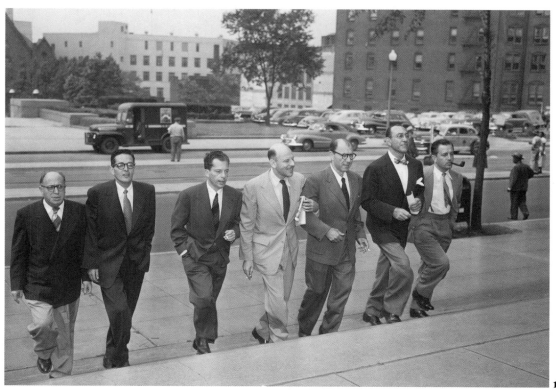

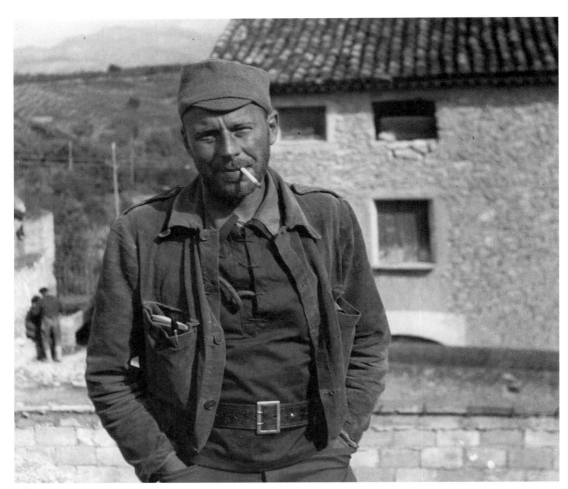

Volunteer Alvah Bessie in Spain, April 1938.

jointly with volunteer Albert Prago on *Our Fight: Writings by Veterans of the Abraham Lincoln Brigade* (1987). A recent poetry collection that amplifies the range of verse inspired by the war is Cary Nelson's collection *The Wound and the Dream: Sixty Years of American Poems about the Spanish Civil War* (2002).

In Europe, novels and memoirs about the Spanish Civil War are considered a classic sub-genre; authors such as André Malraux, Gustav Regler, George Orwell, Arthur Koestler, and Georges Bernanos wrote books that are well known to scholars and the intellectual community. In the United States, only Ernest Hemingway's *For Whom the Bell Tolls* (1940), about the last days of fictional U.S. volunteer Robert Jordan, is regarded a notable work of the 20th century. Much of Hemingway's distinction as author of this book is derived from his first-hand experience as a journalist in Spain and a friend of many combatants. Yet there were also three left-

"...my first professional triumph, in any case, the first effort of mine to be seen in print, occurred at the age of twelve or thereabouts, when a short story I had written about the Spanish revolution won some sort of prize in an extremely short-lived church newspaper. I remember the story was censored by the lady editor, though I don't remember why, and I was outraged."

FROM JAMES BALDWIN,
"AUTOBIOGRAPHICAL NOTES,"
NOTES OF A NATIVE SON
(BOSTON: BEACON PRESS, 1964), 1.

"Sam Levinger, who is dead in a grave which is either unmarked or desecrated in Franco's Spain... wrote before he died:

Comrades, the battle is bloody and the war is long, Still let us climb the gray hills and charge the guns.

Those are tired words, and they have absorbed all the agony which is the truth of life. They are resigned, but they are undefeated. They do not suggest that somebody else charge the guns. They know the worst, but they will make the charge themselves. I miss them very much and I wish we had them back."

FROM MURRAY KEMPTON'S PART OF OUR TIME: SOME RUINS AND MONUMENTS OF THE THIRTIES (NEW YORK, MODERN LIBRARY, 1998, WRITTEN IN 1955), 424.

wing Jewish-American veterans of the Abraham Lincoln Battalion from New York City who would in subsequent decades make signal contributions to the literary tradition of novels by participants in the Spanish Civil War. Their novels were: Alvah Bessie's *The Un-Americans* (1957), William Herrick's *Hermanos!* (1969), and Milton Wolff's *Another Hill* (1994).

Bessie was born into a middle-class family in New York City and attended Columbia University. In the mid-1930s, while residing in rural Vermont partly to work on the novel *Dwell in the Wilderness* (1935), he was persuaded by fellow intellectuals to read Communist publications; soon he was drawn into union struggles in Manhattan. In 1936 Bessie joined the Communist Party and in January 1938, at the age of 33, he volunteered to fight in Spain as a member of the Abraham Lincoln Battalion. A memoir of his experiences, *Men in Battle*, appeared in 1939. In 1941, Bessie was invited to Hollywood by Warner Brothers, where he experienced a modest film career. In 1947 Bessie was called to Washington, D.C., to testify before the House Committee on Un-American Activities. He subsequently became known as one of the "Hollywood Ten" and served a prison sentence for contempt of Congress.

Herrick (born William Horvitz) lost his father, a wallpaper hanger, when he was four. His family was steeped in revolutionary tradition, and his mother was a charter member of the Communist Party. Herrick had been born in Trenton, New Jersey, but spent his teenage years in the Bronx. After traveling around the Midwest and South, Herrick volunteered to fight in Spain at the first opportunity. He sailed for France in December 1936. By February 1937, Herrick had been seriously wounded and placed in a hospital to convalesce. It was during these months that he first became sympathetic to the ideas of the POUM and the anarchists. Returning to New York he became active in the Communist-led Furriers Union, but believed that he was fired in 1939 because of his opposition to the Hitler-Stalin Pact. In the 1950s, Herrick devoted himself to writing and eventually published 10 novels, climaxed by a 1998 autobiography, *Jumping the Line: The Adventures and Misadventures of an American Radical*.

Salud!, published by International Publishers, 1938.

137

Wolff grew up in Brooklyn where his father worked at odd jobs. As a high school student he was enraptured by painting, but he withdrew from his studies to join the Civilian Conservation Corps. When Wolff returned to New York City he discovered that his old friends had become Communists, and he followed them by enlisting in the Young Communist League. As he became increasingly committed to the radical cause, he shed his earlier pacifism on behalf of antifascist militancy and discovered a talent for speaking at street-corner rallies. Partly to escape personal entanglements, Wolff volunteered to serve in the International Brigades. He arrived in Spain in early 1937, and discovered a talent for leadership, as well as for dodging bullets. At the age of 22, Wolff became the Commander of the Lincoln Battalion. After returning to the United States he has spent his life as an articulate spokesman on behalf of the Veterans of the Abraham Lincoln Brigade.

Decades after their service in Spain, all three men published their novels dramatizing the primary experiences of their political lives. For Bessie in *The Un-Americans*, the fascination lay in the interrelationship between one's choice of commitment in Spain in the 1930s and one's capacity to withstand persecution during the McCarthy era of the 1940s and 1950s. Ben Blau, the hero, displays fortitude at both times, but he is personally betrayed by a writer friend whose concealed opportunism during the Great Depression is finally exposed in the crucible of the witch-hunt. The method of Bessie's novel is the most advanced of the three; as he moves between Spain and the United States, Bessie creates an experiment in "intercutting," a technique used in film to create a synchronic effect. [5]

Herrick and Wolff present their narratives with more conventional chronological strategies. For Herrick, the central experience of Spain was the trauma of disillusionment. His protagonist, Jacob Starr, modeled on Arnold Reid, a young communist killed in Spain, is a symbol of misguided idealism who falls victim to the arrogance of power. Wolff seems absorbed in the mystique of war itself. His protagonist, Mitch Castle, in a somewhat dreamlike fashion, finds himself surviving battle after battle and almost thoughtlessly caught up in the execution of one of his own men for alleged cowardice in combat.

Less noteworthy novels were produced by authors who visited Spain briefly or sympathized from afar. John Dos Passos, who was Spain in 1937 to help Ernest Hemingway with the film *The Spanish Earth* (1937, directed by Joris Ivens), wrote *The Adventures of a Young Man* (1939), usually regarded as among his thinnest works and of interest largely as a polemic against Stalinism. Charles Yale Harrison, also a former ally of the Communists, wrote more satirically of his disillusionment in

"I didn't even want to go to Spain. I had to. Because. It didn't make any sense to Max Perkins when I visited him in his office five days before I sailed. He looked at me as one might at a child who had answered the query 'Why do you want to run out in the rain and get all wet?' with nothing more than *because*. 'What's the matter with all of you?' he asked. 'Hemingway's gone off, Dos Passos is there, Martha Gellhorn's going. And now you. Don't you know that Madrid is going to be bombed out? It won't do you any good to go around with the Stars and Stripes pinned on your chests or on your heads. They won't see or care.'"

FROM JOSEPHINE HERBST, THE STARCHED BLUE SKY OF SPAIN AND OTHER MEMOIRS (NEW YORK: HARPER COLLINS, 1992), 132.

"You can think of Times Square with all its cars and all its people, and the focus narrows down and you can see their faces, ordinary commonplace faces like the faces you have known all your life, like the faces of the Spanish men and women and children you have seen in the cities and the small towns and the country, who are waiting back of the lines now, maybe reading a newspaper: Our forces in the Sector of X... repulsed, with heavy casualties, a violent enemy attack and withdrew to predetermined positions on Hill.... And what does that mean, tell me, and do you know? Faces? Do they care about us over there? And do they even think of us with love?"

FROM ALVAH BESSIE, MEN IN BATTLE (NEW YORK: SCRIBNER'S, 1939), 292.

Meet Me on the Barricades (1938). Two other novels about Spain that were published in the late 1930s, William Rollins' *The Wall of Men* (1938) and Upton Sinclair's *No Pasaran!* (1938), promote the Popular Front view, but are pulp fiction romances that tell more about the commercial genre than actual events.

A Communist fellow traveler who lived in New York, Michael Blankfort, published a minor pro-Republican novel, *The Brave and the Blind* (1940). Blankfort's topic was the Siege of the Toledo Alcázar, and it was preceded by a play in 1937 of the same title. In the early World War II years, Dorothy B. Hughes published *The Fallen Sparrow* (1942), a mystery thriller about a Spanish Civil War veteran that would be brought to the Hollywood screen with New Yorker John Garfield in the starring role in 1943.

The Spanish Civil War continued to be an appealing literary theme into the late 20th century. References surface in fictional writings by Tennessee Williams, Edward Albee, Robert Penn Warren, John Barth, Irwin Shaw, William Faulkner, Budd Schulberg, Mary McCarthy, Edmund Wilson, Lionel Trilling, and Norman Mailer. [6] Around the time of the 50th anniversary of the war, two popular novels were published under identical titles. Together they captured the most well known concerns growing out of the war experience: Clive Irving's *Comrades* (1986) recreates the adventures of a United States war correspondent in Madrid; Pael Leaf's *Comrades* (1985) depicts the Cold War ordeal of two friends who were veterans of the Spanish Civil War.

Endnotes

1 Daniel Aaron, *Writers on the Left: Episodes on American Literary Communism* (New York: Columbia University Press, 1992), 196.

2 Peter N. Carroll, *The Odyssey of the Abraham Lincoln Brigade: Americans in the Spanish Civil War* (Stanford: Stanford University Press, 1994), 83.

3 See Stanley Weintraub, *The Last Great Cause: The Intellectuals and the Spanish Civil War* (New York: Weybright and Tally, 1968), 259–300.

4 Franklin Folsom, *Days of Anger, Days of Hope: A Memoir of the League of American Writers, 1937–1942* (Boulder: University Press of Colorado, 1994), 24.

5 Bernard F. Dick, *Radical Innocence: A Critical Study of the Hollywood Ten* (Lexington, Kentucky: University Press of Kentucky, 1989), 114.

6 Stanley Weintraub, *The Last Great Cause*, 301–313.

THE GRAPHIC FIGHT:

NEW YORK POLITICAL CARTOONISTS

AND THE

SPANISH CIVIL WAR

BY JOSHUA BROWN

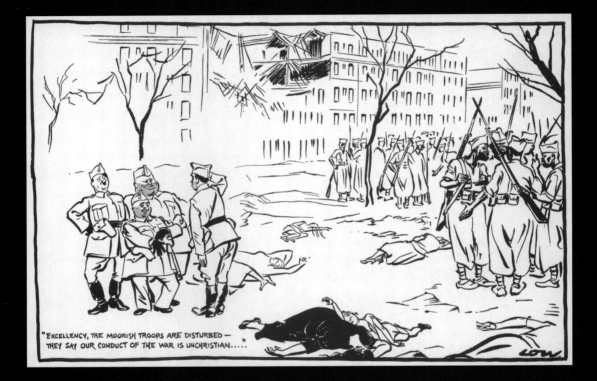

"EXCELLENCY, THE MOORISH TROOPS ARE DISTURBED — THEY SAY OUR CONDUCT OF THE WAR IS UNCHRISTIAN....."

 HE CELEBRATED BRIT-
ish political cartoonist David Low arrived in New York City in November 1936
bearing an unwelcome message. American cartoonists, he declared in an interview
published in *The Literary Digest*, lacked originality. In the opinion of the *London
Evening Standard*'s staff cartoonist, they had "gone sterile" in large part because of
their "willingness... to accept time-worn symbols — the Democratic donkey, the
Republican elephant, *Tammany Tiger*, *John Bull* and *Uncle Sam*." That latter enduring
symbol, Low elaborated, "is no more representative of the American people than
my boot. American cartoonists haven't bothered to see their own President. They
just take an accepted cliché and let it go at that."

Unsurprisingly, to many of his American colleagues Low came across as an
imperious interloper; his remarks provoked Hearst cartoonist Nelson Harding to
first claim he had never heard of Low and then to resort to a chauvinism worthy of
his employer: "As soon as any Englishman lands, he starts knocking something." [1]

But timing is everything, and the Englishman's harangue may have stung his
American brethren all the more because it came at a low point in their fortunes.
Newspaper publishing was embattled by 1936 and nowhere more so than in New
York City. The daily political cartoon was introduced in 1884 in Joseph Pulitzer's
World and quickly became one of the features that both defined and fueled the spec-
tacular rise of the mass-circulation newspaper at the turn of the century. [2] Much
had changed, though, in the ensuing 52 years (including the demise of Pulitzer's
World in the merger of the *World-Telegram* in 1931). The industry's troubles started
long before the 1929 stock market crash, but the Great Depression and consequent
decreasing sales and advertising revenues took a further toll on the city's daily
newspapers, adding to the merging of struggling papers and the slow but inevitable
death of others. [3]

Economic health notwithstanding, Low's criticism of American cartoonists' lack of originality was too generous an estimation. By the late 1930s the trade of political cartooning in the United States was perhaps less attuned to the tenor of the nation's political debate, let alone that of international conflict, than at any other point in its history. A majority of the newspaper and magazine publishers in the country were owned and controlled by wealthy Republicans and from 1932 onward their editorial pages and accompanying cartoons opposed the Roosevelt administration. Whatever the impact of their textual commentary, the papers' cartoons greeted the achievements and failures of the administration with a mix of exuberance and outrage that often bordered on the hysterical in equating the New Deal as an outright threat to the Republic. "Never had cartoonists and public opinion been on such separate tracks," concluded Stephen Hess and Milton Kaplan in their comprehensive study of American political cartoons, "and never had each so little effect on the other." [4]

This national trend was most startling in its New York manifestation. With the exception of the liberal *New York Post*, the daily newspapers defied the diversity of the city's population and perspectives to, instead, offer a conservative vision of domestic politics as well as of the international crisis that over the course of the decade increasingly intruded into Americans' perusal of the news. To be sure, the cartoons that appeared on the papers' editorial pages did not offer a single vision; Rollin Kirby in the *World-Telegram* and Clarence D. Batchelor in the *Daily News* often diverged from the anti–New Deal opinions expressed in adjacent editorials. Moreover, by the latter half of the 1930s, editorials and editorial cartoonists reluctantly began to acknowledge the mounting threat of European fascism.

But in 1936, as the acid test of Spain revealed, New York political cartoonists' engagement with foreign affairs revealed little effort to decipher the origins of the civil war, not to mention the consequences of the United States' and European governments' policy of "neutrality." Even taking into account the necessary haste and improvisation that daily cartoon commentary on the news required (assisted by the speed and dramatic impact of using lithographic crayons or brushes on textured paper), the iconography they employed and the messages they conveyed substantiated Low's criticism. Worse, in stark contrast to David Low's quick and sharp-eyed evaluation of the Spanish Rebel uprising and his immediate identification of its German and Italian underwriters (Figure 1), New York's political cartoonists offered general revulsion at the outbreak of war modified by an exquisitely balanced equanimity toward the two sides of the conflict: in short, isolationism and xenophobia wrapped in an amusing costume marked "objectivity." [5]

It was the moderates among New York cartoonists who set the tone of the visual response to the July 1936 uprising, relying on an exotic representation of Spain in the form of a threatened aristocratic *dueña*, replete with *mantilla* and flowing skirts. Jerry Doyle's "The Spanish Tango" in the liberal *New York Post* interpreted the crisis as a dance of death (Figure 2), while Clarence Batchelor in the *New York Daily News* showed a similar *dueña* desperately clinging to a swinging pendulum labeled "Civil War." Rollin Kirby's allegorical victim in his *World-Telegram* cartoon envisioned a worse fate for the Spanish *dueña*/nation: crucifixion on a cross also labeled "Civil War" (Figure 3). [6]

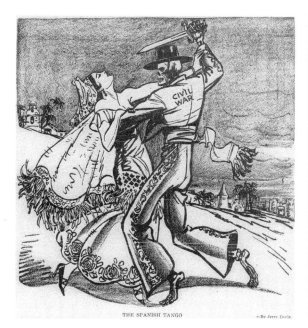

THE SPANISH TANGO —By Jerry Doyle.

FIGURE 2
**Jerry Doyle,
"The Spanish Tango,"
New York Post,
July 23, 1936.**

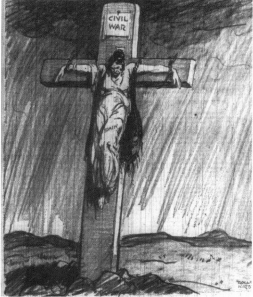

FIGURE 3
**Rollin Kirby,
"Crucified,"
New York World-Telegram,
July 28, 1936.**

FIGURE 4
**Jay N. (Ding) Darling,
"A Night in Spain,"
*New York Herald
Tribune*, November
12, 1936.**

Clarence Batchelor's July 1936 cartoon reiterated the message of his Pulitzer-Prize winning contribution published the previous April, showing "War" as a death's-head prostitute luring "Any European Youth" up into her lair, uttering the chilling invitation to "Come on in, I'll treat you right. I used to know your daddy." As a barometer of mainstream opinion, the Pulitzer Prize conferred legitimacy on a view of the European crisis as filtered through an isolationist lens: an antiwar position that, ruing American involvement in World War I, saw no distinctive issues or causes in the contemporary European situation. [7] It was a perspective shared by the cohort of New York political cartoonists—although Jay N. Darling, the doyen of U.S. cartoonists, better known to his readers as "Ding," reduced the view in the pages of the *New York Herald Tribune* to its cruelest essence: civil war as the murderous expression of Latin temperament (Figure 4). [8]

"A plague on both your houses" may have characterized the view of many New York newspaper cartoonists, but those in the employ of William Randolph Hearst were less reserved about taking sides. Franco found his champion in the pages of the myriad publications comprising the national Hearst press, albeit couched in a host of code words and murky symbols that gave the publisher and his three New York papers a thin cover of deniability.

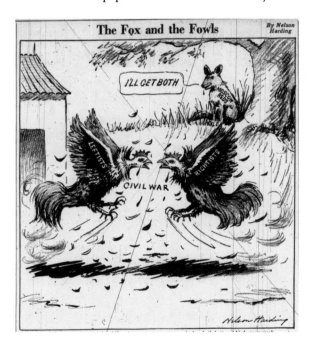

ABOVE: FIGURE 5
Nelson Harding, "The Fox and the Fowls," *New York Evening Journal*, **July 28, 1936.**

With beak and spur and thrashing wing
 The fowls engage savage fight.
Conveniently near at hand
 The hungry fox enjoys the sight.
And as both battered birds grow weak,
 The fox will pounce down from his lair,
And with a hearty appetite
 Dine well upon the helpless pair.

BELOW: FIGURE 6
Dorman H. Smith, "A Sacrifice to Communism," *New York American*, **November 13, 1936.**

White bones and homesteads black
 In futile tragedy.
The centuries turn back
 To primal savagery.
As class meets class in hate
 There is no war so vain,
No land so desolate
 As fratricidal Spain.
 —George E. Phair
(Phair was a sports columnist known for his light-verse commentary, which occasionally moved onto the editorial page.)

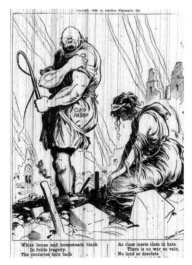

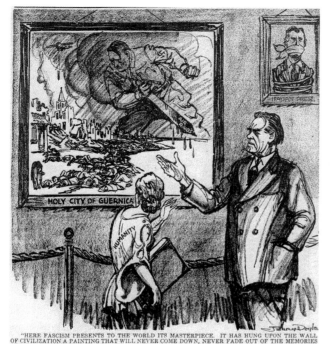

"HERE FASCISM PRESENTS TO THE WORLD ITS MASTERPIECE. IT HAS HUNG UPON THE WALL OF CIVILIZATION A PAINTING THAT WILL NEVER COME DOWN, NEVER FADE OUT OF THE MEMORIES

FIGURE 7
Jerry Doyle, "'Here Fascism presents to the world its masterpiece. It has hung upon the wall of civilization a painting that will never come down, never fade out of the memories of men....'—Borah," *New York Post,* May 11, 1937.

FIGURE 8
C. D. Batchelor. "Practice," *New York Daily News,* May 7, 1937.

Nelson Harding, in the July 23, 1936 edition of Hearst's *New York Evening Journal,* first seemed to share his cartooning compatriots' perspective, offering an alarming image of a huge "Civil War" bomb with a lit dual fuse, the intertwining strands of which spelled out "Communism" and "Fascism." But any doubt as to Harding's true concerns—and certainly that of his publisher, who was notorious for interfering in his newspapers' editorials and political cartoons—were dissipated five days later in "The Fox and Fowls." Showing a "Moscow Reds" fox drooling at the sight of two fighting cocks, labeled respectively "leftists" and "rightists," the predator exclaimed, "I'll get both" (Figure 5). [9]

By November, as Franco's forces mounted an all-out assault on Madrid, Hearst's cartoonists had honed their message using the more lurid yet still opaque term "class warfare." Nelson Harding depicted "Spanish Civilization" as a torpedoed and sinking ocean liner, its helpless passengers leaping overboard, as a "Ruthless Class War" submarine slid into view in the foreground. [10] If readers were confused by the meaning of the term—especially since Harding's cartoon resurrected memories of the 1915 sinking of the passenger ship *Lusitania* by a German U-boat—they only had to consult Hearst's morning newspaper, the *New York American,* for clarification. Under a banner reading "A Sacrifice to Communism," Dorman Smith's November 13, 1936 cartoon showed the bestial figure of "Class Hatred," whip in hand, looming over a stricken female Spain, a ruined church smoldering in the background (Figure 6). [11]

147

FIGURE 9
Frederick Little Packer, "'The Weaker Sex!'"
***New York Daily Mirror*, May 5, 1937.**

FIGURE 11
Burris Jenkins, Jr., "Seeing 'Red' in Spain," *New York Evening Journal*, April 30, 1937.

FIGURE 10
Nelson Harding, "Their Proving Grounds,"
***New York Evening Journal*, April 30, 1937.**

Spain, the bomb-torn territory
Used by European powers
As a proving ground for testing
All their latest modern weapons.
Here experiments and tryouts
Of the murderous inventions
For the next great war in Europe
Desolate that hapless nation.

FIGURE 12
Helen E. Hokinson, "Mrs. Purvis is just back from Spain. She says they're wearing their skirts *quite* short," *The New Yorker*, November 20, 1937.

Until 1939, New York political cartoonists, in tandem with their fellow practitioners across the country, were more preoccupied with the tumultuous domestic matters of political campaigns, industrial conflict, and New Deal policies than with the looming international crisis. But while Spain for the most part lay on the periphery of cartoonists' attention, critical moments in the conflict briefly returned the civil war to graphic prominence. The brutality of the April 26, 1937 aerial bombardment of the Basque town of Guernica was one such event that provoked protests across the spectrum of mainstream newspaper cartooning. Jerry Doyle's May 11th *New York Post* cartoon offered readers a literal transcription of William E. Borah's May 6th speech on the floor of the Senate, depicting the Idaho Republican gesturing towards fascism's "masterpiece," a gruesome "painting that will never come down, never fade out of the memories of men"—presaging, albeit in non-cubist terms, Picasso's celebrated work completed three months later (Figure 7). Responding much more quickly to the bombardment of civilians, in a series of cartoons the *Daily News*' C. D. Batchelor nonetheless seemed to go through a process of absorbing the significance of the event. In the wake of the bombing, a May 2nd cartoon and editorial focused on brutality in Spain, but by contrasting "un-American" bull fighting with baseball (the two sports reputedly expressing the polar essences of two national characters). The next day, Batchelor offered another set of contrasts that indirectly condemned the bombing, comparing "the olden days" when men left women at home as they went off to war versus the present where, in the form of an aerial attack, the "war now comes to her." By May 7th, however, Batchelor finally homed in on the perpetrators of the act: showing a child crouched over the corpse of his mother as bombers disappeared over the horizon, the cartoon was framed

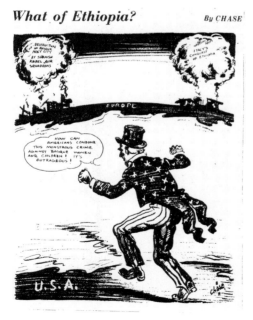

FIGURE 13
Chase, "What of Ethiopia?"
New York Amsterdam News, May 15, 1937.

FIGURE 14
Julio Girona, "'Piqueteando' en la calle 14," *La Voz*, November 25, 1938.

¿Y qué ha dicho la patrona?
Que "cuando gane" Franco
indemnizará a sus vasallos.
　　And what did the patroness say?
　　That "when Franco wins"
　　she will compensate her vassals.

by a prominent headline: "PRACTICE. General [sic] Goering reported pleased with German plane performance in Spain" (Figure 8).

Guernica put Hearst in a difficult position from which his cartoonists extricated themselves by using imaginative, if not outright deceptive, tactics. Fred L. Packer's "'The Weaker Sex!'" in the May 5th tabloid *Daily Mirror* managed to employ "cheesecake" while addressing the plight of Basque women (Figure 9). "Barelegged Basque Fisherwomen," the lengthy caption explained, "attacked invading Italians fighting with Spanish Insurgents, [and] threw them into the sea. Any woman, Basque or Italian, will fight like tigers for their homes." Here, gender conveniently trumped politics—and not a plane in sight! Meanwhile, in the pages of the *Evening Journal* Nelson Harding proposed that all sides were guilty (Figure 10): underneath a drawing of "Big Powers New Armaments" planes bombing a "Spain" target, a typical Harding verse caption declared: "Spain, the bomb-torn territory / Used by European powers / As a proving ground for testing / All their latest modern weapons." [13]

FIGURE 15
William Gropper, "They Shall Not Pass," *Daily Worker,* **September 4, 1936.**

But in the same issue of the *Evening Journal*, Harding's cartoon was dwarfed by popular sports cartoonist Burris Jenkins, Jr.'s pictorial homage to the newspaper's Spain correspondent, H. R. ("Red") Knickerbocker (Figure 11). Rendered more lavishly and with greater detail than the typical daily political cartoon, Jenkins's drawing pictured the intrepid reporter (an admirer of Franco) against a threatening background dominated by the Grim Reaper, surrounded by vignettes of his exploits and hazardous encounters in Spain: Knickerbocker as the journalistic equivalent of a sports star. Faced with the sagging circulation of all his newspapers, not to mention the inconvenience of aerial bombings carried out by former columnists Benito Mussolini and Adolf Hitler, Hearst directed attention to the most important protagonist in the Spanish story—his newspaper and, by extension, himself. In keeping with the fickle nature of pictorial commentary, within a week or two Hearst and his competitors' political cartoonists were once again preoccupied with domestic matters, including a sensational New York-based disaster, the destruction of the *Hindenburg*.[14]

In short, the Republic found little support in the daily press's political cartoons. But the universe of New York's visual commentary extended beyond the pages of mainstream newspapers. The civil war permeated the city's consciousness and regularly emerged in a range of publications that captured the diversity of its print culture. Spain preoccupied a spectrum of cartoonists, from Helen E. Hokinson's wry observations of socially conscious affluence in the fashionable *New Yorker* (Figure 12), to denunciations of the bombing of Guernica (and questions about the comparative lack of outrage at the Italian conquest of Ethiopia) in Harlem's *Amsterdam News* (Figure 13). [15] And in the *ne plus ultra* American immigrant city, a myriad of foreign-language newspapers presented their distinctive constituencies with ongoing pictorial commentary on Spain. With the views of Franco and his adherents in the Catholic Church well represented by Hearst's cartoonists, [16] the ethnic press became a locus of pictorial support for the Republic, especially in the numerous local periodicals affiliated with the Communist Party. The Spanish-language *La Voz,*

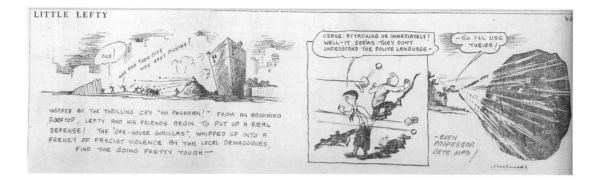

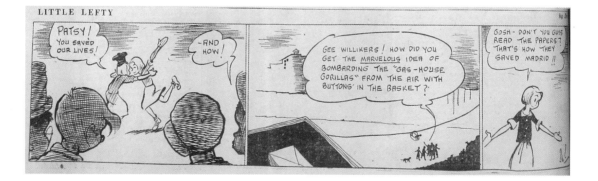

FIGURE 16

Maurice Del Bourgo ("Del"), *Little Lefty,*
Daily Worker, **(from top) August 6, 1937;**
August 7, 1937; August 19, 1937.

FIGURE 17
**Phil Bard,
"Artist and Model!"
Daily Worker,
July 30, 1936.**

FIGURE 20
**C. D. Batchelor,
"Franco Choice,"
New York Daily News,
April 4, 1939.**

FIGURE 19
Rollin Kirby, "The Old Librarian Adds Another Volume," *New York World-Telegram*, March 29, 1939.

STRATEGY

by Ell

—"and that is where our Trotzky reserves are most active"

FIGURE 18
Fred Ellis, "Strategy," *Daily Worker,* **May 7, 1937.**

—"and that is where our Trotzky reserves are most active."

for example, featured the work of the young Cuban artist Julio Girona whose cartoons often focused on the fortunes of the Republic and machinations of fascist Italy and Germany—and revealed some of the ways the civil war split New York's Spanish-speaking communities (Figure 14). [17]

One New York daily newspaper was a consistent and vocal champion of the Spanish Republic: the *Daily Worker*. In the capable hands of new editor and veteran journalist Clarence Hathaway, the Communist Party's newspaper emerged in late 1935 out of the sectarian "Third Period" to embrace the Popular Front, quickly attracting readers beyond the party faithful with the style and substance of a provocative radical tabloid. In keeping with the new vision of Communism as "20th-century Americanism," Hathaway expanded the paper's coverage of news in the United States—and particularly in New York—introducing entertainment features and arts criticism, a popular sports page, comic strips, and daily political cartoons. And from 1936 to 1939 a repertory company of cartoonists rallied support for the Spanish Republic, in the process demonstrating, in contrast to the mainstream daily press, intimate knowledge about events transpiring across the Atlantic. [18]

To be sure, the shift to the Popular Front did not change a reliance on certain revolutionary visual tropes that often substituted for invention when drawing a daily cartoon was up against deadline. Many if not most of the cartoons by staff artists Fred Ellis, William Gropper, Phil Bard, and others featured stalwart workers (in Spain and America) and thuggish and simian fascists and exuded an optimism often at odds with the actual fortunes of the Republic. At their best, though, as exemplified in William Gropper's bold and precise drawings (which often reappeared in the Party-affiliated Yiddish press), they succeeded as miniature mobilization posters (Figure 15). [19]

One of the key subjects for such mobilization was recruitment for and assistance to the Abraham Lincoln Brigade and its international volunteer counterparts. With frequent allusions to the volunteers' perpetuation of founding American ideals, *Daily Worker* cartoons exhorted readers to attend rallies and concerts in support of the Lincoln Brigade, eschewing the detachment professed by contemporary mainstream political cartoonists. [20] The paper's most unusual graphic organizing device was found in its daily sports page comic strip *Little Lefty*, the radical answer to Harold Gray's notoriously conservative, anti-New Deal *Little Orphan Annie*. Drawn by Maurice Del Bourgo, who also produced early issues of *Classics Illustrated* comic books, the adventures of its spunky hero and his gang of progressive urban adolescents often involved Spain and the Lincoln Brigade (Figure 16) and featured letters from young readers to promote donations to aid children in the Spanish Republic. [21]

In their ardent depiction of heroic Spanish Republican workers and American volunteers, the *Daily Worker* cartoons expressed in graphic form the broad progressive and internationalist sentiments of many New Yorkers that were otherwise absent from the daily press. Moreover, the paper's pictorial commentary often breached editorial cartooning etiquette by directly attacking newspapers, publishers, and reporters sympathetic to Franco. Indeed, cartoons such as Phil Bard's pungent July 1936 portrayal of Hearst's reportorial methods (Figure 17) were some of the *Daily Worker*'s most original and effective visual assaults. (Bard would leave his drawing table for Spain in December as one of the first American volun-

teers.)[22] Occasionally, though, events in Spain revealed cracks in the Communist Party newspaper's adherence to the ecumenical vision of the Popular Front. Fred Ellis's "Strategy" (Figure 18), published shortly after the May 1936 Barcelona uprising, aligned with the Comintern's view of the protest led by the dissident Catalan-based POUM party, showing German Foreign Minister Konstantin von Neurath and Benito Mussolini gazing fondly at the city "where our Trotzky reserves are most active." [23]

By 1939, the threat of fascism in Europe was a familiar theme in most of the city's daily news coverage and editorial commentary. Yet, for the most part, the victory of Franco's Rebel forces in March was interpreted by New York's political cartoonists with the same equanimity they had exhibited at the start of the civil war. Under the caption "The Old Librarian Adds Another Volume," Rollin Kirby in the *World-Telegram* showed Father Time resignedly sliding the history of the Spanish conflict onto a bookshelf already laden with other infamous "works" of 20th-century warfare (Figure 19). Some readers may have wondered why the new book was labeled simply "Spanish Civil War" while its neighbors carried the less objective titles of "Italy's Conquest of Ethiopia," "Germany's Rape of Austria," and "Germany's Grab of Czechoslovakia." On the other hand, Hearst's *Journal-American* (the result of the merging of his morning and evening newspapers in 1937) hid its pro-Franco sentiments in cartoons by Nelson Harding that rued the tragedy of civil war, featuring Death taking a holiday and a giant dove circling above a rubble-strewn Spanish landscape. [24]

FIGURE 21
Gardner Rea, "They Call It Peace," *New Masses*, April 11, 1939.

On the other hand, the *Daily News'* Clarence Batchelor once again went through a series of cartoons in a process of working out the consequences of the Republic's fall. From a restrained drawing of the female figure of Mercy gazing over the shoulder of a pensive Franco (captioned with the first lines of Portia's "Quality of mercy" speech from *The Merchant of Venice*), Batchelor's next cartoon turned to a more sinister setting. Borrowing from Jean-Léon Gérôme's popular 1872 painting of the Roman gladiatorial arena, the second cartoon, entitled "Thumbs Up or Thumbs Down?," depicted the *Generalissimo* as an emperor peering down at a victorious "Nationalist Army" fighter poised to kill his vanquished "Loyalist Spain" foe. Three days later, a final cartoon made the "Franco Choice" explicit (Figure 20). But Batchelor's plea for mercy remained couched—as it had been since 1936—in a moral position that focused on the amorphous tragedy of civil war and not the consequences of fascist victory. [25]

For the political cartoon supporters of the Spanish Republic, the consequences were all too obvious. Although the *Daily Worker* persisted in upholding an optimistic viewpoint throughout the brutal fighting and defeats of 1938—including paeans to the Abraham Lincoln Brigade as the volunteers disbanded and returned to

the United States—Fred Ellis's cartoons in the wake of Franco's victory mordantly portrayed "Fifth Column" celebrations in the streets of Madrid and accurately predicted the vicious retribution to follow.[26] But it was Gardner Rea in the *New Masses*, the Communist Party's weekly magazine of politics and culture, who with chilling elegance and awful succinctness captured the horrific meaning of Spanish fascism triumphant (Figure 21).[27]

Endnotes

1 "Cartoon Critic: London Caricaturist Finds American Colleagues Lack Originality," *Literary Digest*, November 21, 1936, 31–32.

2 The "breakthrough" daily political cartoon was an attack on Republican presidential candidate James G. Blaine by Walt McDougall, "The Royal Feast of Belshazzar Blaine and the Money Kings," *New York World*, October 30, 1884. Among many works on the history of political cartoons, see Stephen Hess and Milton Kaplan, *The Ungentlemanly Art: A History of American Political Cartoons* (New York: Macmillan, 1968; revised ed., 1975); Roger A. Fischer, *Them Damned Pictures: Explorations in American Political Cartoon Art* (North Haven: Archon Books, 1996).

3 In 1925 there were fifteen daily New York papers; by 1930 the number was thirteen; and five years later the total had dwindled to ten. On the condition of the New York newspaper industry during the 1930s, see Paul Milkman, *PM: A New Deal in Journalism, 1940–1948* (New Brunswick: Rutgers University Press, 1997), 10.

4 Hess and Kaplan, *The Ungentlemanly Art*, 151.

5 David Low, "Progress of 'Civilization' in Spain" (November 1936), reprinted in idem, *A Cartoon History of Our Times* (New York: Simon and Schuster, 1939), 71. As this cartoon's reference to Franco's "Moorish" troops indicated, Low's critical perspective of the Spanish conflict was at times compromised by a casual racism.

6 Jerry Doyle, "The Spanish Tango," *New York Post* (hereafter NYP), July 23, 1936; C. D. Batchelor, "The Pit and the Pendulum," *New York Daily News* (hereafter NYDN), July 22, 1936; Rollin Kirby, "Crucified," *New York World-Telegram* (hereafter NYWT), July 28, 1936.

7 Batchelor's cartoon, published in the April 25, 1936 *New York Daily News*, won the 1937 Pulitzer prize. The theme continued in Doyle's and Batchelor's cartoons during the Rebels' November assault on Madrid: Doyle, "'I'm proud of you, son; you're doing a swell job!'" NYP, November 10, 1936; "Their Only Conquest," NYP, November 24, 1936; Batchelor, "'I Win,'" NYDN, November 10, 1936. See also Edwin Marcus, "Bullets and Ballots," *New York Times*, July 26, 1936.

8 Jay Norwood ("Ding") Darling, "A Night in Spain," *New York Herald Tribune*, November 12, 1936. Darling dispatched his brush-stroke commentary from his Des Moines home to the *Herald-Tribune*, which nationally syndicated his cartoons. Darling's derision was only outdone by Will B. Johnstone's bizarre "An Old Spanish Custom," NYWT, August 4, 1936, which seemed to suggest that the Latin temperament was ill-suited for anything as serious as civil war. Johnstone divided his time at the drawing table with co-writing a number of the Marx Brothers' plays and films.

9 Nelson Harding, "The Fuse and the Bomb," *New York Evening Journal* [hereafter NYEJ], July 23, 1936; idem, "The Fox and the Fowls," NYEJ, July 28, 1936. See also, T. E. Powers, "Wake Up America! Asleep on His Job—Are We Going to Let the Red Tide Engulf Us?" ibid. The bomb motif also appeared in Cowan's "Burning the Bomb at Both Ends," *New York Daily Mirror* [hereafter NYDM], July 29, 1936. On Hearst's instructions to cartoonists, see David Nasaw, *The Chief: The Life of William Randolph Hearst* (Boston: Houghton Mifflin, 2000), 478. On Hearst and the Spanish Civil War, see ibid., 551–52; Allen Guttmann, *The Wound in the Heart: America and the Spanish Civil War* (New York: Free Press, 1962), 56–57; F. Jay Taylor, *The United States and the Spanish Civil War, 1936–1939* (New York: Bookman Associates, 1956), 123–24.

10 Nelson Harding, "Cause and Effect," NYEJ, November 18, 1936; see also, idem, "The Modern Inferno," NYEJ, November 12, 1936, and T. E. Powers, "I See by the Papers," NYEJ, November 9 and November 11, 1936.

11 Dorman H. Smith, "A Sacrifice to Communism," *New York American* [hereafter NYA], November 13, 1936. The cartoon was positioned adjacent to an editorial entitled, "The Price of Civil War," which began: "The Spanish civil war, brought about mainly by the excesses of Reds and radicals seeking power, is now in its seventeenth week." See also, Malone, "The Lighted Match," NYA, November 10, 1936.

12 Jerry Doyle, "'Here Fascism presents to the world its masterpiece. It has hung upon the wall of civilization a painting that will never come down, never fade out of the memories of men....' — Borah," NYP, May 11, 1937. C. D. Batchelor, "One Sunny Afternoon," *New York Sunday News*, May 2, 1937; idem, "In the olden days man left woman to go to war. That is no longer necessary. The war now comes to her," NYDN, May 3, 1937; idem, "Practice," NYDN, May 7, 1937. As if to counter the impact of Batchelor's last cartoon, the adjacent *News* editorial admonished that, "These war reports from Spain are sickening. But it would be even more sickening if we were mixed in it... The thing for us to do is to keep our emotions under control and our Navy strong enough to keep us out of any war."

13 Frederick Little Packer, "'The Weaker Sex!,'" NYDM, May 5, 1937; Nelson Harding, "Their Proving Grounds," NYEJ, April 30, 1937. See also, Dorman H. Smith, "Spring Comes to Spain," NYA, May 4, 1937.

14 Burris Jenkins, Jr., "Seeing 'Red' in Spain," NYEJ, April 30, 1937; idem, "Gibbons Tells Jenkins of War Writer's Perils," ibid. On Knickerbocker, see Guttmann, *The Wound in the Heart*, 57. Hearst's New York papers were hard-hit by the Depression, their circulations declining throughout the 1930s (exacerbated by a number of anti-Hearst boycotts): Nasaw, *The Chief*, 529. On Mussolini and Hitler as columnists, ibid., 470–77.

15 Helen E. Hokinson, "Mrs. Purvis is just back from Spain. She says they're wearing their skirts *quite* short," *The New Yorker*, November 20, 1937 (see also, September 26, 1936 and May 1, 1937); Chase, "What of Ethiopia?" *New York Amsterdam News*, May 15, 1937.

16 Although periodicals affiliated with the Catholic Church did not refrain from publishing their own cartoons: see, for example, the murderous Republican ape in "Let All of Us Join in Prayer," *Brooklyn Tablet*, October 24, 1936 [see ch. 8 of this book].

17 Julio Girona, "'Piqueteando' en la calle 14" ("Picketing on 14th Street"), *La Voz*, November 25, 1938.

18 Harvey A. Levenstein, "*The Worker*, Cleveland, Chicago, and New York, 1922–1924; *Daily Worker*, Chicago and New York, 1924–1958," in *The American Radical Press, 1880–1960*, Volume One, ed. Joseph R. Conlin (Westport: Greenwood Press, 1974), 224-43; Paul Buhle, "*Daily Worker*," in *Encyclopedia of the American Left*, ed. Mari Jo Buhle, Paul Buhle, Dan Georgakis (New York: Oxford University Press, 1990; second ed., 1998), 174–78.

19 William Gropper, "They Shall Not Pass," *Daily Worker* (hereafter DW), September 4, 1936. Gropper's distinctive style, if ever so slightly subdued, also found an audience beyond the political left in fashionable publications such as *Vanity Fair*. For other examples of heroic resistance, see: Phil Bard, "'We'll Do the Job!'," DW, July 21, 1936; William Gropper, "The Workers on Guard," DW, July 27, 1936; Redfield, "A New Spanish Custom," DW, August 2, 1936; William Gropper, "Full Support," DW, September 2, 1936; Fred Ellis, "They Shall Not Pass," DW, November 15, 1936; idem, "Deliver a Knockout Blow," DW, May 1, 1937; idem, "Defenders of Bilbao," DW, June 16, 1937; idem, "The Answer," DW, July 15, 1937. While it had its share of rousing illustrations and cartoons, the weekly Party-affiliated *New Masses* also offered cartoons with a wry humor more reminiscent of *The New Yorker*: see, for example, Gardner Rea (who also contributed to *The New Yorker*), "'Oh well, if the Fascists did it, that's different!'" *New Masses*, January 5, 1937.

20 See Fred Ellis, "Rally in Union Sq. Today!" DW, November 28, 1936; idem, "Lincoln Brigade Fighting for Spain," DW, March 18, 1937 (the latter's citation of the volunteers' patriotic roots were echoed in William Sanderson, "Traditional Americanism?" *New Masses*, March 2, 1937); Dixon, "Tonight! For Spain!" DW, July 19, 1937.

21 *Little Lefty* started in 1934 and ran, with a few interruptions, until 1943, but its stories from 1936 to 1939 focused on Spain (during which time Lefty headed the "Junior Friends of the Abraham Lincoln Battalion," distributing membership buttons to readers). On *Little Lefty*, see: Allan Holtz, *Stripper's Guide*, April 18, 2006 (http://strippersguide.blogspot.com/2006/04/obscurity-of-day-little-lefty.html). *Little Lefty* had the place of honor on the sports page while other *Daily Worker* comic strips during the late thirties were gathered on their own page, including such humor and adventure serials as: *Barnacle and the Fink*, *Buttons*, *Point of Information* (mimicking Hearst's *Ripley's Believe-It-Or-Not*), *Muffy the Monk*, *Tex Travis*, *Sir Hokus Pokus*, and the tantalizingly titled *Molly McGuire*.

22 Phil Bard, "Artist and Model!" DW, July 30, 1936; see also, William Gropper, "Gropper's Almanac: Diary of a Hearst Correspondent," *Sunday Worker*, August 23, 1936.

23 Fred Ellis, "Strategy," DW, May 7, 1937.

24 Rollin Kirby, "The Old Librarian Adds Another Volume," NYWT, March 29, 1939; Nelson Harding, "'Death Takes a Holiday,'" *New York Journal American*, March 30, 1939; idem, "Happy Landing?" *New York Journal American*, April 10, 1939.

25 C. D. Batchelor, "'The quality of mercy is not strained....,'" NYDN, March 30, 1939; idem, "'Thumbs Up or Thumbs Down?'" NYDN, April 1, 1939; idem, "Franco Choice," NYDN, April 4, 1939.

26 For the Abraham Lincoln Brigade, see: Fred Ellis, "In the Same Book," DW, October 9, 1938; idem, "America Will Welcome Lincoln Battalion Home," DW, October 10, 1938. For cartoons assessing the war's aftermath, see: Fred Ellis, "Out of Madrid Sewers," DW, March 30, 1939; idem, "Halt the Spanish Fascist Axman!" DW, March 31, 1939.

27 Gardner Rea, "They Call It Peace," *New Masses*, April 11, 1939.

"THE LIFTED FIST:" PERFORMING THE SPANISH CIVIL WAR, NEW YORK CITY, 1936-1939

BY PETER GLAZER

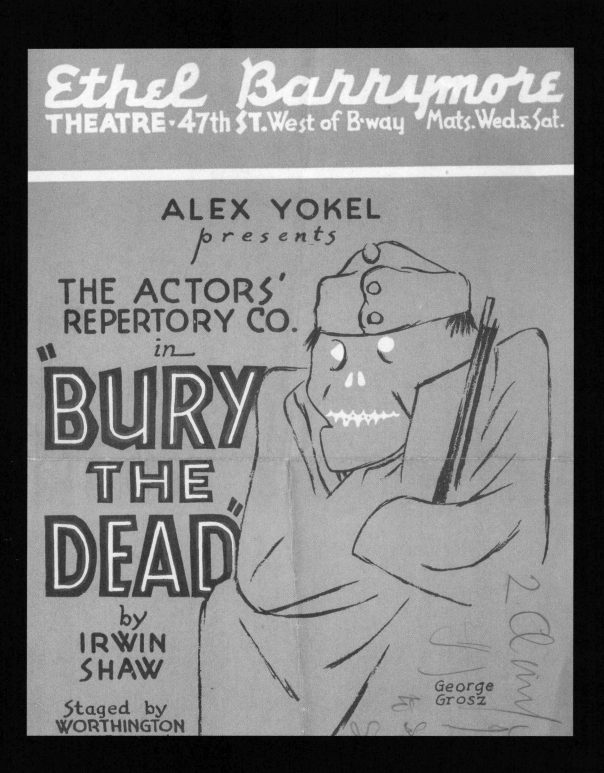

PREVIOUS SPREAD
**Martha Graham
performs "Deep
Song", 1937 (detail).
Photograph by
Barbara Morgan.**

ABOVE
**Window card for
Irwin Shaw's 1936
play Bury the Dead.**

"For the love of God—listen to me! While you sit here eating and drinking, to-night, Italian planes are dropping twenty-thousand kilos of bombs on Paris. God knows how many they killed. God knows how much of life and beauty is forever destroyed! And you sit here, drinking, laughing with them—*the murderers!...* [W]*e stand together! France—England—America! Allies!... The free democracies against the Fascist tyranny!"*

—Quillery, from *Idiot's Delight* by Robert Sherwood, March 1936.

N SEPTEMBER 19, 2005, IN New York City at the Great Hall in Cooper Union, a group calling itself "Artists Against War" staged a reading of Irwin Shaw's 1936 play *Bury The Dead* to protest the war in Iraq and raise funds to aid war victims on both sides of the conflict. Forty actors took part in the performance. [1] In Shaw's anti-war drama—which originally premiered in New York on April 18, 1936 and ran through the first five months of the Spanish Civil War—six dead soldiers rise from the dirt to tell the world of the horrors of war. "I would regard it as a criminal plot against my life if the United States involved itself in a war," Shaw wrote in *The New York Times* May 3, 1936, "and dragged me into its army to fight for it against some other young men just as eager as I to stay alive in this bright and pleasant world." Shaw's sentiments were not uncommon in the years and months before Franco began his own war drama on the international stage in July 1936, and even after the Spanish Civil War began. That Shaw's play remains relevant 70 years later is a sorry testament to the state of the world, but also a reminder that the issues and desires surrounding the Spanish Civil War manifest in performances during that period were, and are, pressing. The stage is a place where a culture performs its dreams and its nightmares; where tensions are expressed and ideological battles exposed.

Though Shaw's play was not about Spain, its sentiments were immediately pertinent. Many who went to Spain believed they were fighting to save the peace; to prevent another world war; to stop fascism before it was too late. The play quoted in the epigraph, Robert Sherwood's *Idiot's Delight*, opened at the Shubert Theater in March 1936, won the Pulitzer Prize in May and did not close until late January 1937,

six months after the war began and a month after the first U.S. volunteers traveled to Spain. A vehicle for Alfred Lunt and Lynne Fontanne, Sherwood's "leg show and frivolity... are played against a background of cannon calamity," Brooks Atkinson wrote in his opening night review. "Having fought in the last war and having a good mind and memory, [Sherwood] is also acutely aware of the dangers of a relapse into bloodshed throughout the world today." Among the main characters are an arms merchant and a French radical, Quillery, trapped with a number of other international travelers in a resort in the Alps as war is imminent. "While they are unhappily waiting Mr. Sherwood has time to deliver a number of hard-fisted statements about war in general and international politics in particular," Atkinson reported. [2] Quillery's speech, made just before he is dragged off to a firing squad for his leftist sentiments, perfectly and harrowingly anticipates the Spanish Civil War, though France stands in for Spain as the fascist target. The play was written six months before the war in Spain began. This was mainstream Broadway theater and the winner of the Pulitzer Prize, with two of Broadway's biggest stars. Leg show and all, world politics and Sherwood's own anti-war sympathies and fears provided both context and content for the thousands who saw his play.

Cast members of *You Never Know* (left to right) Lee Stephenson, Mary Ann Carr, Alice McWhorter, and Mildred Riley, at the headquarters of the Relief Ship for Spain, ca. 1938.

Idiot's Delight may have been a significant commercial and critical success, but there were many other performances in New York City surrounding the Spanish Civil War that dealt more directly with the conflict. Two other plays written during and about the war that reached Broadway did not actually premiere until after it was over, but shared distinguished pedigrees: Maxwell Anderson's *Key Largo* and Ernest Hemingway's *The Fifth Column*. Paul Muni played a disillusioned American volunteer in the former, which ran for three months, and Lee Strasberg directed an adaptation of the latter in 1940, which Hemingway despised, Atkinson loved, and ran for only 87 performances. Neither was commercially successful. [3] But it was primarily lower profile theater practitioners and the left-leaning dance community who took on the Spanish Civil War with more artistic passion, specificity, and, by most accounts, success.

"Though Spain has rocked with civil war for eight months," *Time* magazine reported in March 1937, "until last week the New York stage had seen no drama based upon the conflict. That lack was remedied by the Allied Theatre, a workers' and technicians' semiprofessional acting company." [4] The play was *Spain Laughs* by Joseph S. King, which had a brief tryout run at the Manhattan Lyceum Theater on East 4th Street, now the La MaMa Experimental Theater Club. [5] "Apparently having taken a good look at Clifford Odets' high-powered *Waiting for Lefty*," *Time*'s critic wrote, "King has planted his story in proletarian soil behind the Loyalist lines outside Madrid," but "instead of Lefty... King's characters are waiting for the general of the people's army." The play espoused a pro-Loyalist stance, and like Odets' play, it was constructed as a series of vignettes. In one, "a prostitute promises to reform, help the government cause;" in another, "a man quarrels with his son for joining the *milicianos*, then volunteers himself." A "hand-picked... partisan audience" enjoyed the performances, but the play was not deemed to have commercial Broadway potential. [6]

Higher expectations might have greeted the arrival of Irwin Shaw's play *Siege* at the Longacre Theater in December 1937, after the success of his one-act *Bury the Dead*, but it was leveled by an unusually vituperative Brooks Atkinson. "Mr. Shaw pours out a good many prose poems about dying, machine-gun bullets and love, and curses up and down the set like a man who cannot think under heaven what to say. The talk has no form, no style, and no point of view behind it." It did not matter in the end, Atkinson stated, because the scenery was so bad it distracted from *any* point of view, and the director "has no idea what it is all about... and so everyone is well met." Though finding *Siege* barely intelligible, Atkinson suggested that Shaw "has abandoned his anti-war program in favor of fighting the Rebels in Spain," a not uncommon change of heart at the time, grounded in politics more than dramaturgy. Much of the left, and many others, moved from the sentiments of *Idiot's Delight* to those of *Siege*. Whatever Atkinson's political inclinations—and he did not hesitate to praise "the drama of the Left" as "increasingly dynamic" in March 1935 or favorably review Hemingway's *The Fifth Column* in 1940—he gave no quarter to what he considered ham-handed writing and execution.[7]

Other, smaller productions may have made sharper, cleverer statements. *Time* was wrong in stating that *Spain Laughs* was the first drama on the war to reach the New York stage. On September 20, 1936, Kenneth White's musical piece *Who Fights This Battle?* saw five performances in the Hotel Delano Grand Ballroom at 103 West 43rd Street, produced by the Theatre Committee for the Defense of the Spanish Republic. Directed by 26-year-old Joseph Losey and with a score by Paul Bowles, Earl Robinson was musical director, and Nicholas Ray and Norman Lloyd were in the cast.[8] The play chronicled Spanish history from the departure of King Alphonso in 1931 and the formation of the second Republic to what was then the present day. "A lively, dramatized documentary on the political situation in Spain," Bowles wrote, *Who Fights This Battle?* "had a staunchly anti-Fascist coloration, as indeed it should have." The event raised $2,000, forwarded to Madrid's minister of education. The last song, "Lullaby," performed by a woman singing "to wounded and tired Loyalist soldiers... exhorts the audience to reaffirm their commitment to the struggle against fascism even while they may sleep: 'Dream for us / Freedom—/ You who fight, / Sleep, and fight. / Sleep, now. Sleep.'"[9] So much had changed since *Bury the Dead*.

John D. Shout, in an essay on American plays about the war in Spain, mentions two other interesting small-scale productions presented in New York City: Michael Blankfort's 1937 *The Brave and the Blind* and Theodore Kaghan's 1938 comic one-act *Hello, Franco*. Blankfort's play, which dealt with the siege of the Toledo Alcázar by Loyalists in

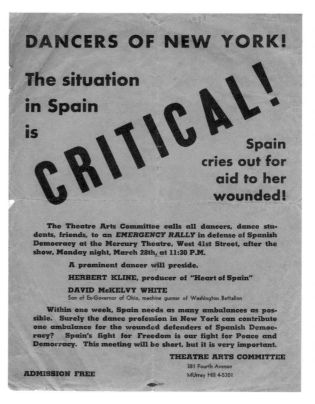

DANCERS OF NEW YORK!

The situation in Spain is **CRITICAL!**

Spain cries out for aid to her wounded!

The Theatre Arts Committee calls all dancers, dance students, friends, to an *EMERGENCY RALLY* in defense of Spanish Democracy at the Mercury Theatre, West 41st Street, after the show, Monday night, March 28th, at 11:30 P.M.

A prominent dancer will preside.

HERBERT KLINE, producer of "Heart of Spain"

DAVID McKELVY WHITE

Son of Ex-Governor of Ohio, machine gunner of Washington Battalion

Within one week, Spain needs as many ambulances as possible. Surely the dance profession in New York can contribute one ambulance for the wounded defenders of Spanish Democracy? Spain's fight for Freedom is our fight for Peace and Democracy. This meeting will be short, but it is very important.

THEATRE ARTS COMMITTEE

381 Fourth Avenue

ADMISSION FREE MUrray Hill 4-5301

Flyer of the Theater Arts Committee, March 1938.

**Costumed dancers of
the Federal Theater
Project production
Guns & Castanets,
one of several theater
pieces to address the
Spanish civil war, 1939.**

**Dancer Consuelo
Moreno performing
at a benefit meeting
for the Relief Ship for
Spain, ca. 1938.**

PREVIOUS SPREAD
**Martha Graham
performs *Deep
Song*,1937.
Photographs by
Barbara Morgan.**

166

1937, was first produced by the Rebel Arts Players at Labor Stage, 432 West 44th Street, to raise money both for the Republic and for American sharecroppers. Kaghan placed six members of the Abraham Lincoln Brigade—described as "a typically multi-ethnic Popular Front cross-section"—in a house equipped with a telephone near the front lines. Awaiting orders but convinced the phone will never work, the volunteers imagine calling their arch enemy. "I don't like to seem crude, Franco, but I think you stink," one states aloud, phone in hand. "That's right. As a matter of fact, everybody I know thinks you stink." A second volunteer "calls" the Rebel leader while in the guise of a well known newspaper magnate: "Hello, Franco, this is Willie. Yeh. Willie Hearst, your boss. Listen, Franco, you're not doing so well.... The last time you lost a battle I lost the *New York American*... you got to make the war more colorful. My readers like color." They conclude with a call to Hitler, depart the house without any orders, and the phone they had thought broken finally rings down the curtain on an empty stage.[10] *Hello, Franco* was produced at the Mercury Theater by the New Theater League, also responsible for a revival of *The Brave and the Blind*.

Theater was certainly not the only performance genre addressing the situation in Spain. As chronicled by Ellen Graff, dancers were among the most outspoken artists advocating left-wing causes in their work, and the Spanish Civil War gave many a focus for their radical beliefs. Even Martha Graham, of bourgeois upbringing and not predisposed to the concerns of the working class, "emerged as a political choreographer" in 1936 and 1937. Graham's 40-minute *Chronicle*, which premiered December 20, 1936, less than a week before the first organized group of U.S. volunteers shipped off from New York City, did not deal directly with the war in Spain, but did speak to Graham's own "fears for the world." The titles of its three sections create a narrative of their own: "Dances Before Catastrophe: Spectre—1914 and Masque," "Dances After Catastrophe: Steps in the Street and Tragic Holiday," and "Prelude to Action." Soon after, she created two solo pieces inspired by the Spanish Civil War: *Immediate Tragedy* and *Deep Song*. In both cases, as reviewed in *Dance Observer*, the Spanish struggle was made to resonate beyond its specifics: "It is not Spain that we see in her clear impassioned movement; it is the realization that Spain's tragedy is ours, is the whole world's tragedy. The dedication is not a Spaniard's; it is an American's."[11]

Angna Enters had been in Spain at the time of the rebellion and created two dances drawing upon her experiences there. *Flesh Possessed "Saint"—Red Malaga. 1936* and *Spain Says "Salud!"* were performed at the Alvin Theater on Broadway in late December 1936, where the latter received an ovation, according to *The New York Times*, marred only by "one persistent hisser."[12] Other dancer/choreographers were moved to make dances about the war demonstrating their solidarity with the Loyalist cause: Lily Mehlman's 1937 suite *Spanish Women*, Sophia Delza's *We Weep for Spain* and *We March for Spain*, and Jane Dudley and Sophie Maslow's *Women of*

"I MUST KEEP FIGHTIN'"

"I want to go to Spain," Paul Robeson stated
in 1937. He was already a huge celebrity—having
received ovations for *Show Boat* and *Othello* in
London, *The Emperor Jones* and *All God's Chillun
Got Wings* in New York City, and in scores of
concert engagements. An avowed antifascist, he
donated his earnings from *Chillun* to Jews fleeing
Hitler in 1933. The Spanish Republican cause
became his passion. "He called upon people of
color everywhere to participate in the Spanish
struggle 'against the new slavery,'" Martin
Duberman wrote in *Paul Robeson: A Biography*.
In June 1937, Robeson interrupted a vacation in the
Soviet Union and flew to London to participate in
a mass rally at Royal Albert Hall organized to aid
refugees from Spain's Basque region. "The artist
must take sides," he famously said. "He must elect
to fight for freedom or for slavery. I have made my
choice." Seven months later, he crossed the border
into Spain to perform for the troops, the only
major American artist to do so.

He began at the hospital in Benicasim,
singing in three different locations within an hour.
Soldiers surrounded Robeson the moment he
was recognized, as they did everywhere he went,
"astonished" that it was really him. He took special
pleasure meeting the black volunteers: Ted Gibbs,
Claude Pringle, Frank Warfield, Andrew Mitchell.
He traveled to Albacete and then Tarazona, where
he sang in a church packed with 1,500 members of
the Brigade the day before they headed to the front.
He sang "Water Boy," "Lonesome Road,"
and "Fatherland." The volunteers were ecstatic.
"It was just like a magnet drawing you," one of
them said, "as if somebody was reaching out to
grasp you and draw you in."

One of the constant requests was for "Ol'
Man River," which Robeson had made famous
in *Showboat*, but he did not sing the same lyrics

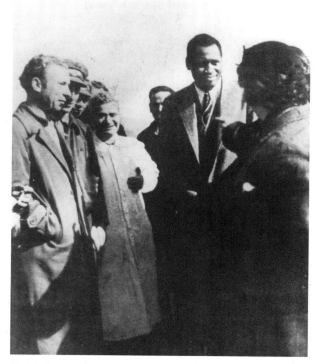

**Paul Robeson with
an unidentified group in
Spain, January 1938.**

he sang in the show. He had first performed this
altered version at a second Albert Hall rally a
month before he went to Spain, and the change
had a tremendous effect. At this moment in
history, for this man and his audience, Oscar
Hammerstein II's penultimate line—"I'm tired of
livin' and scared of dyin'"—would not hold, no
matter how celebrated the song. "The battlefront
is everywhere" Robeson had intoned. Robeson
turned Hammerstein's lyric of defeat into a
rallying cry. "I must keep fightin' until I'm dyin',"
he sang, and the crowds exploded in joy and
applause. When the volunteers from Tarazona
moved to the front on January 27, 1938, that lyric
must have been ringing in their ears. [1]
—Peter Glazer

1 Drawn from Martin Bauml Duberman's *Paul Robeson*,
 New York: Knopf, 1988 and "Journey into Spain" by Eslanda
 Goode Robeson, collected in *The Heart of Spain: Anthology of
 Fiction, Non-Fiction and Poetry*, edited by Alvah Bessie, New York:
 Veterans of the Abraham Lincoln Brigade, 1952.

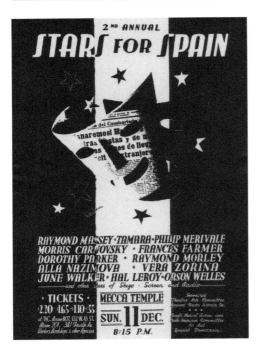

Spain, which empathized with the plight of Spanish peasant women.[13] A benefit, *Dance for Spain*, organized by the Medical Bureau to Aid Spanish Democracy, was presented at the Adelphi Theater in May 1937. It featured work by Delza, Mehlman, José Limón, Charles Weidman, Anna Sokolow, and well-known dancer/choreographer Helen Tamiris.[14]

Tamiris also created *Adelante* for the New York dance unit of the WPA. In this work, a dying Loyalist soldier, shot by a fascist firing squad, looks back on Spanish history and "the struggle of his people for democracy."[15] Unapologetically pro-Loyalist, and choreographed during the war and at a time when the Federal Theater Project was under scrutiny by the House Committee on Un-American Activities, sections of the piece were considered too controversial by Hallie Flanagan, head of the FTP. Drawing on material from WPA files, Elizabeth Cooper details Flanagan's attempts to soften the dance's political message and iconography. Among other comments recounted by Cooper, Flanagan suggested that a scene satirizing the Rebel generals be cut, that both the fascist and Loyalist salutes be "abstracted," and, on a similar note, that a line from the narration—"the lifted fist proclaims its challenge in the face of death"—be removed entirely.[16] Originally intended to be performed during the Spanish conflict, *Adelante* was not seen until April 20, 1939 at Daly's Theater, after the war was over. The delay, Cooper suggests, was not accidental, but the result of censorship of the strongly political piece by the government-funded FTP.

It may have been censored and lost the impact it might have had if presented during the war itself, but *Adelante* reached the stage nonetheless, and it surely offered audiences a way to think about the war now lost, the practiced impotence of the Western democracies, the many kilos of bombs dropped on Madrid and Barcelona, the life and beauty forever destroyed. As in Irwin Shaw's 1936 anti-war play, where only the dead are endowed with the knowledge and perspective to inform the living, in Tamiris' dance it is a dying soldier, felled by a firing squad—also Quillery's fate—who leads the audience through history to help them understand the present and, hopefully, their responsibility to the future.

TOP
Playbill for Irwin Shaw's 1937 play, *Siege*.

BOTTOM
Flyer for second annual *Stars for Spain* benefit, ca. 1938.

Endnotes

1 *Upon These Boards.* "Bury the Dead: A Theatrical Act of Peace." Copyright 2003-2005 Upon These Boards: http://www.uponheseboards.org/production/bury__project.htm.

2 Brooks Atkinson, "Alfred Lunt and Lynne Fontanne Appearing in Sherwood's 'Idiot's Delight,'" *New York Times*, 25 Mar. 1936, 25.

3 John D. Shout, "Staging the Unstageable: American Theatrical Depictions of the Spanish War," *The Spanish Civil War and the Visual Arts*, Western Societies Program, Occasional Paper number 24, Center for International Studies, Cornell University (1990), 78-80.

4 "Spain Laughs," *Time*, 22 Mar. 1937.

5 "News of the Stage," *New York Times*, 3 Mar. 1937, 26.

6 "Spain Laughs."

7 "Drama of the Spanish Revolution, With Words by Irwin Shaw and Sets by Geddes," *New York Times*, 9 Dec. 1937, 31.

8 Eric Winship Trumbull, "Musicals of the American Workers' Theatre Movement — 1928-1941: Propaganda and Ritual in Documents of a Social Movement," Dissertation, University of Maryland, 1991: http://www.nvcc.edu/home/etrumbull/diss/ch4.htm.

9 Trumbull.

10 Shout 80-81.

11 Henry Gilfond quoted in Ellen Graff, *Stepping Left: Dance and Politics in New York City, 1928–1942* (Durham: Duke U P, 1997), 121.

12 John Martin, "The Dance: Two Events," *New York Times*, 12 Dec. 1936, X10. John Martin, "Miss Enters Gives Recital of Dances," *New York Times*, 28 Dec. 1936, 15.

13 Graff 120, 121.

14 John Martin, "The Dance: WPA Theatre," *New York Times*, 16 May 1937, 17.

15 Elizabeth Cooper, "Dances About Spain: Censorship at the Federal Theatre Project," *Theatre Research International*, 29.3 (2004), 241.

16 Cooper 241.

LEGACIES

OF THE

SPANISH CIVIL WAR

IN NEW YORK

BY STEVEN H. JAFFE

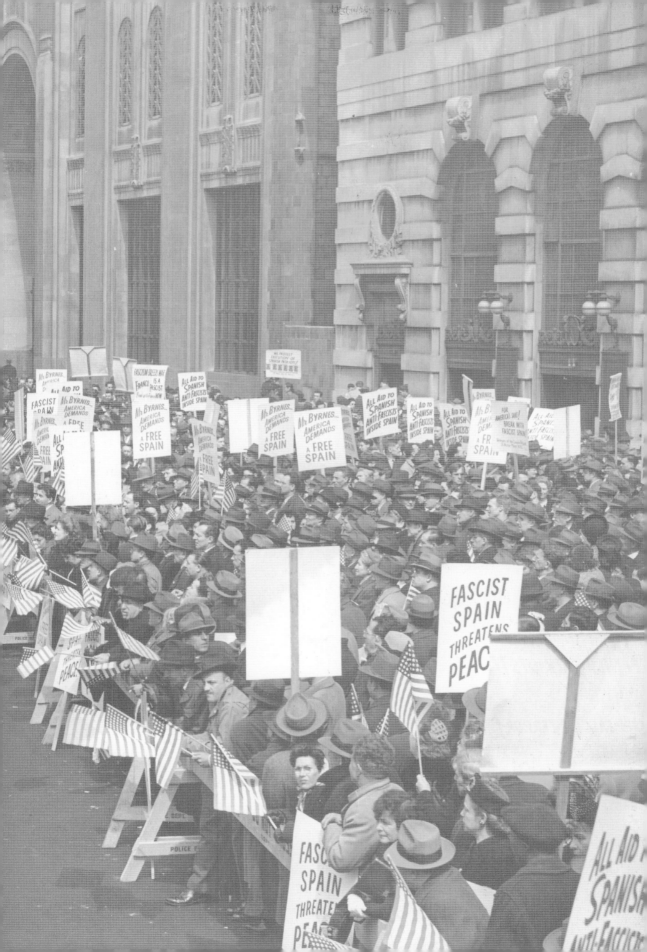

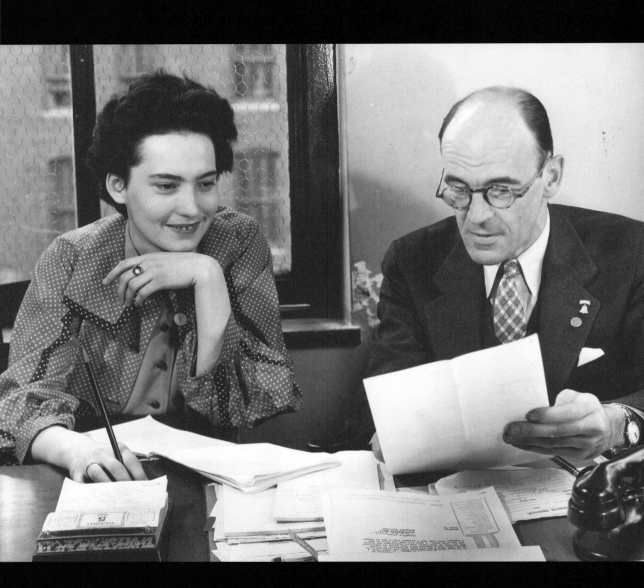

PREVIOUS SPREAD
**Former Lincoln-
Washington Battalion
Commander Milton
Wolff addresses crowd
at a rally outside
Madison Square
Garden, ca. 1946.**

ABOVE
**Kate Lenthier and
David McKelvy
White in the office of
the Friends of the
Abraham Lincoln
Battalion, ca. 1938.
Lenthier's husband
John was fighting in
Spain, and White had
recently returned.**

Yet you remain, Madrid, the conscience of our lives.
— Edwin Rolfe, *Elegia*, 1948

REAKING NEWS:
Generalissimo Francisco Franco is still dead!" With these words, "anchorman"
Chevy Chase commenced a gag that ran for several weeks on "Saturday Night Live,"
a new comedy series broadcast from New York in the fall of 1975. While the line
has become part of our collective memory of the '70s, most forget the joke's origi-
nal point. As Chase read President Ford's statement lauding the late Generalissimo
as a trusted friend of the United States, a photograph from the 1930s appeared on
screen, showing Franco and Adolf Hitler standing together, right arms raised in the
fascist salute. It was fitting that a New York-based program reminded the rest of
the country of Franco's true colors and of the surreal Cold War logic that had made
him an American ally. Just as New York had been the city outside Europe where the
Spanish Civil War had mattered most, New Yorkers remained passionately involved
in the causes and ideologies of the Spanish struggle in the decades to follow. As
an emblem of political identity, as a badge of personal commitment to a constel-
lation of values, and as a source of what historian Peter Glazer has labeled a "radi-
cal nostalgia" that sustains and energizes political engagement, the Spanish Civil
War has lingered long in the city's conscious memory, and also as a deep seedbed
whose presence is not always obvious. Many of her generation would agree with

novelist Josephine Herbst, who reflected in 1966 that "nothing so vital, either in my personal life or in the life of the world, has ever come again." But if "Spain" as a watchword and symbol continued to bring New Yorkers together in common cause, it just as frequently divided them over the implications of the civil war for the city's, nation's, and world's future. Franco may have stayed dead in 1975, but New Yorkers have kept the Spanish Civil War alive for seven decades. [1]

As the war drew to a close in early 1939, the Spanish struggle still resonated across the city, from the West Side docks where a cheering crowd greeted returning Lincoln Battalion veterans in December 1938, to Flushing Meadows, where "Lincolns" served as security men for the Soviet Pavilion at the 1939–40 World's Fair. In December 1937, Steve Nelson, William Lawrence, and David McKelvy White had founded the Veterans of the Abraham Lincoln Brigade (VALB) in New York as a national organization for the estimated 1,500 American combatants who would ultimately return from Spain. About 600 of these veterans, the largest number in any one place, settled or resettled in the Greater New York City area. In a larger sense, folksinger and activist "Sis" Cunningham reminisced in 1999, "all of us, even if we never left the United States, had to come back from Spain." [2]

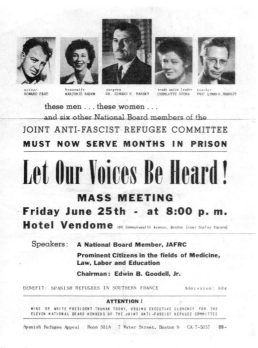

Flyer for a mass meeting in response to the jail sentencing for board members of the Joint Anti-Fascist Refugee Committee, 1950.

Yet the meaning of the veterans' war record and their monolithic identity as freedom fighters were immediately challenged from within and without. In a prelude to McCarthyism, in 1938 Congressman Martin Dies's committee began investigating ties between the Communist Party and Lincoln Brigade recruitment and in 1940 subpoenaed three New York-based veterans to testify. In 1940 the FBI also searched and ransacked VALB's national office in Manhattan. Meanwhile, a small number of New York veterans openly broke with both the VALB and the Communist Party. Some alleged that the Party acted in an authoritarian manner both within the Brigade in Spain and in the VALB. Other alienating factors included Stalin's purges and the Nazi-Soviet Pact of 1939, which theoretically converted the German butchers of Guernica into the Lincoln veterans' allies. Some of the dissidents had never been Communists; others renounced their earlier allegiance, or were kicked out of the Party. "The Communist Party had thrown the hammer and sickle out of the window," declared veteran Henry Thomas, "while I was fighting fascists in Spain." Fellow veteran Morris Maken proposed forming an alternative, anti-Stalinist veterans' group, but the proposal came to nothing. The majority of Lincoln veterans remained Communists. Few were willing to criticize the very real interpenetration of the Party and Brigade leadership. [3]

Indeed, while the cause of Republican Spain had stirred New Yorkers of every leftist orientation, the conduct of the war itself divided them. Much like George Orwell, New York Trotskyists and independent Marxists such as the writer-activists Herbert Solow, V.F. Calverton, Lionel Trilling, Anita Brenner, William Phillips,

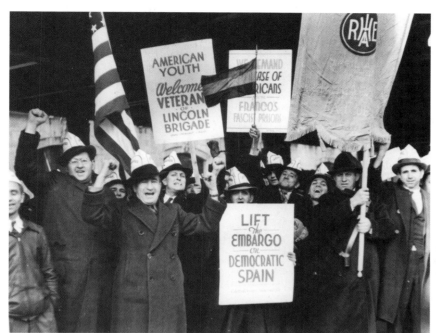

Rally to welcome
returning members of
the Lincoln Brigade to
New York, ca. 1938.

and Philip Rahv and the anarchist Carlo Tresca all viewed the Stalinist suppression of left-wing parties and militias in Spain as a continuation of the appalling Moscow Purge Trials, proof that Stalin had betrayed the revolution. When these writers blasted Stalin's record in Spain in the pages of *Partisan Review* or the *Socialist Appeal*, Communist intellectuals like the poet and Lincoln Brigade soldier Edwin Rolfe responded by denouncing their "stinking pro-Fascist actions." Such conflicts continued to embitter New York's literary life long after the war ended. Archibald MacLeish and John Dos Passos ended their friendship with Ernest Hemingway over Hemingway's indifference to the Loyalist execution of two Spanish writers as "traitors." The feud between sometime Communist Lillian Hellman and former Trotskyist Mary McCarthy began at a 1940 dinner party at Sarah Lawrence College, where Hellman ridiculed Dos Passos's having "sold out" on Spain because he didn't like Spanish food, and McCarthy replied that Dos Passos's true motivation was the Communist execution of the POUM leader Andrés Nin. [4]

For most New York leftists and liberals, however, such disputes became irrelevant with the Nazi invasion of Russia in June 1941 and Japan's attack on Pearl Harbor. Now progressives could point to the Spanish conflict as the dress rehearsal for the general war against fascism to which the U.S. was finally committed. John Gates, Lincoln veteran and head of the Young Communist League, volunteered for the army at the Whitehall Street induction center and led his fellow enlistees in the Pledge of Allegiance. The cause of Spain—"the Good Fight"—remained a common denominator for the coalition who had joined together in the mid-1930s Popular Front around such issues as labor unionism, racial equality, antifascism, and a generally sanguine view of the Soviet Union. Through the 1940s, left-affiliated New York labor unions proudly welcomed Lincoln veterans into their ranks.

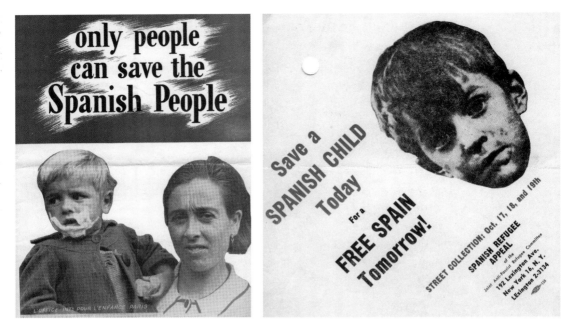

1939 flyer appealing for aid for Spanish refugees.

Flyer for "Save a Spanish Child" week in New York, ca. 1939.

More broadly, for rank-and-file merchant seamen, garment workers, furriers, cigar makers, electrical workers, teachers, and other union members, rallying and raising funds for Republican Spain and refugee relief were part of the enduring culture of the labor movement. Picketing Spanish ships at the docks, or making donations to the Joint Anti-Fascist Refugee Committee (JAFRC) and other groups aiding Loyalist refugees in France and North Africa, remained a badge of left-wing and labor identity during the '40s and '50s.[5]

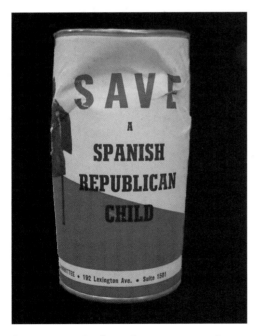

Collection can for Spain that was presented as evidence against Julius and Ethel Rosenberg during their espionage trial in the early 1950s.

Similarly, New York periodicals appealing to the left wing of the New Deal urban coalition kept Spain alive through anti-Franco exposés. Especially notable was the daily *PM*, which during its short life (1940-48) challenged the Army on its discriminatory "anti-subversive" treatment of Lincoln veterans, warned of Spanish government "fifth columnists" seeking to infiltrate American institutions, and, in the reportage of I.F. Stone, implicated the U.S. government for allowing the sale of oil to Franco that found its way into Hitler's tanks and planes. For union members, progressive journalists, and their allies, Spain remained a touchstone of having been right all along about fascism, and of the need for vigilance against its continuing manifestations around the world.[6]

The onset of the Cold War, however, marked such "premature antifascism" as a target for government investigators. In fact, the harassment unleashed by the Dies Committee in 1938 had continued through the war years. Archibald MacLeish complained to J. Edgar Hoover

in 1942 that "any association with Loyalist Spain is given as a basis of suspicion of loyalty to the United States," and some government workers lost their wartime jobs for affiliating with or donating to pro-Republican groups. The late '40s and '50s brought a concerted assault on the Communist ties and "fellow traveling" of Lincoln veterans and Loyalist sympathizers in New York and throughout the country. In 1946 the House Un-American Activities Committee subpoenaed 16 members of the executive board of JAFRC, an organization founded in 1942 in New York to provide humanitarian and medical aid to Loyalist refugees in France. When the board refused to hand over its records to the Committee, 11 members, including the novelist Howard Fast and Dr. Edward Barsky, who had treated battle casualties in Spain, went to prison in 1950. In 1947, President Truman's attorney general placed the Abraham Lincoln Brigade, the VALB, and the JAFRC on an official list of subversive organizations. The following year New York Board of Education

member George Timone, an avowed Franco admirer, sought to purge the schools of members of the CIO Teachers Union, who had raised money for JAFRC and other "front" organizations.[7]

When Senator Joseph McCarthy launched his crusade against Communists in 1950, one of his first targets was Spanish émigré Gustavo Duran, a former State Department employee and now a United Nations functionary in New York. During the civil war Duran had been an officer in the SIM, the Spanish Communist counterpart to the Soviet secret police, although Duran denied any wrongdoing. The taint of Republican Spain became *prima facie* evidence of sub-

The pamphlet *Spain and Vietnam,* by Lincoln Brigade veteran Robert Colodny, was translated and distributed in Spain in addition to its U.S. edition.

version and disloyalty. After all, the red-hunters triumphantly asked, had not the Soviet spies Julius and Ethel Rosenberg once collected money in Times Square under the slogan, "Save a Spanish Republican Child"? Did not Gustavo Duran attend a 1951 meeting commemorating the Spanish Republic? Duran was finally cleared by a Loyalty Board in 1955, but the larger message was unambiguous.[8]

McCarthyism coincided and intersected with the genesis of a new American right in New York for whom the civil war was still very much alive. The group of intellectuals who formed around William F. Buckley, Jr.'s *National Review* (1955) included Roman Catholic conservatives and disgruntled ex-Trotskyists and ex-Communists who defended McCarthy's attempts to ferret out unregenerate supporters of Republican Spain from government. While lay Catholics might be divided over the Spanish legacy, the Church hierarchy remained ardently pro-Franco, as exemplified by New York Archbishop Francis Spellman's cordial 1946 meeting with the Spanish foreign minister in Madrid. Groups like the Catholic War Veterans and Knights of Columbus also continued to laud Franco for his anticommunism and defense of Catholicism. Buckley drew on this tradition, as well as on the energies of ex-Trotskyists James Burnham and his own Yale mentor Willmoore Kendall, both of whom had turned rightward in response to Communist conduct in

AFTERWARDS

It is possible to walk down New York streets without being shot at, to work without listening for sirens, to sleep in a bed and to take many showerbaths. There is much food to be bought and the water is good to drink. All over New England are weekend lakes each with its sunlight, birches and pines, canoes, laughter, and sunsets. Along the seacoast it is possible to lie in the sand and later, when the light begins to fail, to look out over the ocean towards Spain until vision melts into darkness and night blinds the eyes.

Dogs had to be shot because they developed unpleasant carnivorous appetites. Four shellshocked infantrymen stood solemnly at the side of the road, powerless as mileposts to dig for their comrades who had just been buried by a shell. We blew up two trapped ambulances. Captain R. lost his hand-knitted winter socks when the laundress blew up in her home with her father, mother and two small brothers. We took the blood out of four asphyxiated cavalrymen before they were cold and ran it into the arms of the wounded. We did not talk of women, we did not dream of women, and there were no dirty jokes. When the planes come really close it is not possible to smoke. Lice are not such a nuisance. Acorns, olives pulled off the trees by moonlight and wild onions taste good. No surgeon has amputated a hand so neatly as a bomb sheared the suede gloved wrist of a nurse. Lieutenant E. had his teeth fixed in Barcelona for ten packages of Lucky Strikes.

Was it really true that the English anti-tank company had cut a week's firewood with explosive shells when there were no axes? Why was it that a nurse gained twenty pounds in a year on a diet of rice-bread, onions and oranges? Why didn't the mechanic in the front line mobile garage go home when he heard that he had inherited fifty thousand dollars? How is it possible for a driver to keep on the road for sixty hours and why is it possible to sleep at the wheel without crashing? How had the Companies of Steel, in the early days stopped tanks, planes and cavalry with their big hearts and bare hands? Why were there so many dead horses and mules? Why was it so hard to tell fresh-bombed houses from old-bombed houses, and new dead from old dead? Why did the wounded lie so still and so seldom cry out? Had we been able to catch those rabbits so easily

because they were shellshocked? Why did the sight of an old woman at midnight far from any town hobbling her way towards the rear affect us more than rows of dead?

How could so little hatred have been possible? Quietly the newspapers in the cities talked of "the Invaders" or, more simply, of "Them." No one read or spoke of "the enemy" or of "the fascists." Since hatred was the daily business of life, since They always performed exactly as we knew They would, there was little anger no fists brandished at the sky no loudmouthed radio denunciations no cursing in the streets or up at the lines unless a very close friend got what all of us, sooner or later, knew we would get.

The rain had washed the color out of the banners hung out during the early days of processions and excitement. If there were bands I did not hear them. Only the posters on the walls of the towns villages and gardens were fresh. Medals, reviews, gold braid and dappled neurotic martial horses had always been missing and were not regretted. There was little saluting in the cities and less at the front. We had the best semi-professional army ever to be wholly recruited trained and seasoned, against the wish and with the opposition of most of the War Nations, during wartime in Europe. Hungry for Their infantry, our steel jaws could snap only at the air. Our ravenous squinting eyes so seldom sighted down the barrels of our rifles anything that was human.

We always had the feeling of having our hands held behind our backs. The Republic was flogged like a horse tied up short at the head by enemies it could not reach.

We killed naturally and with constant gnawing desire to kill more and more, but we hated death and war and we could never manage to think of ourselves precisely as soldiers.

James Neugass

REPRINTED FROM "WAR IS BEAUTIFUL," AN UNPUBLISHED MANUSCRIPT, WITH THE PERMISSION OF THE JAMES NEUGASS ESTATE.

James Neugass drove an ambulance in Spain for six months, including at several battles, before he was wounded and sent home in 1938. He later published several novels and volumes of poetry, and died of heart failure on a subway platform in Greenwich Village in 1949.

CUARTEL GENERAL DEL GENERALISIMO

ESTADO MAYOR

SECCION DE OPERACIONES.

PARTE OFICIAL DE GUERRA

correspondiente al día 1º. de Abril de 1939.- III Año Triunfal

En el día de hoy, cautivo y desarmadó el Ejército rojo, han al-
canzado las tropas Nacionales sus últimos objetivos militares.

LA GUERRA HA TERMINADO.

BURGOS 1º. de Abril de 1939
Año de la Victoria
EL GENERALISIMO,

Last Franco communique: "The war has ended," April 1939.

Spain and other Stalinist depredations. For 20 years, as it became a mouthpiece for American conservatives, *National Review* questioned Franco's one-man rule but also praised him as the "national hero" who had put down the "grotesque" Republic. This distinctive New York strain of conservatism would echo in President Reagan's 1984 remark that the Lincoln Brigade had fought on "the wrong side." [9]

Yet the civil war also continued to resonate within the city's New Deal political coalition, long after the demise of the Popular Front. For many postwar liberals in New York, the Spanish Republican cause remained what it had always been: the call to arms to put down fascism, not a summons to embrace Marxism. At the same time, New York's New Deal tradition remained distinctive in its taking for granted a far left presence in the city's public heritage. For labor leaders, clergymen, civil rights advocates, and other non- and anticommunists in New York's liberal establishment, Lincoln veterans could be championed as freedom fighters rather than as red heroes. For many New Yorkers of the Spanish Civil War generation into the 1960s and 1970s, memories of the civil war era were part of a nostalgia for the Popular Front moment—a moment when one did not have to be a Communist to find exuberant common cause with others in supporting positions significantly to the left of the American political mainstream. For New York's liberal Democrats, members of the American Labor and Liberal parties, Democratic Socialists, and liberal ex-radicals, that historical moment continued to underpin commitment to progressive change at home and abroad, whether envisioned as gradual or abrupt.

Spain also provided a bridge between the Old Left of the '30s and a New Left emerging in the 1960s. Early in the decade, history professor Dante Puzzo used an emblematic geography to prod his City College students to confront the choices that lay ahead: "Those of you who desire a comfortable, safe, risk-free life, I'll see you in Scarsdale. But those of you who want to do something more courageous, who want to change the world, I'll meet you in Madrid!" For some among the

young, the choice between the suburbs and the barricades was already embodied in songs being strummed on guitars in Greenwich Village coffeehouses. Both Woody Guthrie and Pete Seeger's Almanac Singers had made their New York debuts at fundraisers for Spanish refugee relief in 1940 and 1941, and the Lincoln Brigade songs recorded by Seeger, Tom Glazer, and Bess and Baldwin Hawes in New York in 1944 (and reissued in 1961-62) echoed down through anti-Cold War hootenanies and clandestine singalongs in Spain itself. At the 1964 Newport Folk Festival, Phil Ochs joked that, "I wouldn't be surprised to see an album called 'Elvis Presley Sings Songs of the Spanish Civil War'..." Ochs wrote and sang a ballad condemning American travelers for supporting Franco's regime with their tourist dollars. As they immersed themselves in the Civil Rights movement or the anti-Vietnam War protests, some young New Yorkers ignored or dismissed what Bob Dylan had come to call the "politics of ancient history." But others found an idealism and defiance they could embrace in the old Spanish "protest songs." Democratic Socialist Michael Harrington, a veteran of '50s singalongs at the Village's White Horse Tavern, confessed in 1977 that "I had read and internalized my Orwell; I knew the crimes committed by the GPU in the name of antifascism in Spain; and yet, I never cease to thrill at the songs of the International Brigade." [10]

Veterans of that brigade provided the most vigorous and complex linkages between Old and New Lefts, in New York as elsewhere. While the national number of surviving "Lincolns" steadily diminished, down to fewer than 400 by the 1980s

Christmas season stamps urging aid to Spanish refugees, ca. 1938.

and to about 50 today, veterans acted on their political convictions time and again, either as official representatives of the VALB or on their own. For 35 years, every rapprochement in relations between the United States and Franco brought forth the Lincolns to picket consulates and government offices: to demand Franco's trial as a war criminal in 1945; to protest federal loans to Franco's government in 1950-51, the Spanish-U.S. military treaty of 1953, Spain's admission to the United Nations in 1955, and its presence at the New York World's Fair of 1964. Lincoln veterans repeatedly sought to keep the fate of Spain in the newspapers and on the diplomatic agenda, especially in pleas for amnesty for Franco's political prisoners. [11]

Such activism translated into work for other causes. In the late '30s and early '40s, veterans and their friends picketed against Japanese and Italian imperialism and French indifference to the plight of Loyalist refugees. Veterans successfully fought the "whites only" residential policy in Long Island's Levittown in 1947, paraded in Harlem in 1965 in solidarity with the Selma civil rights protest, and marched on the Pentagon with other anti-war activists in 1967. Their berets and clenched fists were conspicuous at rallies against South African apartheid, Reagan's Central American policies, Pinochet's regime in Chile, the nuclear arms race and, most recently, the Iraq War. Along with Lincolns belonging to posts in the Midwest and West Coast, New Yorkers raised funds to send ambulances, wheelchairs, and hospital generators to Cuba, Nicaragua, and El Salvador. [12]

Yet such activism did not represent some mythical solidarity in the face of adversity. The veterans often disagreed with each other, sometimes bitterly, and with

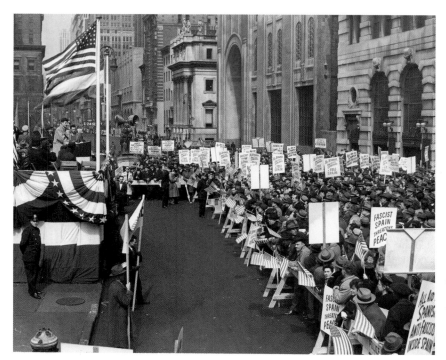

Former Lincoln-
Washington Battalion
Commander Milton
Wolff addresses crowd
at a rally outside
Madison Square
Garden, ca. 1946.

an intensifying abandon, as McCarthyism, Franco, and the Cold War subsided. Internal conflicts between Communists and non-Communists almost destroyed VALB by 1979, when a policy revision broke the impasse by committing the organization to activism only on issues for which a consensus could be reached. This solution, however, did not end arguments over policy, ideology, and history between veterans and their allies both inside and outside VALB. One of the most painful disputes involved recriminations over a 1986 *Village Voice* article in which veteran William Herrick charged that Oliver Law, the first black man in American history to command white troops, had been executed in Spain by his own soldiers for cowardice under fire. Veterans and scholars argued heatedly about the case as if its events had occurred yesterday, not 50 years before. [13]

Memories of the Spanish war have continued to exert a hold on New Yorkers. From the Abraham Lincoln Brigade Archives in the Tamiment Library at New York University to the City College plaque honoring students and faculty killed in Spain, from pride in the 42-year sanctuary for Picasso's *Guernica* at the Museum of Modern Art to debates over the politics of the Catholic group *Opus Dei*, the war and its aftermath remain present. To be sure, the passing of the generations who lived through it and grew up in its shadow will change and probably diminish its legacies in New York. Still, the arguments, the passions, and the romance of the Spanish Civil War have proved resilient in a city that sent forth men, women, money, and succor to the Spanish Republic, and took its surviving veterans back with cheers and banners, but whose population never saw eye to eye about the meaning and justice of the cause. Memories and allegiances resurface, often unpredictably. During a Nuclear Freeze march in Manhattan during the 1980s, historian Robert W. Snyder observed "an unlikely spectator: tall, lean, conservatively dressed, with a gray crew cut—in every appearance a retired military man." Yet as surviving veterans of the Abraham Lincoln Brigade paraded past, the man stood "startled in surprise. Then he snapped to attention and raised his right hand in a crisp salute." [14]

Endnotes

1 Peter Glazer, *Radical Nostalgia: Spanish Civil War Commemoration in America* (Rochester: University of Rochester Press, 2005); Judy Kutulas, *The Long War: The Intellectual People's Front and Anti-Stalinism, 1930–1940* (Durham: Duke University Press, 1995), 100.

2 Peter N. Carroll, *The Odyssey of the Abraham Lincoln Brigade: Americans in the Spanish Civil War* (Stanford: Stanford University Press, 1994), 211, 212, 214, 219; Agnes 'Sis' Cunningham and Gordon Friesen, *Red Dust and Broadsides: A Joint Autobiography*, ed. Ronald D. Cohen (Amherst: University of Massachusetts Press, 1999), 177.

3 A number of the dissenters cooperated with government authorities in 1939–40 to name Communists within the Lincoln Brigade and VALB. Later, in 1954, Morris Maken, William Herrick, and Robert Gladnick also testified against their former comrades. Carroll, 225-231, 233, 300, 304.

4 Alan M. Wald, *The New York Intellectuals: The Rise and Decline of the Anti-Stalinist Left from the 1930s to the 1980s* (Chapel Hill: The University of North Carolina Press, 1987), 62, 76, 87; Kutulas, 122, 153; Carroll, 83; Roy Hoopes, *Ralph Ingersoll: A Biography* (New York: Atheneum, 1985), 173–175; Carol Brightman, *Writing Dangerously: Mary McCarthy and Her World* (San Diego: Harcourt Brace & Company, 1992), 234, 325, 608–609. A furor involving Hellman, McCarthy, James T. Farrell, and Dwight MacDonald also erupted in New York in the late '50s over Hellman's joining the board of the Spanish Refugee Aid Committee.

5 Carroll, 214, 362; Maurice Isserman, *Which Side Were You On? The American Communist Party During the Second World War* (Urbana, University of Illinois Press, 1993), 27, 126; F. Jay Taylor, *The United States and the Spanish Civil War, 1936–1939* (New York: Bookman Associates, 1956), 136, 142, 237; "Sea Union Proposes A Boycott of Spain," *New York Times*, July 16, 1946, 6; "Spanish Ship Picketed," *New York Times*, November 30, 1946, 20; "Anti-Red Action is Taken by NMU," *New York Times*, September 20, 1949, 59. Both the national CIO and AFL formally condemned Franco's Spain in 1946, a stance the AFL reaffirmed in 1950. Common cause over Spain and other issues, however, could not quell internecine strife between Communists and non-Communists in numerous New York unions, nor prevent expulsion of Communists from unions during the late '40s and '50s. Nor did all New York unionists appreciate the cause: Lincoln veteran Fred Keller lost his Radio City Music Hall job in 1939 when union pickets charged him with killing nuns in Spain for five dollars a head. At the same time, conflicting views of Franco's regime (along with other political and cultural disputes) helped to keep ethnic tensions alive withing New York's New Deal coalition, pitting socially conservative Catholics on one side against Jewish and Protestant liberals and leftists on the other, each of whom were seeking to define and carry forward FDR's legacy in their own ways.

6 For the experiences of Lincoln veterans in the U.S. military during World War II, see Carroll, 244–264, 269-273, 276–278. Another source of pro-Loyalist sentiment was the small community of Spanish emigres and visitors to New York, including Jose Camprubi, editor of *La Prensa*; businessman and JAFRC board member Manuel Mangana; Juan Negrin, former premier of the Spanish Republic; and Julio Alvarez del Vayo, the Republic's foreign minister, who became foreign editor for *The Nation*. These antifascists contended with pro-Franco Spanish businessmen, immigrants, and diplomats in the city. A New York character known as "Red Mary" allegedly funneled money to the Spanish underground during the '40s. Carroll, 282; Hoopes, 255; Isserman, 182; Paul Milkman, *P.M: A New Deal in Journalism, 1940–1948* (New Brunswick: Rutgers University Press, 1997), 72, 80, 95-98; Robert C. Cottrell, *Izzy: A Biography of I.F. Stone* (New Brunswick: Rutgers University Press, 1992), 104, 113, 132, 152.

7 New York University dismissed German professor Lyman Bradley in 1951 for his conviction as a member of the JAFRC board. Communist hunters with strong ties to the Franco regime included New Jersey Congressman J. Parnell Thomas and Nevada's Pat McCarran, "the Senator from Madrid." One New York Lincoln Veteran, Morris Cohen, did become an atomic spy for the Soviets; see Carroll, 242–243. In 1955 the federal Subversive Activities Control Board concluded that VALB was a "communist-front organization." Not until 1973 were the Lincoln Brigade and VALB removed from federal lists of subversive organizations. Howard Fast, *Being Red: A Memoir* (Boston: Houghton Mifflin, 1990), 143–156, 173-179, 219–221; Ellen Schrecker, *Many Are the Crimes: McCarthyism in America*, (Princeton: Princeton University Press, 1998), 114, 322; David Caute, *The Great Fear: The Anti-Communist Purge Under Truman and Eisenhower* (New York: Simon and Schuster, 1978), 177–178, 280, 416; Michael J. Ybarra, *Washington Gone Crazy: Senator Pat McCarran and the Great American Communist Hunt* (Hanover: Steerforth Press, 2004), 473-476, 504; Cedric Belfrage, *The American Inquisition 1945-1960: A Profile of the "McCarthy Era,"* (Indianapolis: Bobbs-Merrill, 1973/New York: Thunder's Mouth Press, 1989), 56, 75–76, 85, 117, 121, 284; Milkman, 80; Carroll, 286–290, 309–311; Stanley Levey, "City's School Heads Deny Infiltration by Communists," *New York Times*, September 29, 1948, 1.

8 Carroll, 61, 291. Pundits and historians on left and right continue to disagree about Duran's complicity in the SIM persecution of non-Communists in Spain. For the left, see Caute, 332–338; for the right, see Arthur Herman, *Joseph McCarthy: Reexamining the Life and Legacy of America's Most Hated Senator* (New York: Free Press, 2000), 101–102, 109, 163; William F. Buckley, Jr. and L. Brent Bozell, *McCarthy and His Enemies: The Record and Its Meaning* (Washington: Regnery Publishing 1954/With new Introduction, 1995), 140–146.

9 Other New York groups hostile to JAFRC "reds" included the American Legion, which awarded Franco a medal in 1951, the Veterans of Foreign Wars, and the American Jewish League Against Communism. In 1955, Buckley endorsed efforts by HUAC and the red-hunting agency Aware to identify entertainers who had sponsored JAFRC. Buckley was actively courted by the Franco regime in the early 1960s. Buckley's brother-in-law and early collaborator L. Brent Bozell moved to Spain in the early sixties, where he became a Carlist and a devotee of Catholic mysticism. John B. Judis, *William F. Buckley, Jr.: Patron Saint of the Conservatives* (New York: Simon and Schuster, 1988), 27, 59–60, 80, 207, 318 207, 318; William F. Buckley, Jr., *Let Us Talk of Many Things: The Collected Speeches* (Roseville: Prima Publishing, 2000), 13-15; "Leftists Barred in City Schools," *New York Times*, January 21, 1949, 23; Carroll, 219; Caute, 351; William F. Buckley, Jr., "Letter from Spain," *National Review*, October 26, 1957, 369, 375; "Aid to Spain," *National Review*, August 1, 1959, 233; "The Iron Law," *National Review*, October 24, 1975, 1160; "Remark by Reagan on Lincoln Brigade Prompts Ire in Spain," *New York Times*, May 10, 1985, A11.

10 Another New York recording that became part of the left-wing musical canon was Ernst Busch's *Six Songs for Democracy*, sung by German International Brigade veterans and recorded in 1940. Harrington, who had written pieces critical of Franco for the *Catholic Worker* in 1951–52, joked in 1963 that "I thought every little American kid" had learned such songs as "The Four Insurgent Generals, the 15th Brigade, and Song of the United Front." Author's interview with Jeffrey Scheer, a student of Puzzo's between 1960 and 1964, Pomona, New York, December 28, 2005; Ed Cray, *Ramblin' Man: The Life and Times of Woody Guthrie* (New York: W.W. Norton, 2004), 166, 218, 322; Richard A. Reuss with Joanne C. Reuss, *American Folk Music & Left-Wing Politics, 1927–1957,* (Lanham: Scarecrow Press, 2000), 118–120, 134; Peter D. Goldsmith, *Making People's Music: Moe Asch and Folkways Records* (Washington: Smithsonian Institution Press, 1998), 87, 139; Glazer, 177–182; Seeger's spoken remarks, "Jarama Valley," *Spain in My Heart: Songs of the Spanish Civil War*, Appleseed Recordings, 2003: APR CD 1074; Robert Shelton, *No Direction Home: The Life and Music of Bob Dylan* (Beech Tree Books, 1986), 257; Phil Ochs, "Spanish Civil War Song" (1962–64), *The Broadside Tapes 1*, Smithsonian Folkways Recordings, 1995: SFW40008 1989; Michael Harrington, *The Vast Majority* (New York: Simon and Schuster, 1977), 175; Maurice Isserman, *The Other American: The Life of Michael Harrington* (New York: Public Affairs, 2000), 78, 84, 203; Dan Wakefield, *New York in the Fifties*, (Boston: Houghton Mifflin, 1992), 131–132.

11 Carroll, 281, 293, 297, 350, 360, 362, 364, 370; Peter N. Carroll's e-mail communication to author, March 18, 2006; Ybarra, 475.

12 New York consistently remained the site of the largest VALB post, followed in size by the San Francisco Bay Area, Chicago, Los Angeles, Detroit, and Seattle posts; Carroll to author, March 18, 2006. Richard Bermack, with foreword by Peter N. Carroll, *The Front Lines of Social Change: Veterans of the Abraham Lincol Brigade* (Berkeley: Heyday Books, 2005), 77–78, 80, 83, 87; Carroll, 220–221, 231–232, 352–358, 372–380.

13 Carroll, 315–319, 335–336, 370–371, 376–378, 401; Bermack, 70–71.

14 *Opus Dei*, a Catholic prelature with centers in New York and 18 other American cities, follows the teachings of Spanish priest Saint Josemaría Escrivá (1902–1975), who was canonized by Pope John Paul II in 2002. American Catholics are engaged in an ongoing debate over the alleged authoritarian and cult-like nature of the group, Escrivá's ties to Franco, and charges that Escrivá applauded Hitler for killing Jews and Communists; see James Martin, SJ, "Opus Dei in the United States," *America: The National Catholic Weekly*, February 25, 1995; www.opusdei.org; www.mond.at/opus.dei; www.odan.org (sites viewed March 24, 2006). Glazer, 153; Robert W. Snyder, "Remembering Irving Weissman" (Eulogy), New York, December 22, 1998, used by courtesy of Robert W. Snyder.

PHOTO ESSAY
NEW YORKERS
IN THE
ABRAHAM
LINCOLN
BRIGADE

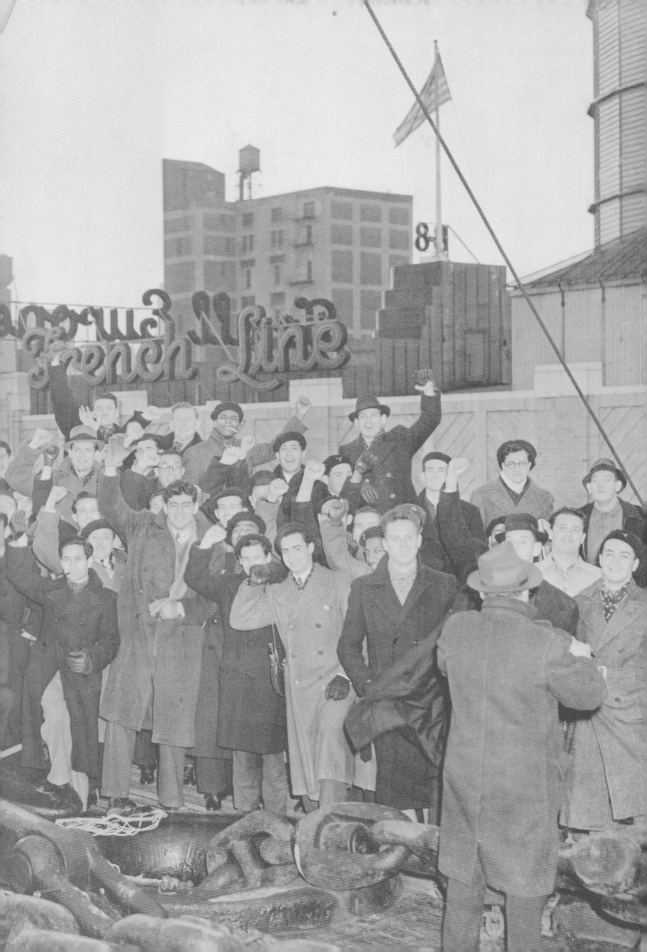

PREVIOUS SPREAD
**Returning Lincoln
Brigade volunteers at
dock in New York,
1938.**

ABOVE
**Aviator Joe Rosmarin
with his plane at Floyd
Bennett Field, ca.1935.**

RIGHT
**Student protest at
City College,
November 1934.**

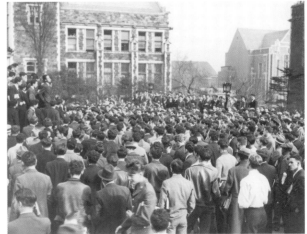

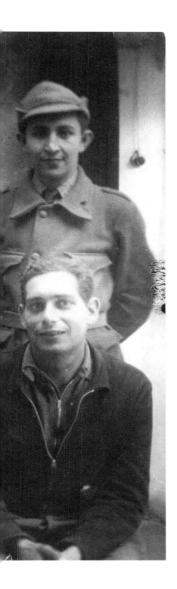

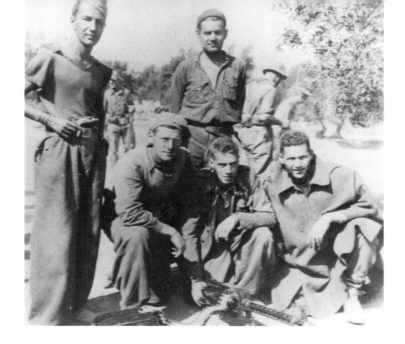

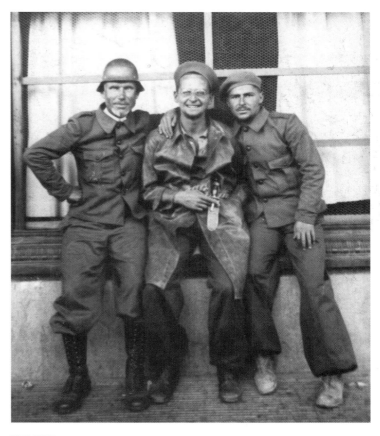

TOP TO BOTTOM

Students and former students of colleges in New York City, posing for a portrait in Spain, October 1937. They are (left to right) Len Levenson (NYU), Paul Sigel (NYU), two unidentified men, and Elkan Wendkos (CCNY). Levenson is believed to have been the only one of the five to survive the war.

New Yorkers Charles Nusser (center) and Hy Stone (right) with volunteer Gaspar, in Spain, May 1937.

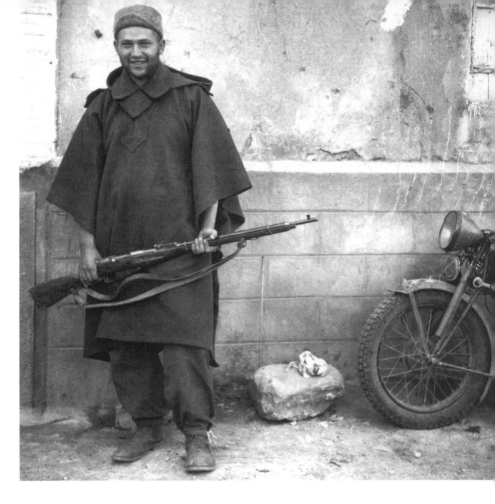

CLOCKWISE FROM TOP

NYU student and volunteer Elkan Wendkos in Spain, September 1937.

Lincoln-Washington Battalion Commissar George Watt in Spain, May 1938.

Volunteer Abe Smorodin of Williamsburg, Brooklyn, in Spain, August 1938.

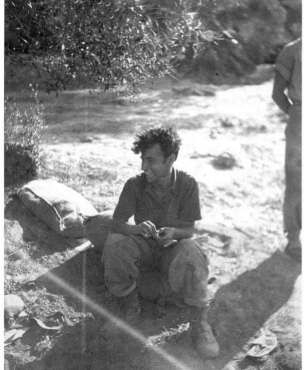

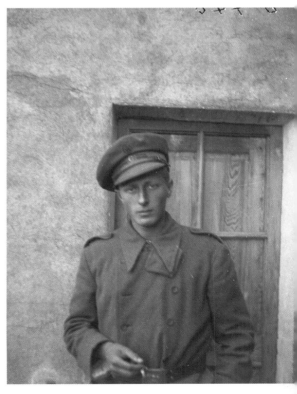

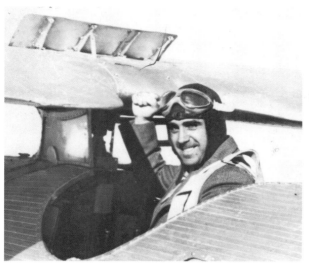

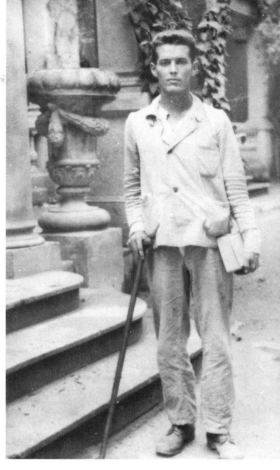

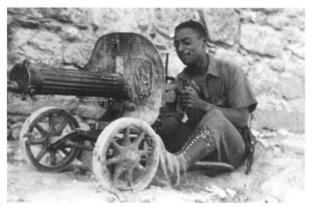

CLOCKWISE FROM TOP LEFT
Aviator Ben Leider in the cockpit of his plane. Leider was killed near Madrid in February 1937.

Jim Lardner, son of author Ring Lardner, wounded in Spain. Lardner is believed to have been the last American to die in the war, in early 1939.

The reception of Ben Leider's coffin when it was returned to New York in August 1938.

Volunteer Walter Garland with a machine gun in Spain, ca. 1937.

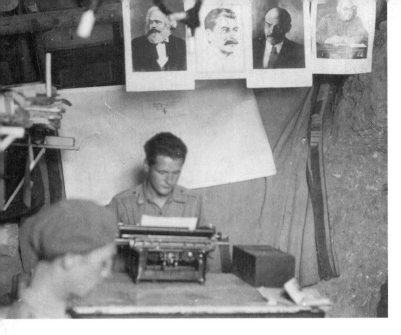

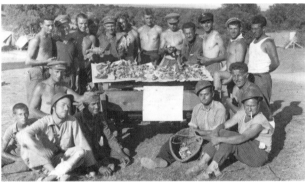

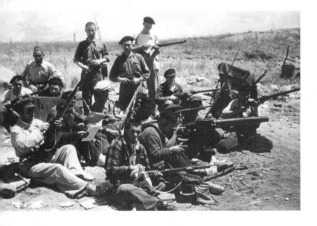

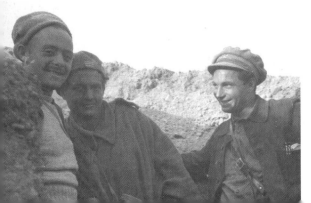

TOP TO BOTTOM
An unidentified solider types under portraits of Marx, Lenin, Stalin, and Spanish General Miaja, ca. 1937.

Soldiers posing with shrapnel pieces they collected following an attack, ca. 1937. The sign reads: "The remains of fascist bombs dropped in the camp of 1st regiment on July 8; No Casualties."

International Brigades soldiers with their artillery, ca. 1937.

Volunteers Saul Wellman, Robert Thomson, and David Doran (left to right) at Fuentes de Ebro, October 1937.

OPPOSITE PAGE, CLOCKWISE FROM TOP
A group of wounded International Brigades soldiers posing with various newspapers, ca. 1937.

Lincoln-Washington group at Senes, October 1937.

Lincoln-Washington kitchen crew at Senes, October 1937.

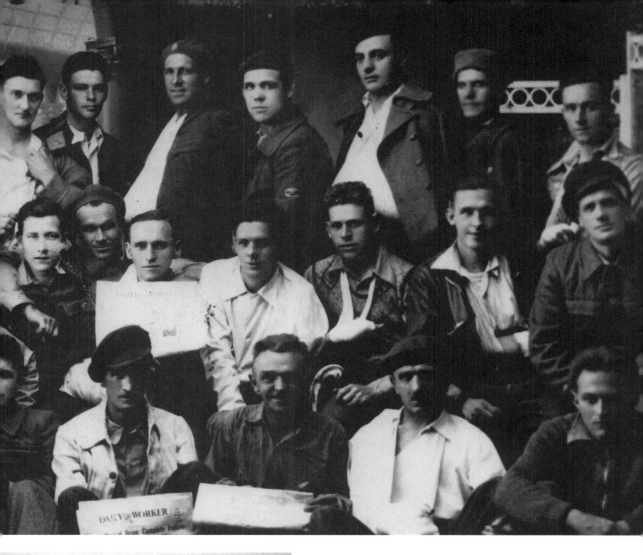

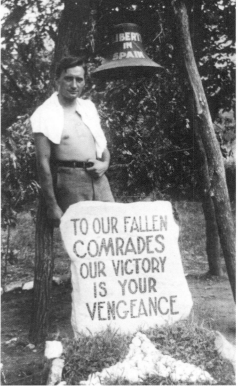

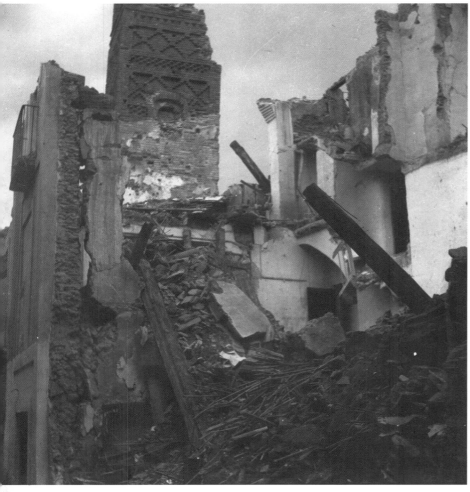

CLOCKWISE FROM TOP LEFT

Two Lincoln-Washington soldiers help a wounded comrade, no date.

A volunteer poses with bell and sign commemorating fallen soldiers, ca. 1937.

Belchite street scene, August 1937.

Fascist air bombardment at Fuentes de Ebro, October 1937.

Anti-gas section of the Lincoln-Washington Battalion, December 1937.

Soldiers at Les Masies (near Montblanch), Catalonia, October 25, 1938. Photograph by Robert Capa.

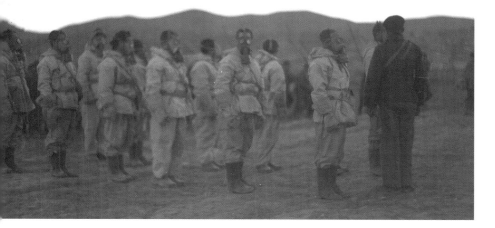

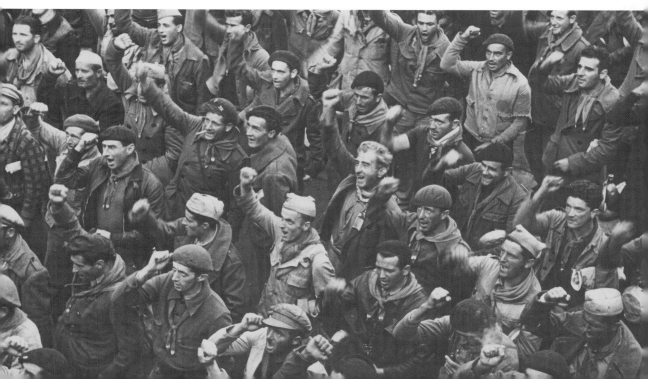

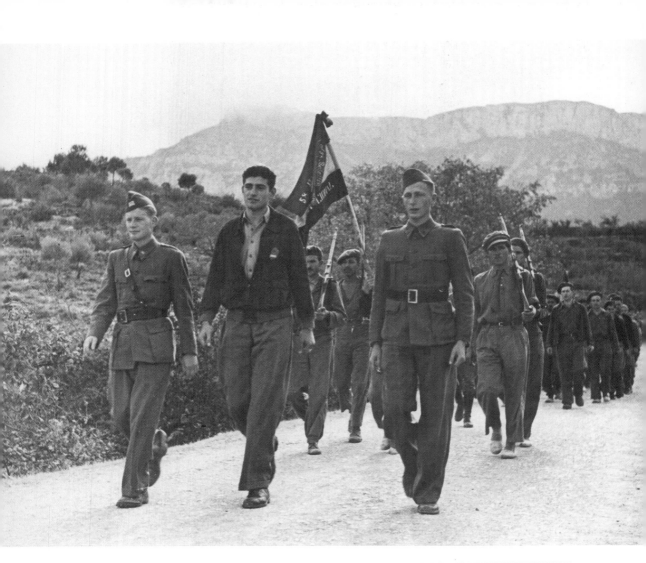

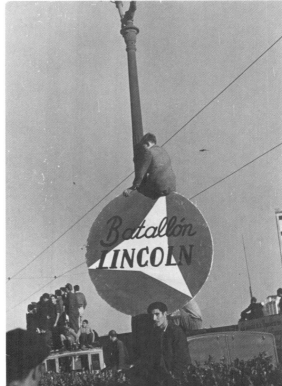

ABOVE
The American Abraham Lincoln
Brigade, led by Milton Wolff
(center, without cap), at the farewell
ceremony for the International
Brigades. Barcelona, October 1938.
Photograph by Robert Capa.

RIGHT
Barcelona, October 25, 1938.
196 Photograph by Robert Capa.

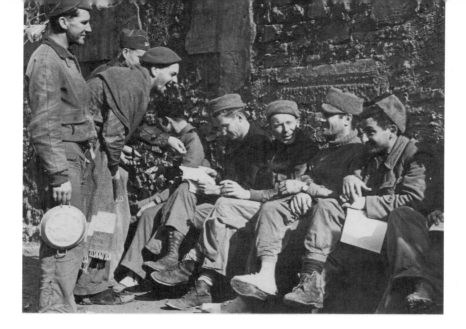

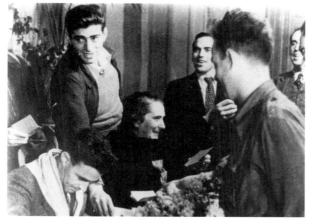

TOP TO BOTTOM

**Soldiers at Les Masies (near Montblanch),
Catalonia, October 25, 1938.
Photograph by Robert Capa.**

**Milton Wolff, commander of the
Lincoln-Washington Battalion
(left, standing) with Dolores Ibárruri,
known as La Pasionaria (center)
during the farewell luncheon
for the International Brigades in
October 1938.**

**Barcelona, October 25, 1938.
Photograph by Robert Capa.**

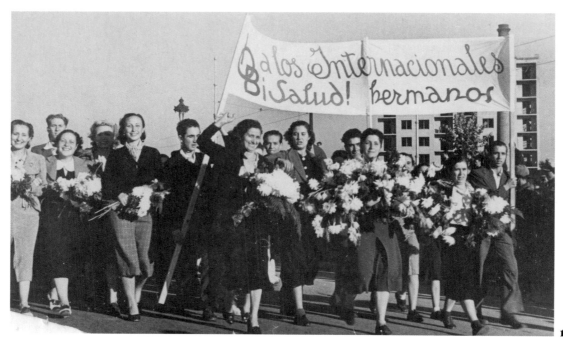

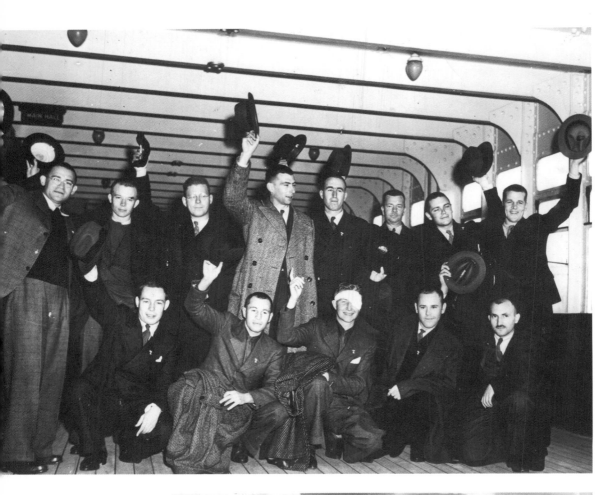

Prisoners released from fascist camps, returning to New York, October 1938.

Volunteers Harry Hakam (front row, center), Harry Fisher (standing second from left), and others returning to New York on the *Ile de France*, **September 1938.**

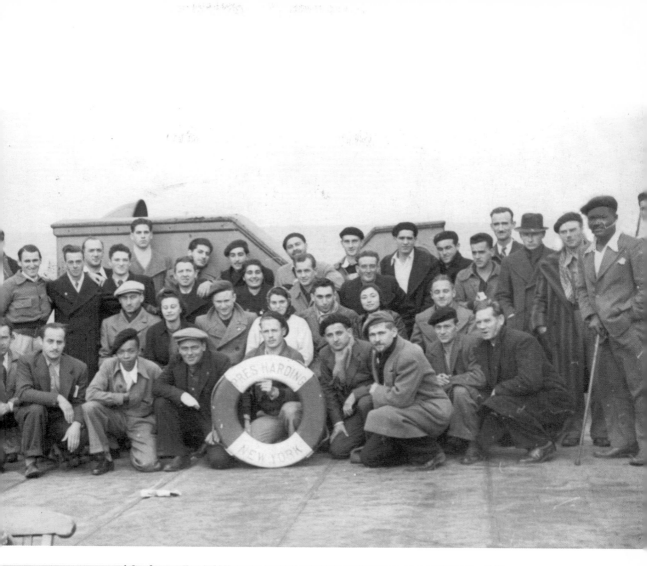

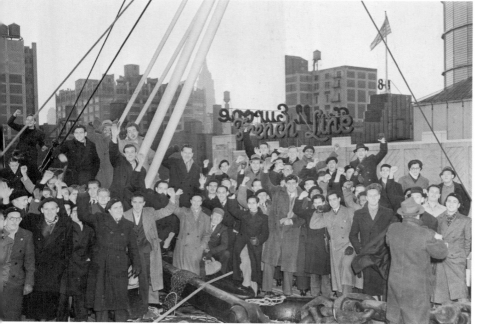

A group of Lincoln Brigade volunteers returning from Spain on the *SS Harding*, ca. 1938.

Returning Lincoln Brigade volunteers at dock in New York, 1938.

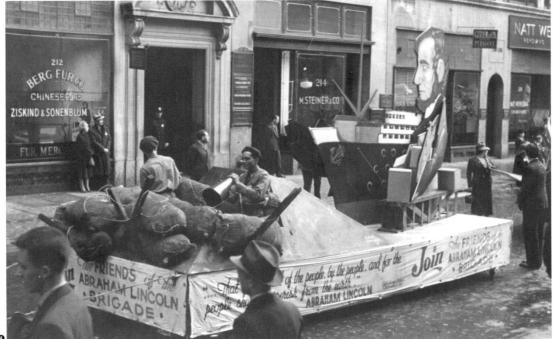

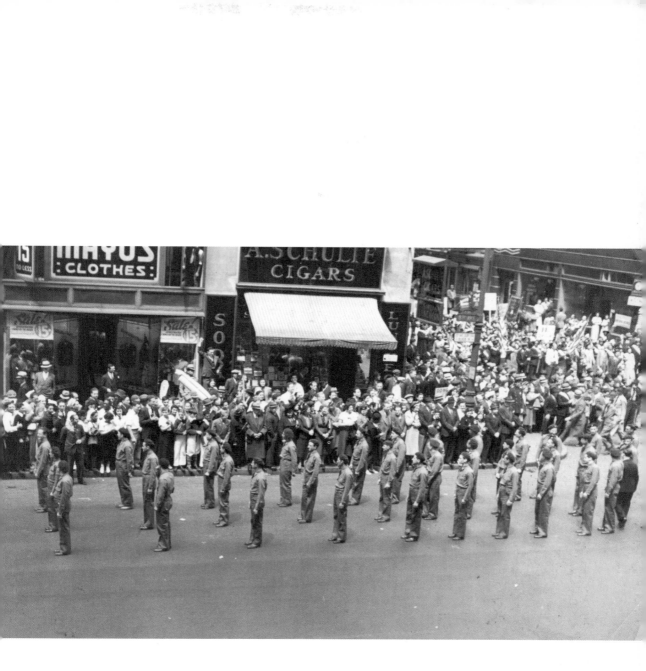

THESE PAGES AND FOLLOWING SPREAD
**Beginning in 1938,
Lincoln Brigade
veterans figured
prominently in May Day
celebrations in
New York, particularly
in parades.** **201**

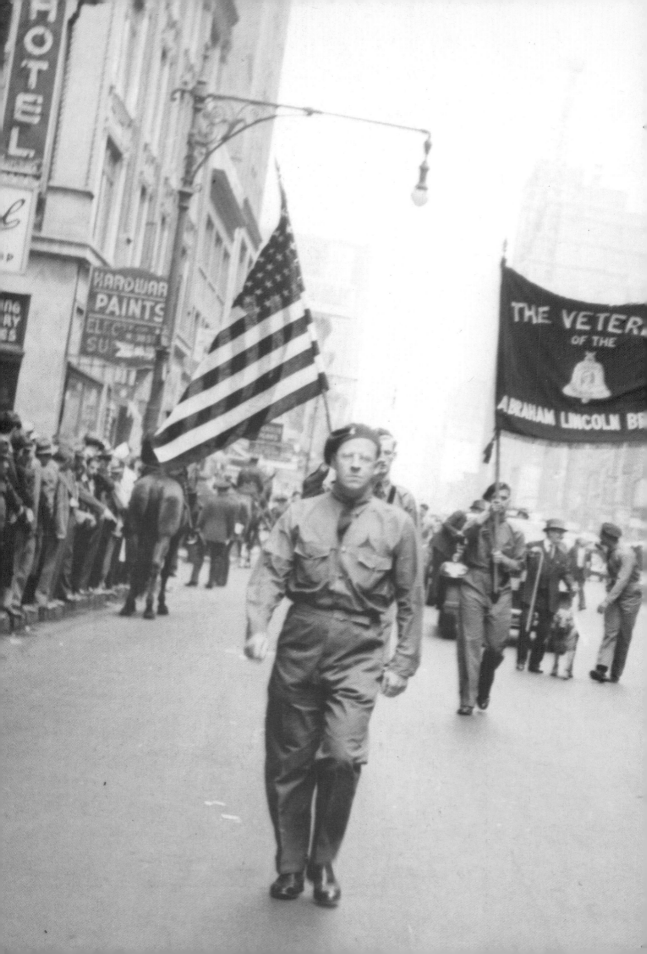

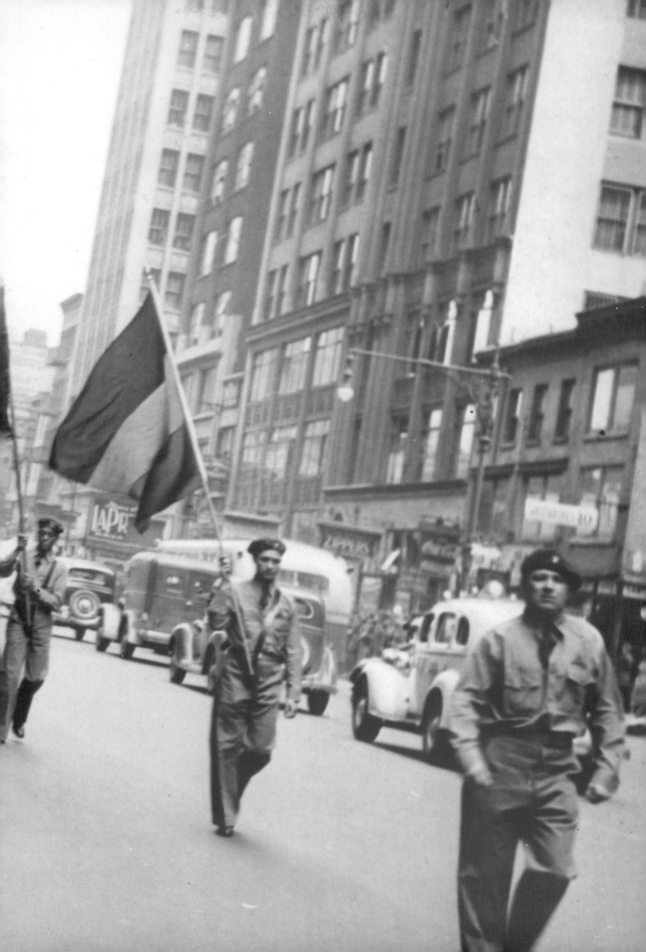

ADDITIONAL READINGS

Abraham Lincoln Brigade Archives website: www.alba-valb.org

Bermack, Richard, with a foreword by Peter N. Carroll. *The Front Lines of Social Change: Veterans of the Abraham Lincoln Brigade*. Berkeley: Heyday Books, 2005.

Carroll, Peter N. *The Odyssey of the Abraham Lincoln Brigade: Americans in the Spanish Civil War*. Stanford: Stanford University Press, 1994.

Carroll, Peter N., Michael Nash, Melvin Small, eds. *The Good Fight Continues: World War II Letters from the Abraham Lincoln Brigade*. New York: New York University Press, 2006.

Caute, David. *The Great Fear: The Anti-Communist Purge Under Truman and Eisenhower*. New York: Simon and Schuster, 1978.

Collum, Danny Duncan and Victor A. Berch, eds. *African Americans in the Spanish Civil War: "This Ain't Ethiopia, But It'll Do."* New York: G. K. Hall, 1992.

Cooper, Elizabeth. "Dances About Spain: Censorship at the Federal Theatre Project." *Theatre Research International* 29.3 (2004): 232-246.

Fast, Howard. *Being Red: A Memoir*. Boston: Houghton Mifflin, 1990.

Glazer, Peter. *Radical Nostalgia: Spanish Civil War Commemoration in America*. Rochester: University of Rochester Press, 2005.

Graff, Ellen. *Stepping Left: Dance and Politics in New York City, 1928–1942*. Durham: Duke University Press, 1997.

Guttmann, Allen. *The Wound in the Heart: America and the Spanish Civil War*. New York: Free Press of Glencoe, 1962.

Kowalsky, Daniel. *Stalin and the Spanish Civil War*. New York, 2004.

Kutulas, Judy. *The Long War: The Intellectual People's Front and Anti-Stalinism, 1930–1940*. Durham: Duke University Press, 1995.

Helen Langa, *Radical Art: Printmaking and the Left in 1930s New York*. Berkeley: University of California Press, 2004.

Lieberman, Robbie. *"My Song is My Weapon": People's Songs, American Communism, and the Politics of Culture, 1930–1950*. Urbana: University of Illinois Press, 1995.

Nelson, Cary and Jefferson Hendricks, eds. *Madrid 1937: Letters of the Abraham Lincoln Brigade from the Spanish Civil War*. New York: Routledge, 1996.

Ottanelli, Fraser M. *The Communist Party of the United States: From the Depression to World War II*. New Brunswick, N.J.: Rutgers, 1991.

Payne, Stanley. *The Spanish Civil War, the Soviet Union, and Communism*. New Haven: Yale, 2004.

Rosenstone, Robert A. *Crusade of the Left: The Lincoln Battalion in the Spanish Civil War*. New York: Pegasus, 1969.

Shout, John. D. "Staging the Unstageable: American Theatrical Depictions of the Spanish War." *The Spanish Civil War and the Visual Arts*. Kathleen Vernon, ed. Ithaca: Center for International Studies, Cornell University, 1990.

Spain in My Heart: Songs of the Spanish Civil War. Appleseed Recordings, 2003: APR CD 1074.

Taylor, F. Jay. *The United States and the Spanish Civil War, 1936–1939*. New York: Bookman Associates, 1956.

Trumbull, Eric Winship. "Musicals of the American Workers' Theatre Movement—1928–1941: Propaganda and Ritual in Documents of a Social Movement." Dissertation, University of Maryland, College Park, 1991. http://www.nvcc.edu/home/etrumbull/diss/ch4.htm.

Wald, Alan M. *The New York Intellectuals: The Rise and Decline of the Anti-Stalinist Left from the 1930s to the 1980s*. Chapel Hill: University of North Carolina Press, 1987.

ACKNOWLEDGMENTS

We are especially grateful to Perry and Gladys Rosenstein of the Puffin Foundation, Ltd., whose vision and support made the exhibition and the catalog a reality.

This project could not have been accomplished without the participation of the Abraham Lincoln Brigade Archives (ALBA), an independent non-profit educational organization, and its Board of Governors. ALBA creates diverse programs to preserve and disseminate the history of the U.S. volunteers and the anti-fascist traditions they embodied. The ALBA collection is open for research at the Tamiment Library of New York University. ALBA acknowledges a grant from the Program for Cultural Cooperation between Spain's Ministry of Culture and United States Universities to create educational resources to accompany this exhibition. These curricula are available at no charge on the ALBA website. For more information, visit the ALBA website: www.alba-valb.org.

We also recognize the advice and encouragement of the Cervantes Institute of New York, particularly former director Antonio Muñoz Molina who arranged for co-sponsorship of this project; his enthusiastic successor Eduardo Lago; as well as librarian Lluís Agustí Ruiz. The Instituto Cervantes is a worldwide non-profit organization created by the Spanish government in 1991 to promote the teaching, study, and use of Spanish as a second language and to contribute to the advancement of the Spanish and Hispanic American cultures throughout non-Spanish speaking countries: www.cervantes.org.

NYU's King Juan Carlos I of Spain Center has also been a steadfast partner in this and many other projects related to the legacy of the Spanish Civil War: www.nyu.edu/kjc.

The Museum of the City of New York embraced this exhibition with total commitment. Special thanks to Susan Henshaw Jones, Sarah Henry, Thomas H. Mellins, and Autumn Nyiri.

Michael Nash and Gail Malmgreen of the Tamiment Library made major contributions to the discovery of exhibition materials. Always we knew we could count on the support of our ALBA colleagues, particularly Julia Newman, Tony Geist, Joshua Brown, Dan Czitrom, Fredda Weiss, and Libby Bouvier. Joshua Freeman participated in early planning sessions. Beth Compa, who has become part of the family, provided tremendous research skills. Natasha Whitney gave generously in transcribing material for this catalogue.

209

CONTRIBUTORS

JOSHUA BROWN is Executive Director of the American Social History Project and Professor of History at The Graduate Center, City University of New York. He is the author of *Beyond the Lines: Pictorial Reporting, Everyday Life, and the Crisis of Gilded Age America* (University of California, 2002), co-author of *Forever Free: The Story of Emancipation and Reconstruction* (Knopf, 2005), and co-producer/director of many award-winning documentaries, CD-ROMs, and Web projects. He has written extensively on the visualization of the past and his cartoons and illustrations have appeared in popular and scholarly publications as well as digital media.

JUSTIN BYRNE, Acting Director of Graduate Studies of NYU in Madrid, holds a Ph.D. in History and Civilization from the European University Institute, Florence. As a visiting professor at New York University in 2005, he led a research-based seminar on the Lincoln Brigade, working intensively with the ALBA collection in the Tamiment Library.

PETER N. CARROLL is Chair of the Board of Governors of the Abraham Lincoln Brigade Archives. He is the author of *The Odyssey of the Abraham Lincoln Brigade: Americans in the Spanish Civil War* (Stanford, 1994), co-editor with Michael Nash and Melvin Small of *The Good Fight Continues: World War II Letters from the Abraham Lincoln Brigade* (New York University, 2006), and co-curator and co-editor with Anthony Geist of the exhibition and catalog, *They Still Draw Pictures: Children's Art in Wartime from the Spanish Civil War to Kosovo* (Illinois, 2002).

E. L. DOCTOROW, born in New York City in 1931, holds the Glucksman Chair in American Letters at New York University and has won many awards for creative fiction. Among his historical novels are *The Book of Daniel, Ragtime, Billy Bathgate* and, most recently, *The March*.

JAMES FERNANDEZ is Chair of NYU's Department of Spanish and Portuguese Languages and Literatures, and founding director of the King Juan Carlos I of Spain Center. He has published a book on autobiography in Spain, *Apology to Apostrophe: Autobiography and Rhetoric of Self-Representation in Spain* (Duke, 1992), and has written widely on the historical and cultural links between Spain and the Americas.

PETER GLAZER, Associate Professor in the Department of Theater, Dance, and Performance Studies at the University of California, Berkeley, is also a professional playwright and director. He sits on the Governing Board of the Abraham Lincoln Brigade Archives, and has been co-writing and directing events commemorating the Abraham Lincoln Brigade since 1993. He is the author of *Radical Nostalgia: Spanish Civil War Commemoration in America* (University of Rochester Press, 2005).

STEVEN H. JAFFE, an independent scholar who has worked as an historian and curator at the South Street Seaport Museum and New-York Historical Society, is the author of *Who Were the Founding Fathers: Two Hundred Years of Reinventing American History* (Henry Holt, 1996). His book *New York at War: The City as Target and Stronghold* (Basic Books) will be published in 2008.

EDUARDO LAGO is the Director of the Cervantes Institute in New York and a tenured member of the Spanish and Literature faculty at Sarah Lawrence College, where he has taught since 1993. A distinguished translator and literary critic, Lago is also the author of the novel *Llámame Brooklyn* (Barcelona: Destino, 2006), which won Spain's most prestigious literary prize, the Premio Nadal, in 2006. The protagonist of the novel is a Spanish Civil War orphan raised in Brooklyn by a veteran of the Abraham Lincoln Brigade.

HELEN LANGA is Associate Professor of American and Modern Art History at American University in Washington, D.C. She is the author of *Radical Art: Printmaking and the Left in 1930s New York* (University of California Press, 2004).

PATRICK MCNAMARA has been an assistant archivist at the Diocese of Brooklyn since 2000. His primary area of research is American Catholic anticommunism during the twentieth century. He received his Ph.D. from Catholic University and is the author of *A Catholic Cold War: Edmund A. Walsh, S.J., and the Politics of American Anticommunism* (Fordham University Press, 2005). He has co-authored a history of the Brooklyn Diocese, *Diocese of Immigrants* (2004). He teaches history at St. Francis College, Brooklyn, and historical theology at the Seminary of the Immaculate Conception, Huntington, NY.

FRASER M. OTTANELLI is Associate Professor and Coordinator of the Italian Studies Program at the University of South Florida. His publications include *Italian Workers of the World: Labor Migration and the Formation of Multiethnic States* (University of Illinois, 2001) (editor) and *The Communist Party of the United States: From the Depression to World War II* (Rutgers, 1991).

JUAN SALAS is an art historian, documentarian, and independent curator of photography based in New York City.

ERIC R. SMITH is a Ph.D. candidate at the University of Illinois at Chicago. He is currently writing the dissertation "'Resisting the Tide': The North American Committee, the United Front, and the Politics of Aiding the Spanish Republic, 1936–1940."

ROBERT W. SNYDER, a historian, is an Associate Professor of Journalism and Media Studies at Rutgers-Newark. He is the author of *The Voice of the City: Vaudeville and Popular Culture in New York* (Oxford, 1989, Ivan R. Dee, 2000) and *Transit Talk: New York Bus and Subway Workers Tell Their Stories* (Rutgers, 1997, 1999), and co-author of *Metropolitan Lives: The Ashcan Artists and Their New York* (Norton, 1995). He is at work on a book about crime and postwar New York City.

ALAN WALD is a Professor of English and in the Program in American Culture at the University of Michigan. His book *Trinity of Passion: The U.S. Literary Left and the Anti-Fascist Crusade* will appear from the University of North Carolina Press in 2007.

MIKE WALLACE is Distinguished Professor of History at John Jay College of Criminal Justice (CUNY); Founder of the Gotham Center for New York City History (CUNY Graduate Center); and co-author of the Pulitzer-Prize winning *Gotham: A History of New York City to 1898* (Oxford, 1999).

Credits

Page 90
 The Jesús Colón Papers, The Archives of the Puerto Rican Diaspora, Centro de Estudios Puertorriqueños, Hunter College, CUNY
Pages 92-93; 97
 5754514/ Time Life Pictures/ Courtesy of Getty Images
Page 94
 Courtesy of the Roman Catholic Diocese of Brooklyn
Page 96
 Courtesy of the Roman Catholic Diocese of Brooklyn
Page 98
 Courtesy of georgetownbookshop.com, Bethesda, MD
Page 99 (top left)
 Courtesy of georgetownbookshop.com, Bethesda, MD
Page 99 (top right)
 Courtesy of georgetownbookshop.com, Bethesda, MD
Page 99 (bottom left)
 Courtesy of georgetownbookshop.com, Bethesda, MD
Page 99 (bottom right)
 Courtesy of georgetownbookshop.com, Bethesda, MD
Page 100
 Brooklyn College Archives and Special Collections
Page 101
 Spanish Refugee Relief Association, Rare Book and Manuscript Library, Columbia University
Pages 102-103; 107 (right)
 Courtesy of Helen Langa
Page 104
 Courtesy of Philip Guston Estate and McKee Gallery, New York
Page 106
 Courtesy of Helen Langa
Page 107 (left)
 Courtesy of Helen Langa
Page 108
 Courtesy of Columbus Museum of Art, Ohio: Museum Purchase, Derby Fund, from the Philip J. and Suzanne Schiller Collection of American Social Commentary Art 1930-1970, 2005.013.068
Page 109 (left)
 Courtesy of the Smithsonian American Art Museum
Page 109 (right)
 Courtesy of Helen Langa
Page 110
 Collection of Brigit Refregier, Woodstock, New York.
Page 111 (top)
 Courtesy of Saint Louis Art Museum, gift of Vincent Price
Page 111 (bottom)
 Courtesy of Helen Langa
Page 112
 Courtesy of Helen Langa
Page 113
 Courtesy of Helen Langa
Page 114 (left)
 Courtesy of Helen Langa

Page 114 (right)
 Courtesy of Helen Langa
Page 115 (top)
 Courtesy of the Smithsonian American Art Museum
Page 115 (bottom)
 Courtesy of the Smithsonian American Art Museum
Page 116
 Courtesy of Columbus Museum of Art, Ohio: Museum Purchase, Derby Fund, from the Philip J. and Suzanne Schiller Collection of American Social Commentary Art 1930-1970, 2005.013.221
Page 120-121
 Courtesy of Tamiment Library, New York University, ALBA Periodicals
Page 122
 Spanish Refugee Relief Association, Rare Book and Manuscript Library, Columbia University
Page 124
 Courtesy of Tamiment Library, New York University, ALBA Periodicals
Page 125
 Courtesy of Tamiment Library, New York University, ALBA Periodicals
Page 126
 Courtesy of Tamiment Library, New York University, ALBA Periodicals
Page 127
 Courtesy of Tamiment Library, New York University, ALBA Postcards
Pages 130-131
 Courtesy of Tamiment Library, New York University, Edwin Rolfe Photographic Collection
Page 132
 Courtesy of Tamiment Library, New York University, ALBA, VALB Photographic Collection
Page 135 (top)
 Courtesy of Tamiment Library, New York University
Page 135 (bottom)
 © Bettmann/CORBIS
Page 136
 Courtesy of Tamiment Library, New York University, 15th International Brigade Photographic Unit Collection
Page 137
 Courtesy of James D. Fernández
Pages 140-141; 150
 Courtesy of Tamiment Library, New York University
Page 142
 Courtesy of Joshua Brown
Page 145 (top left)
 Courtesy of Joshua Brown and the New York Post
Page 145 (top right)
 Courtesy of the General Research Division, The New York Public Library, Astor, Lenox and Tilden Foundations
Page 145 (bottom)
 Courtesy of the General Research Division, The New York Public Library, Astor, Lenox and Tilden Foundations
Page 146 (left)
 Courtesy of the General Research Division, The New York Public Library, Astor, Lenox and Tilden Foundations

Page 146 (right)
 Courtesy of the General Research Division, The New York Public Library, Astor, Lenox and Tilden Foundations
Page 147 (left)
 Courtesy of Joshua Brown and the New York Post
Page 147 (right)
 Courtesy of the General Research Division, The New York Public Library, Astor, Lenox and Tilden Foundations
Page 148 (top left)
 Courtesy of the General Research Division, The New York Public Library, Astor, Lenox and Tilden Foundations
Page 148 (top right)
 Courtesy of the General Research Division, The New York Public Library, Astor, Lenox and Tilden Foundations
Page 148 (bottom left)
 Courtesy of the General Research Division, The New York Public Library, Astor, Lenox and Tilden Foundations
Page 148 (bottom right)
 © The New Yorker Collection. Helen E. Hokinson from cartoonbank.com. All Rights Reserved
Page 149 (left)
 Courtesy of Joshua Brown and New York Amsterdam News. Reprinted with permission
Page 149 (right)
 Courtesy of Joshua Brown
Page 151 (top)
 Courtesy of Tamiment Library, New York University
Page 151 (center)
 Courtesy of Tamiment Library, New York University
Page 151 (bottom)
 Courtesy of Tamiment Library, New York University
Page 152 (top left)
 Courtesy of Tamiment Library, New York University
Page 152 (top right)
 Courtesy of the General Research Division, The New York Public Library, Astor, Lenox and Tilden Foundations
Page 152 (bottom)
 Courtesy of the General Research Division, The New York Public Library, Astor, Lenox and Tilden Foundations
Page 153
 Courtesy of Tamiment Library, New York University
Page 155
 Courtesy of the General Research Division, The New York Public Library, Astor, Lenox and Tilden Foundations
Pages 158-159; 164
 © Barbara Morgan, The Barbara Morgan Archive and the NYPL Performing Arts Library
Page 160
 Museum of the City of New York Theater Archive
Page 162
 Spanish Refugee Relief Association, Rare Book and Manuscript Library, Columbia University

Page 163
Courtesy of Tamiment Library, New York University
Page 165 (top)
© Barbara Morgan, The Barbara Morgan Archive and the NYPL Performing Arts Library
Page 165 (bottom)
© Barbara Morgan, The Barbara Morgan Archive and the NYPL Performing Arts Library
Page 166 (top)
Jerome Robbins Dance Division, The New York Public Library for the Performing Arts, Astor, Lenox and Tilden Foundations.
Page 166 (bottom)
Spanish Refugee Relief Association, Rare Book and Manuscript Library, Columbia University
Page 167
Courtesy of the Archivo Histórico del Partido Comunista de España
Page 168 (top)
Museum of the City of New York Theater Archive
Page 168 (bottom)
Spanish Refugee Relief Association, Rare Book and Manuscript Library, Columbia University
Pages 170-171; 181
Courtesy of Tamiment Library, New York University, ALBA, VALB Photographic Collection
Page 172
Courtesy of Tamiment Library, New York University, ALBA, VALB Photographic Collection
Page 174
Courtesy of Tamiment Library, New York University, Charlotte Todes Stern Papers
Page 175
Spanish Refugee Relief Association, Rare Book and Manuscript Library, Columbia University
Page 176 (top left)
Courtesy of Tamiment Library, New York University, ALBA, Sylvia Boehm Acker Collection
Page 176 (top right)
Courtesy of Tamiment Library, New York University, ALBA, Joint Anti-Fascist Refugee Committee Collection
Page 176 (bottom)
Courtesy of the National Archives and Records Administration, Northeast Region, New York
Page 177
Courtesy of Al Koslow
Page 179
Library of Congress Prints & Photographs Division (LC-USZ62-125964)
Page 180
Spanish Refugee Relief Association, Rare Book and Manuscript Library, Columbia University
Pages 184-185; 199 (bottom)
© Bettman/CORBIS

Page 186 (top)
Courtesy of City College of New York Archives
Page 186 (bottom)
Courtesy of Susan Richter
Page 187 (top)
Courtesy of Valerie Hakam Sacay
Page 187 (bottom)
Courtesy of Tamiment Library, New York University, ALBA, Toby Jensky Collection
Page 188 (top)
Courtesy of Tamiment Library, New York University, ALBA, Small Photographic Collections
Page 188 (bottom left)
Courtesy of Tamiment Library, New York University, ALBA, Edward K. Barsky Collection
Page 188 (bottom right)
Courtesy of Tamiment Library, New York University, ALBA, Small Photographic Collections
Page 189 (top)
Courtesy of Tamiment Library, New York University, ALBA, Len Levenson Collection
Page 189 (bottom)
Courtesy of Tamiment Library, New York University, ALBA, Charles Nusser Collection
Page 190 (top)
Courtesy of Tamiment Library, New York University, 15th International Brigade Photographic Unit Collection
Page 190 (bottom left)
Courtesy of Tamiment Library, New York University, 15th International Brigade Photographic Unit Collection
Page 190 (bottom right)
Courtesy of Tamiment Library, New York University, 15th International Brigade Photographic Unit Collection
Page 191 (top left)
Courtesy of Tamiment Library, New York University, ALBA, VALB Photographic Collection
Page 191 (top right)
Courtesy of Tamiment Library, New York University, ALBA, Small Photographic Collections
Page 191 (center)
Courtesy of Tamiment Library, New York University, ALBA, African-Americans in the Spanish Civil War: Research Files Collection
Page 191 (bottom)
Courtesy of Tamiment Library, New York University, ALBA, VALB Photographic Collection
Page 192 (top)
Courtesy of Tamiment Library, New York University, ALBA, Small Photographic Collections
Page 192 (2nd from top)
Courtesy of Tamiment Library, New York University, ALBA, VALB Photographic Collection
Page 192 (2nd from bottom)
Courtesy of Tamiment Library, New York University, ALBA, Small Photographic Collections

Page 192 (bottom)
Courtesy of Tamiment Library, New York University, 15th International Brigade Photographic Unit Collection
Page 193 (top)
Courtesy of Tamiment Library, New York University, ALBA, VALB Photographic Collection
Page 193 (bottom left)
Courtesy of Tamiment Library, New York University, 15th International Brigade Photographic Unit Collection
Page 193 (bottom right)
Courtesy of Tamiment Library, New York University, 15th International Brigade Photographic Unit Collection
Page 194 (top left)
Courtesy of Tamiment Library, New York University, 15th International Brigade Photographic Unit Collection
Page 194 (top right)
Courtesy of Tamiment Library, New York University, Stanley Postek Collection
Page 194 (bottom)
Courtesy of Tamiment Library, New York University, 15th International Brigade Photographic Unit Collection
Page 195 (top)
Courtesy of Tamiment Library, New York University, 15th International Brigade Photographic Unit Collection
Page 195 (center)
Courtesy of Tamiment Library, New York University, 15th International Brigade Photographic Unit Collection
Page 195 (bottom)
International Center of Photography © Cornell Capa
Page 196 (top)
International Center of Photography © Cornell Capa
Page 196 (bottom)
International Center of Photography © Cornell Capa
Page 197 (top)
International Center of Photography © Cornell Capa
Page 197 (center)
Courtesy of Tamiment Library, New York University, ALBA, Small Photographic Collections
Page 197 (bottom)
International Center of Photography © Cornell Capa
Page 198 (top)
Courtesy of Tamiment Library, New York University, VALB Photographic Collection
Page 198 (bottom)
Courtesy of Tamiment Library, New York University, ALBA, Small Photographic Collections
Page 199 (top)
Courtesy of Tamiment Library, New York University, ALBA, Small Photographic Collections
Page 200 (top)
Courtesy of Tamiment Library, New York University, VALB Photographic Collection

Page 200 (bottom)
 Courtesy of Tamiment Library, New York
 University, VALB Photographic Collection
Page 201
 Courtesy of Tamiment Library, New York
 University, VALB Photographic Collection
Pages 202-203
 Courtesy of Tamiment Library, New York
 University, VALB Photographic Collection

Index

MUSEUM OF THE CITY OF NEW YORK
New York

NEW YORK UNIVERSITY PRESS
New York and London

Library of Congress Cataloging-in-Publication Data

Facing fascism: New York and the Spanish Civil War /
edited by Peter N. Carroll and James D. Fernández.
 p. cm.
Includes bibliographical references and index.
ISBN-13: 978-0-8147-1681-6 (pbk: alk. paper)
ISBN-10: 0-8147-1681-4 (pbk: alk. paper)
1. Spain--History--Civil War, 1936-1939--Foreign public
opinion, American. 2. Public opinion--New York (State)--
New York--History--20th century. 3. Spain--History--Civil
War, 1936-1939--Press coverage. 4. Spain--History--Civil War,
1936-1939--Art and the war. 5. New York (N.Y.)--Intellectual
life--20th century. I. Carroll, Peter N. II. Fernández, James D.
DP269.P8F33 2007
946.081'1--dc22 2006036351

New York University Press books are printed on acid-free
paper, and their binding materials are chosen for strength
and durability.

Design: Pure+Applied | www.pureandapplied.com

Manufactured in China

p 10 9 8 7 6 5 4 3 2 1